**ART & DESIGN**

ACADEMY GROUP LTD
42 LEINSTER GARDENS, LONDON W2 3AN
TEL: 0171-402 2141  FAX: 0171-723 9540

EDITOR: Nicola Kearton
SUB-EDITOR: Ramona Khambatta
ART EDITOR: Andrea Bettella
CHIEF DESIGNER: Mario Bettella
DESIGNER: Phil Kirwin

SUBSCRIPTION OFFICES:
*UK*: VCH PUBLISHERS (UK) LTD
8 WELLINGTON COURT, WELLINGTON STREET
CAMBRIDGE CB1 1HZ
TEL: (01223) 321111  FAX: (01223) 313321

*USA AND CANADA*: VCH PUBLISHERS INC
303 NW 12TH AVENUE DEERFIELD BEACH,
FLORIDA 33442-1788  USA
TEL: (305) 428-5566 / (800) 367-8249
FAX: (305) 428-8201

*ALL OTHER COUNTRIES*:
VCH VERLAGSGESELLSCHAFT MBH
BOSCHSTRASSE 12, POSTFACH 101161
69451 WEINHEIM
FEDERAL REPUBLIC OF GERMANY
TEL: 06201 606 148  FAX: 06201 606 184

© 1995 *Academy Group Ltd*. All rights reserved. No part of this publication may be reproduced or transmitted in any form or by any means, electronic or mechanical, including photocopying, recording or any information storage or retrieval system without permission in writing from the Publishers. Neither the Editor nor the Academy Group hold themselves responsible for the opinions expressed by writers of articles or letters in this magazine. The Editor will give careful consideration to unsolicited articles, photographs and drawings; please enclose a stamped addressed envelope for their return (if required). Payment for material appearing in *A&D* is not normally made except by prior arrangement. All reasonable care will be taken of material in the possession of *A&D* and agents and printers, but they regret that they cannot be held responsible for any loss or damage.
**Subscription rates for 1995 (incl p&p)**: *Annual subscription price*: UK only £65.00, World DM 195 for regular subscribers. *Student rate*: UK only £50.00, World DM 156 incl postage and handling charges. *Individual issues*: £14.95/DM 39.50 (plus £2.30/DM 5 for p&p, per issue ordered).
**For the USA and Canada**: *Art & Design* is published six times per year (Jan/Feb; Mar/Apr; May/Jun; Jul/Aug; Sept/Oct; and Nov/Dec) by Academy Group Ltd, 42 Leinster Gardens, London W2 3AN, England and distributed by VCH Publishers, Inc., 303 N.W. 12th Avenue, Deerfield Beach, FL 33442-1788; Telefax (305) 428 8201; Telephone (305) 428-5566 or (800) 367 8249. Annual subscription price; US $135.00 including postage and handling charges; special student rates available at $105.00, single issue $26.95. Second-class postage paid at Deerfield Beach, Fl 33441. **POSTMASTER**: Send address changes to Art & Design, c/o VCH Publishers, Inc., 303 N.W. 12th Avenue, Deerfield Beach FL 33442-1788.
Printed in Italy. All prices are subject to change without notice. [ISSN: 0267-3991]
The full text of *Art & Design* is also available in the electronic versions of the Art Index.

# CONTENTS

ART & DESIGN **MAGAZINE**
*Monkeydoodle special pages for Art & Design by Goldsmiths' College students* • Guy **Brett** *on* Adam **Nankervis** • Christos **Marcopoulos** • *Books* • *David* **Mach**

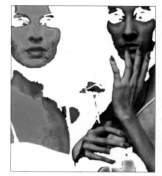
Paul Thurlow (of Goldsmiths' College, see p ii), a section of *The Witnesses*, 1995

ART & DESIGN **PROFILE** No 43

## ART & CULTURAL DIFFERENCE
*Nikos* **Papastergiadis** *And* • *John* **Berger** *Ella* **Shohat** *& Robert* **Stam** *The Politics of Multiculturalism* • *Juan* **Davila** • *scenario* **URBANO** • *Andrew* **Renton** *on Kathy* **Temin** *Néstor García* **Canclini** *Rethinking Identity in Times of Globalisation* • *Penelope* **Harvey** *Postscript* • *Victor* **Anant** • *Jean* **Fisher** *interviews Jimmie* **Durham** • *Paul* **Carter** *Encounters Guy* **Brett** *on David* **Medalla** • *Sarat* **Maharaj** *on Rita Donagh* • *Irit* **Rogoff** *False Endings Judith* **Pascal** *on Constanze* **Zikos**

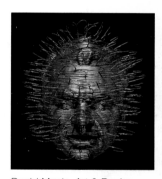
David Mach, *Art & Design* Monograph, Academy Editions, 1995

D1127080

Rita Donagh, *Morning Workers' Pass*, 1978

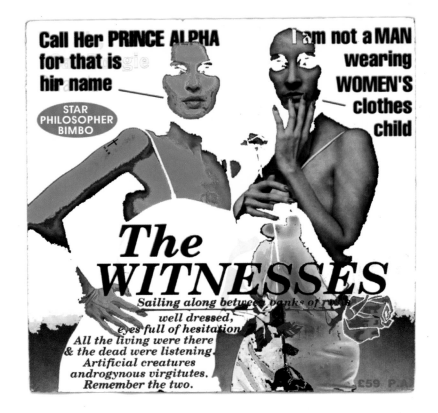

1 'We Have All The Time In The World.' Louis Armstrong. Taken from the film soundtrack *On Her Majesty's Secret Service*. Re-released on 7 November 1994 to coincide with its use in the Guinness advertising campaign.

2 'Mother Fist she never gets angry, Mother Fist she never gets bored. I don't have to feed her, I just have to need her, she cries "give me the word".' Marc Almond. Taken from the album *Mother Fist and Her Five Daughters*, Virgin Records Ltd, 1987.

3 Queen: 'Look on the skin, the symbol of what lies within. Now turn red. Tempt Snow White, to make her hunger for a bite.' From *Snow White and the Seven Dwarfs*, Walt Disney Classics Home Video.

4 'You can walk and talk in virtual reality, you can have whatever you want in virtual reality, all you've got to do is dream. It's just like the real thing only better, it's reality . . . only better.' Momus. Taken from the album *Voyager*, Creation Records.

***Monkeydoodle – Fax Richard Hamilton:*** *What is that untranslatable crease between saying and showing, between the conceptual and visual? This is the work-in-progress on the issue by Goldsmiths' College final year students on the Fine Art/Art History course on 'Richard Hamilton, Duchamp and Joyce'. The project involves trying to write an essay that drifts into making an object – an anti-essay – where idea and image pull faces at each other, a mimicking, a monkey-business, hence the project's name à la James Joyce – Monkeydoodle.* Sarat Maharaj

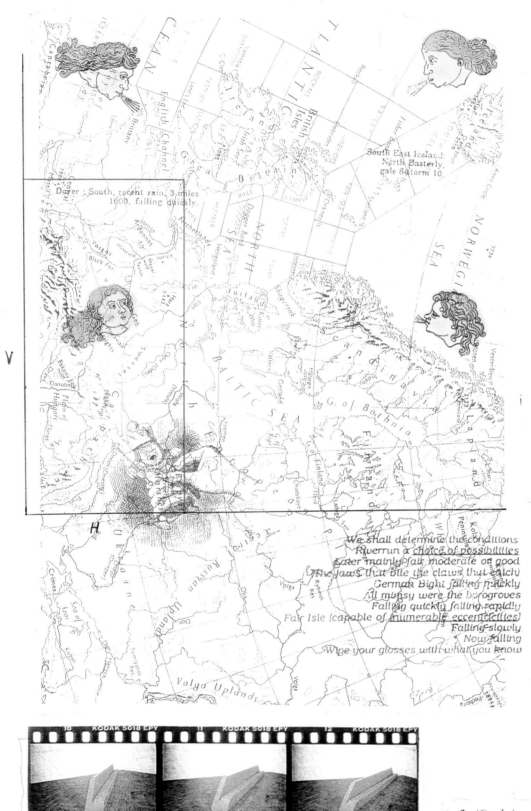

1 'Blood, Shit and Semen.' *A Study in Perpetual Motion* by Jake Chapman and *Working Maquettes* by Dinos Chapman, 1994, clay and photocopies.

2 'Ah, my friend, you do not know, you do not know, What life is, you who hold it in your hands'; (Slowly twisting the lilac stalks) 'You let it flow from you, you let it flow, And youth is cruel, and has no more remorse, And smiles at situations which it cannot see.' Extract from *Portrait of a Lady*, TS Eliot, 1917. Published in *The Complete Poems and Plays of TS Eliot*, by Guild Publishing, London, 1969.

3 'Even when you sleep machines fly over you. Ah . . . The modern world, at any moment they could crash.' Text taken from *The Modern World*, a wall painting by Jessica Diamond, 1989/1991/1994.

4 'We were lulled into believing morphine dispelled pain, rather than making it tangible. A mad Disney cartoon transforming itself into every conceivable nightmare.' Dialogue taken from *Blue*, a film by Derek Jarman.

Left: 'Dado'
8'x1'

1 'Don't Be Weak-Kneed about it', David Robilliard, 1987, acrylic on canvas, 100 x 150cm.

2 'Knocking on Joe is an expression used by American prisoners to describe the desperate measures they would take in order to avoid hard labour – by crushing fingers, hands, legs, whatever it took. This ballad tells of one who has risen above all this, whose suffering has elevated him to some sort of sacred ground hallowed by his own memories, in which he is invulnerable to comfort, brutality or further pain.' Extract from the sleeve-notes for *The Firstborn is Dead*, Nick Cave and the Bad Seeds, 1985, Mute records.

3 *The Youthful Bacchus*, Caravaggio, *c*1589, oil on canvas, 93 x 85cm.

4 'In the 18th century they said "We'll shortly know all there is to know. All things will be clear to us one day". Well I'm sick to death of optimism. Sick to death of the shit it drops us in. Will they find a cure for hope? No-one can say. But tell me you'll be there when I'm knocked out flat with a drip feed in my arm, and tell me you'll be there when the swansong starts to fade.' Momus, Extract from 'Enlightenment', taken from *Timelord*, Creation Records.

CHAIN MAIL QUESTIONNAIRE

Please tick the appropriate boxes

1. With what do we associate the letters PC?
a) Police constable ☐
b) Political correctness ☐
c) Personal computer ☐
d) Post card ☐

2. Of the following, which is the best way to send a visual impression of a holiday?
a) By fax ☐
b) By letter ☐
c) By telephone ☐
d) By postcard ☐

3. If you have answered (d) above, what image do you think would be most popular?
a) Clear blue sky ☐
b) Sparkling sea or snow ☐
c) Polluted beach ☐
d) Hotel under construction ☐

4. What message would we most likely send?
a) Having a lovely time ☐
b) Getting a tan ☐
c) This is the most amazing place ☐
d) Met loads of people ☐

5. What message would we least likely send?
a) Having a miserable time ☐
b) Sunburnt and itching ☐
c) This is the most amazingly awful place ☐
d) Met loads of people but loathe them all ☐

6. How do we like to portray ourselves in a postcard message?
a) Young and glamorous ☐
b) Stylish and svelte ☐
c) Good fun ☐
d) Desirable and sexy ☐

7. How would we like the recipient to feel?
a) Envious ☐
b) Unwordly ☐
c) Parochial ☐
d) Inferior ☐

8. How, as the recipient, are we mostly likely to feel?
a) Jealous ☐
b) Dismissive ☐
c) Lucky them ☐
d) Relieved not to be there ☐

9. What makes us send postcards?
a) To prove we actually went ☐
b) To reflect our sense of adventure ☐
c) To convey our gregarious nature ☐
d) To portray our self delusion ☐

10. When are we most likely to lie?
a) On a postcard ☐
b) On a postcard ☐
c) On a postcard ☐
d) On a postcard ☐

1 'There are certain systems that use urine, well the system cleans this water, to the level of distilled water, and afterwards this water can be used to produce oxygen.' Text from *27 November 1990 London England 13.30*, Henry Bond and Liam Gillick. Quoted in *Technique Anglaise*, edited by Andrew renton and Liam Gillick. Published by Thames and Hudson, 1991.

2 'Cockroaches are your gods, give up your plate of food to them, whether you do or not, they will survive you and your stupidity. You try to kill them with gas and poison just like you do your own kind, the 'roach comes back, stronger, faster, more immune. You watch television, you lock your doors to protect yourself from your race. You put needles in your arms, you sell your bodies, you find new and inventive ways to mutilate yourself and others. You are weak. Cockroaches are your gods.' Extract taken from *Body Bag* by Henry Rollins. Printed in *Cease to Exist*, published by Creation Press. 1991.

3 'Whatever You Say Say Nothing.' Part IV, Seamus Heaney, in *North*. 1975.

4 *Font*, Gavin Turk, 1993, ceramic on wood plinth, height and colours variable.

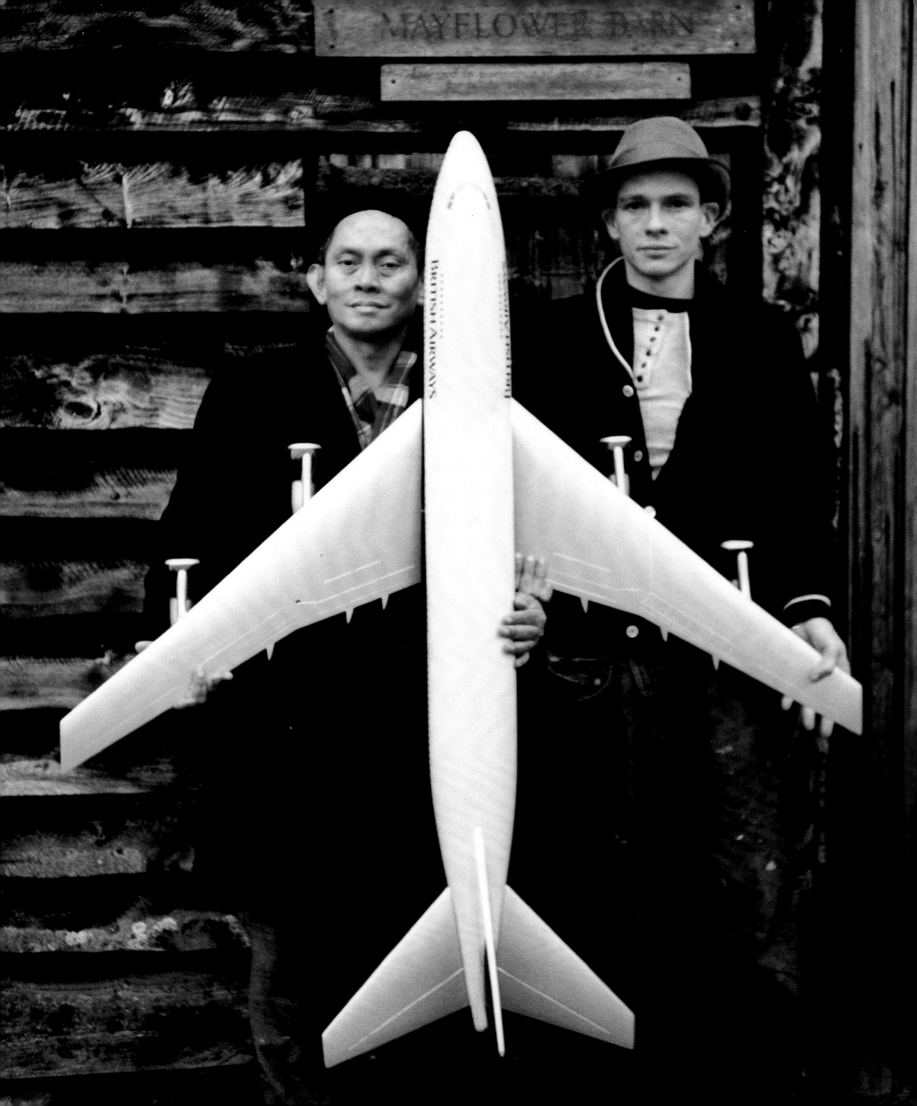

# ADAM NANKERVIS' 'CARGO CULT'

## AT THE MONDRIAN FAN CLUB
### Guy Brett

Nothing could have been more splendidly against the grain than the events which accompanied David Medalla's solo exhibition at 55 Gee Street (held from December 31st 1994-February 26th 1995). What was so unusual was the action of an artist who, while showing his own work to good advantage, would throw open his space to other artists, so the place at weekends resembled the piazza of an Italian Renaissance town with knots of people talking, then occasionally thronging to watch a performance, a talk, a video screening.

How rare this is, at a time when it is considered uncool for artists to be even seen in their exhibitions after opening day (it is assumed they have jetted off to another city on the museum circuit). Often, in a curious way, a vital process seems to have ended at the moment when the exhibition begins! But this hospitality has always been Medalla's style, and The Mondrian Fan Club, as his exhibition at Gee Street was called, was only the latest such phenomenon.

It was in the hubble-bubble of one of these evenings that I caught a remarkable performance by Adam Nankervis. Nankervis, a young Australian artist, was in London, assisting at the Medalla show, on his way from New York to Copenhagen. I was attracted by the incongruous combination of a deep, sonorous sound emanating, like the hum of huge engines, from a frail, flimsy set hung with many-coloured papery curtains. Centre stage was a ghostly Boeing, wrapped also in paper, imprinted all over with pencil-rubbings of tin-can tops, as if an ultra-modern technological body had decided to experiment with tattooing and skin-painting. As I moved closer I saw the sounds alternated with the unamplified voice of the artist who stood on one side of his small stage, reading from a book.

Nankervis's performance focused on travelling, but in a special sense. Its principal theme, or unifying motif, was that vivid instance of the meeting of different belief systems brought about by the expansion of transportation: the cargo cult. This phenomenon becomes a motif encapsulating the possibility of different

nations of causality, and different relationships between use value and symbolic value (at the same time as making us wary of such ordering intellectual terms which spring so conveniently to mind). Nankervis' speech mingled the autobiographical and the researched, a combination of intimacy and distance. A traveller's description of the origins of the cargo cult on the island of Tanna in the New Hebrides intercut with an event from the artist's own experience which had affected him deeply. He made a visit with a friend to Flores, an island off the coast of Timor, and was taken by locals to a cave. There people had reconstructed an aircraft from the fragments of crashed Japanese warplanes, and buried underneath it the abandoned bodies of Japanese and Australian airmen: not in this case a phenomenon of the cargo cult but an act of respect for the unknown dead soldiers. The paradox of an aircraft re-made in a subterranean space was echoed in the enfolding curtains of Nankervis's stage-set.

His performance stressed the tensions between things that have affected one directly and the knowledge gained by reading and research, in the desire to make sense of reality. The subjective and objective were woven together in his text in an attempt to recapture the 'magic of story time'. The artist confessed himself 'intrigued by the mysterious ways in which modern mythologies have come into being by the interpenetration of 20th-century technology and traditional cultures', and described his art works as 'an examination, a visual interpretation and a poetic evocation of these new paradigms of emerging global cultures'.

The short performance contained both delicacy and power. It reminded one again that 'examinations' of culture are themselves cultural events. Nankervis' performance, in itself and within the frame of the Mondrian Fan Club, was a special way of integrating inherited culture in the present moment in a form that was participatory and inclusive and somewhat different from the proprieties of academia and art museums.

*Adam Nankervis (right) with David Medalla and Boeing in front of the Mayflower Barn, Jordans, Buckinghamshire, reputed to incorporate some timbers of the 'Mayflower', the ship of the Pilgrim Fathers*

# SURVEY APPARATUS FOR THE STATUE OF LIBERTY

## LIBERTY ISLAND, 4 JULY 1990
## Christos Marcopoulos

### The Transfer of Identity

Chiasmus is the grammatical figure by which the order of words in one of two parallel clauses is inverted in the other. The survey apparatus transferred the inner surface of the skin of the Statue of Liberty to the outer surface of the skin of the human arm, as an electrotype is transferred to its base. The interaction of exploring fingers with the integument of the statue passes through the transfer mechanism of the apparatus, to be scratched with a knife on the forearm. The topography of the statue is not merely recorded on, but unified with, the surface of the body.

In Kafka's *Penal Colony*, the crime for which the convict has been convicted is mechanically inscribed on his body. To Foucault, the body is its own panopticon, subjected to the authority of every sensory impulse from the world by which it is surrounded. The apparatus provides a record of the tactile impulses that transfer surface to surface; it is also the transaction itself of skin to skin, a chiasmus of flesh. *Nicholas Barker*

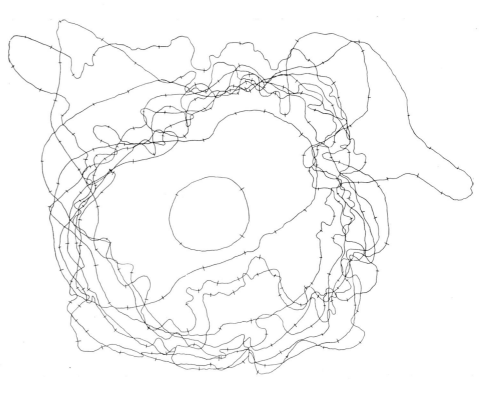

*The apparatus was designed and constructed during the months of April and June 1990. The materials employed were: brass metal stock, steel, nylon string, steel wire and leather. After first being tested on a simple contour by the architect, it was presented to the visiting public for use in their ascent within the Statue of Liberty on the 4th of July 1990 (photos by Ari); RIGHT: Layered sections taken at regular intervals of the skin of the Statue of Liberty.*

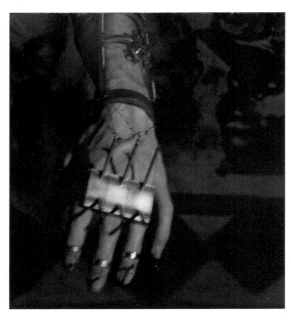

**THE BLACK ATLANTIC: Modernity and Double Consciousness** by Paul Gilroy, Verso, 1993, 261pp, HB £34.95, PB £11.95.

This book presents a powerful argument for the possibility of liberation from the cultural and national frameworks which limit shared cultural understanding. The Black Atlantic marks a space for race and roots to be configured as an exchange of narratives between Africa, America, the Caribbean and Europe beyond national and ethnic boundaries. Instead roots become routes which are central to the narratives of slavery and the Black diaspora. These routes form a poetic structure through which Gilroy considers Black experiences and memories as a 'counter culture' which both records the marginalisation of the Black identity and places it within modernism.

In particular, he considers Black music, ranging from the 19th-century Jubilee Singers to Jimi Hendrix and rap, as a cultural response which describes these political and historical events. Gilroy also explores WEB Du Bois' philosophy of 'double consciousness', Richard Wright's 'double vision' and Toni Morrison's novel *Beloved*, to suggest that these writers manifest a self-conscious Black modernism, which in turn enriches our understanding of modernism as a whole. For Gilroy these writers' thinking provides the scope for 'an explicitly transnational and intercultural perspective'.

**BAROQUE MEMORIES** by Paul Carter, Carcanet Press, b/w ills, 1994, 194pp, HB £14.95.

Carter writes that to 'understand the Baroque it is necessary to stay on the surface'. Surfaces, visibility and invisibility, ambiguity and transformation are themes which structure the experiences of Christopher, an explorer of the Baroque, in the City of L—. Carter weaves tales of Christopher's travels in this spectacular city together with reflections on the nature of the Baroque, desire, culture and perception.

Nine chapters trace the explorer's meetings with characters who have semblances of both historical figures and fantastic beings: the Contessa von Economico, the tour-guide Philophilus, Martin Magellan, Doctor Duende and Nostalgia. Through the figure of Nostalgia Carter explores the mutual pull and repulsion of nostalgia which can be said to be a condition of post-modernism. In addition, the potential for personal transformation and liberation are suggested in the way the physical spaces and architectural features of the city constructs contact between the characters, their status and identity in history.

**DON'T LEAVE ME THIS WAY: Art in the Age of AIDS**, compiled by Ted Gott, National Gallery of Australia, distributed by Thames and Hudson, 1994, b/w and colour ills., 246pp, PB £12.95.

This book grew out of the exhibition of the same name organised by the National Gallery of Australia, Canberra. It contains essays, writings, songs, reproductions of posters and work by American, European and Australian artists and photographers which charts the responses to HIV/AIDS in relation to the gay community, political and cultural awareness, the media and discrimination, desire and loss.

In addition to the important work by artists such as Andreas Serrano, Juan Davila, Nyland Blake, Cindy Sherman and David Wojnarowicz, the book contains reproductions and essays on the visual work by artists and communities involved with HIV/AIDS in Australia. Photographer William Yang's intimate narrative from *Sadness*. *A Monologue with Slides*; photographs from the project 'Self-Imaging: Australian People Living with HIV/AIDS'; and posters produced by health councils and gay groups indicate the development of positive codes of representation about the issue in the West.

Carole S Vance's essay 'The War on Culture' forcefully reminds us of the existence of discrimination against these marginal communities. She argues that recent institutional and political attacks in the US made on visual arts dealing with sexuality, for example, Serrano's *Piss Christ*, are part of a systematic programme to restore right-wing traditions. Jan Zita Grover considers the historical shifts, and strategies for portraying people living with AIDS developed by those involved in HIV/AIDS, such as ACT UP/New York and those outside. Zita Grover suggests that the book's various responses will contribute to community's 'accommodation to HIV/AIDs that will be more or less intimate, more or less mortal'.

**JUANITO LAGUNA** by Juan Davila, Chisenhale Gallery, 1994, Exhibition Catalogue, b/w and colour ills, 24pp, PB £6.00

This catalogue from the exhibition organised by the Chisenhale Gallery, London, includes full-page colour photographs and essays by Guy Brett and Carlos Perez Villalobos which explore Davila's 'critical ambivalence' to difference and the production of art.

Davila's installation brings together a wide range of elements from Latin America, Europe and Australia in the act of *mestizaje*. Davila translates this Latin American term for the mixing of races into a challenging piece of work which includes the themes of authenticity, transgression and colonisation. Mixed-media elements are joined together to appear as 'body' of different components – it is placed on the floor and painted onto the walls of a gallery – and a critical comment about the body in culture. The body is evident at various levels, ranging from his provocative use of kitsch and masquerade to his identification with contemporary issues about AIDS.

Davila challenges the concept of the authentic, unified author through his spectacular mimicing of modernist techniques and styles and the feminisation of his own name. The allegorical scenes of the South American character, Juanito Laguna (who featured in Argentine artist Antonio Berni's work), present Laguna as an ambiguous gendered being who confronts Western notions and fear of the 'Other', and remarks on the contemporary marginalised transsexual community.

**GLOBAL VISIONS: Towards a New Internationalism in the Visual Arts**, edited by Jean Fisher, Kala Press in associa-

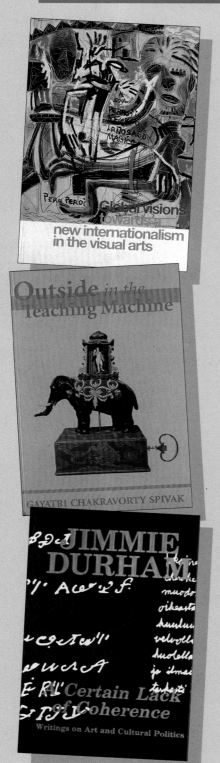

Art & Design would like to apologise sincerely to Renée van de Vall for the production errors that appeared in her article 'Silent Visions: Lyotard on the Sublime' included in The Contemporary Sublime: Sensibilities of Transcendence and Shock, A&D 1/2 95. Clyfford Still, 1957-D, no 1, 1957 was reproduced on its side, with its left edge turned downwards. Barnett Newman, Vir Heroicus Sublimis, 1950-51 was flipped 180 degrees.

tion with The Institute of International Visual Arts, London, 1994, b/w ills, 184pp, PB £11.95
This publication presents the papers delivered at the inaugural conference of the International Visual Arts, held at the Tate Gallery, London, 1994. The book's preface is by Gavin Jantes and contributors from an international group of artists, critics, curators and academics include Evelyn Nicodemus, Hal Foster, Rasheed Araeen, Jimmie Durham and Judith Wilson.

Fisher's editorial firmly places the conference's attempt at dialogue after Multiculturalism. She highlights the limitations of Internationalism's historical and intellectual precursor: its failure to undo the inequalities between Western institutions and post-colonial cultures. Instead she introduces the papers as rigorous interrogators of international art and culture.

The contributing voices are organised into four sections; the codification of Internationalism; Art History and art museums; diversity and difference; and issues of curatorship. Art Historian Sarat Maharaj calls for the International arena to be the ground for a 'scene of translations'. Critic Hou Hanru uses the metaphor of entropy to explore Chinese artists' strategies which break down the traditional 'cultural-artistic system'. Challenging the simplistic categorisation of the 'othered' artist Gordon Bennett advocates a process of hybridisation as the agent for change. Curators Raiji Kuroda and Gerado Mosquera's essays argue for greater development in 'local' criteria for evaluating the visual arts and therefore liberating curatorial practice from the dependency upon Western forms of interpretation.

**OUTSIDE IN THE TEACHING MACHINE** by Gayatri Chakravorty Spivak, Routledge, 1993, 325pp, HB £35.00 PB £12.99.
This thought-provoking book investigates contemporary debates in Multiculturalism, including difference, feminisms, translation, post- colonialism and cultural studies.

The 13 essays consider how these discourses and disciplines structure our understanding of culture and are concerns which belong to perceptions of

the 'other', challenging the boundaries of academicism. Spivak focuses on the articulation of these issues in relation to film, literature, visual art, the Third World and the US Constitution. In addition, she alerts us to the need for rigorous development of cultural studies to avoid any superficial understanding of Multiculturalism.

An interview with Spivak serves as an introduction to the subsequent essays in its pursuit of risk-taking philosphical and deconstructive strategies. She argues that a radical nonessentialist theory is dependent upon the disruptive possibility of essentialism. In 'The Politics of Translation' she suggests a relationship between the act of translating from a Third World reading and a 'cultural translation' in the writings of JM Coetzee, Toni Morrison and Wilson Harris. Spivak proposes the need for a Transnational Cultural Studies. Central to this realisation is the recognition of the limits of our own language and the scope for expression in the pursuit of greater cultural understanding.

**A CERTAIN LACK OF COHERENCE: Writings on Art and Cultural Politics** by Jimmie Durham, edited by Jean Fisher, Kala Press, 1993, b/w ills, 267pp, PB, £11.95
'The Cherokee word for Cherokee is Ani Yunh Wiya. If translated might literally, it might mean "The People", as so many other Indian nations call themselves. None of the words by which you call us are words by which we call ourselves. Consider the import of such a phenomena upon your knowledge of what you call your country.'

This anthology brings together a valuable source of Jimmie Durham's creative and intellectual writings since 1974. His essays and poems fiercely challenge the Eurocentric perception of difference and the 'other'. They range from a call for a united American Indian resistance to colonisation; energetic criticism of artistic, institutional and political responsibility in confronting primitivism to an interrogation of the naming/un-naming of the 'other' by colonialist language and history. Durham's writing of these issues is rich and witty. In 'Sav-

age Attacks on White Women, As Usual', Durham examines the historical loss of American Indians in colonisation and and contemporary American prejudices in a catalogue essay for an exhibition of American Indian art. But it is also a critique on touristic art exhibitions. 'We want to figure out how not to entertain you, yet still engage you in discussions about what is really the centre of your reality, although an always invisible centre'.

**BEYOND THE FANTASTIC: Contemporary Art Criticism from Latin America**, edited by Gerado Mosquera in association with Oriana Baddeley, Institute of International Visual Arts,1995, 384 pp, £NA
The title of Beyond the Fantastic alludes to the stereotype of the marvellous which is so common in the expectations of European and North American audiences with regard to Latin America. This assumption is called into question in this selection of new theoretical discourses on Latin American visual arts. The writings are centred on the notion, formed in the 1960s, of Latin America as a distinctive cultural field where theories founded on social and political views took the place of traditional impressionistic and metaphorical interpretations. However the writings are conditioned by developments in Post-structuralism and cultural studies which took place during the 1980s. They also represent a reversal of the utopian ideals of modernism reflecting the specific experiences of the last two decades where the triumphs of the left led to a backlash of repression by the military dictatorships. The new spirit is pragmatic, showing 'a lifting of the burden of great schemes and a greater concentration on small horizontal changes'. Among the writers included in the anthology are Néstor García Canclini and Mirko Lauer, two of the great names of the 1960s and 70s, as well as leading figures today as well as Nelly Richard, Luis Camnitzer, Guillermo Gómez Peña, Celeste Olalquiaga, Pierre Bocquet and Carolina Ponce de Léon. *NK*

*Unless otherwise stated all reviews by Peggy Rawes.*

# DAVID MACH

## LIKENESS GUARANTEED

*Art & Design Monograph*

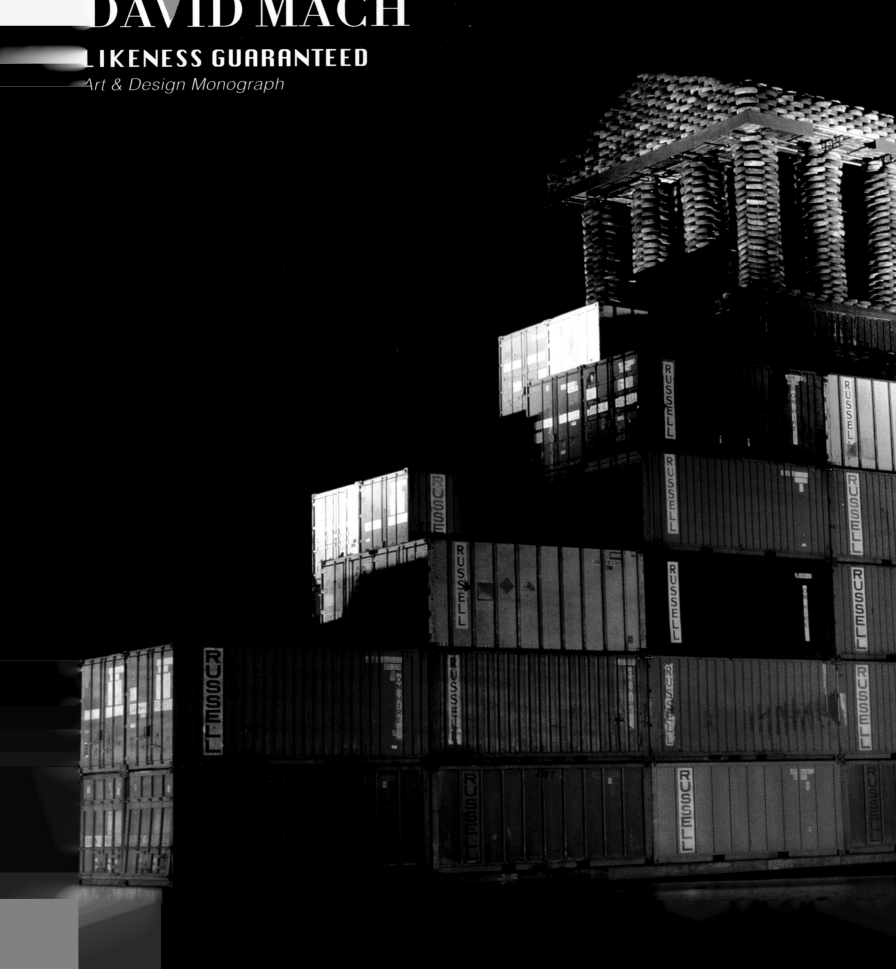

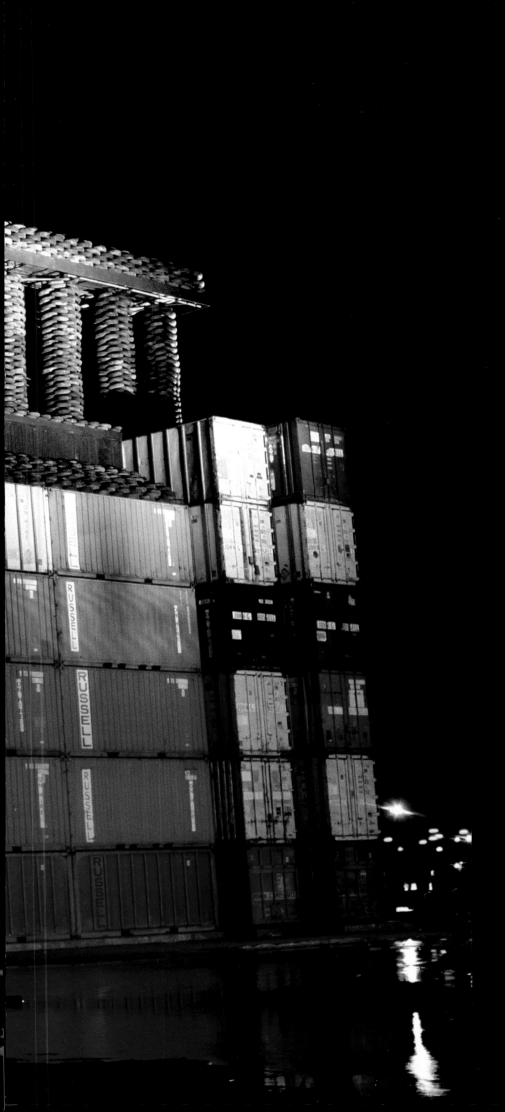

Scottish born sculptor David Mach rose to prominence in the early 1980s with his remarkable large-scale sculptures and installations, most notably *Polaris*, the submarine made from tyres exhibited at the Hayward Gallery, London. From his earliest student pieces at Duncan Jordanstone College of Art and the Royal College, Mach's work has been characterised by his use of multiple mass-produced objects, most famously and consistently magazines. At first he used these units to create representational works – *Silver Cloud*, *Volkswagen*, *Running Out of Steam*, *Centurion Tank* – but then moved on to explore and deliver the 'extraordinary messages' that they carried within them. The liquid-like properties of the glossy journals, their advertisements and indiscriminate treatment of news events became huge swirls and vortices swallowing and sweeping along objects as large as cars and lorries: 'I found that the materials had their own energy, their own flow'. Passing comment on the materialism and commercialism of society, Mach employs humour as a strong weapon, 'to put humour in [a work] probably makes it more serious', and in striving to present his work to as wide an audience as possible he values the 'performance' aspect of assembling the installations, the 'theatre/drama' and the interaction it affords between site, work, sculptor, assistants and audience.

*David Mach: Likeness Guaranteed* presents the vast range of the sculptor's work. In 'Thinking Big' Paul Bonaventura examines the themes and ideas behind Mach's sculptures, while in an interview with Tim Marlow the sculptor reflects on his work and discusses his most recent ideas and proposals. Produced to mark the *Likeness Guaranteed* exhibition at Newlyn Art Gallery, this book presents in full colour all of Mach's best known works, the magazines, the installations, the gargoyles, the trophies, the match heads, the coat hanger heads, as well as drawings for huge new projects at Darlington and an art corridor for the M8 in Scotland.

*Images from Temple at Tyre, Leith Docks, Edinburgh, November 1994 (photos by Lloyd Smith) from a forthcoming Art & Design Monograph on David Mach, ISBN 1 85490 350 0, £21.95, 128pp publication date: July 1995*

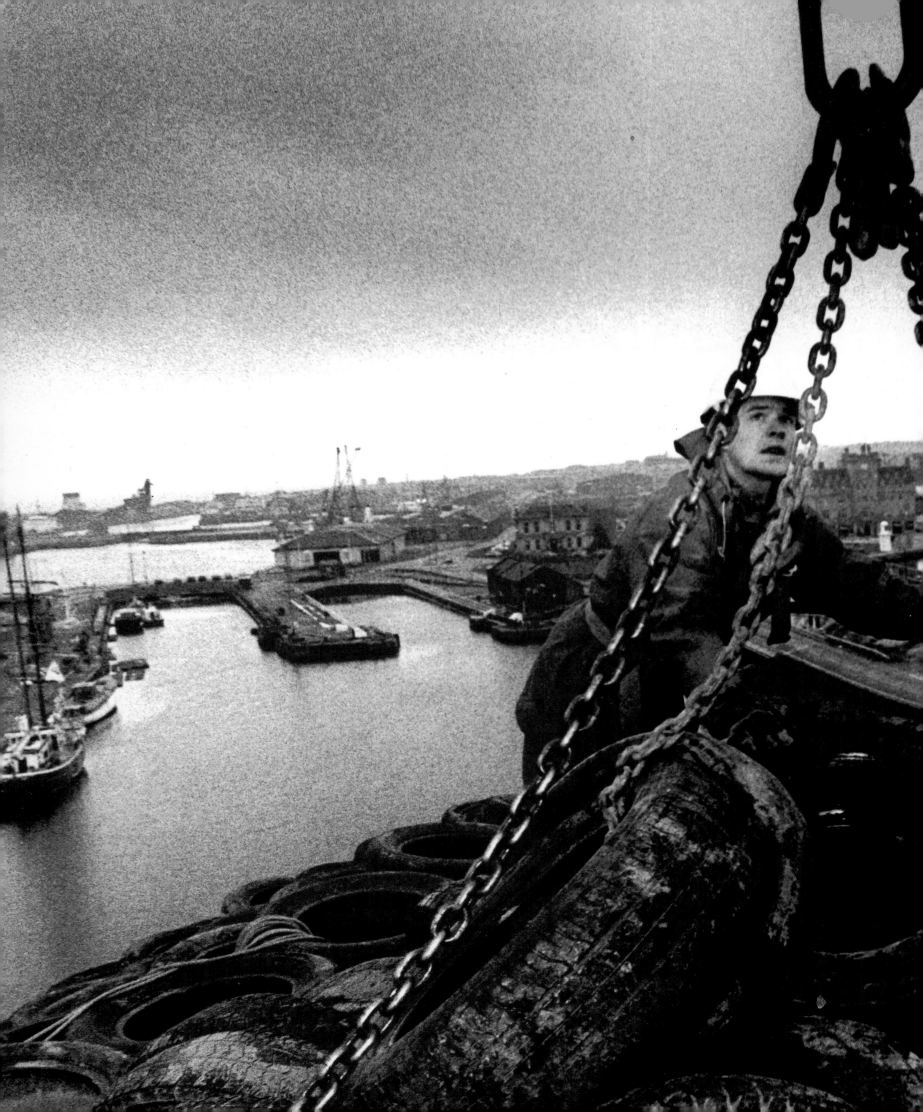

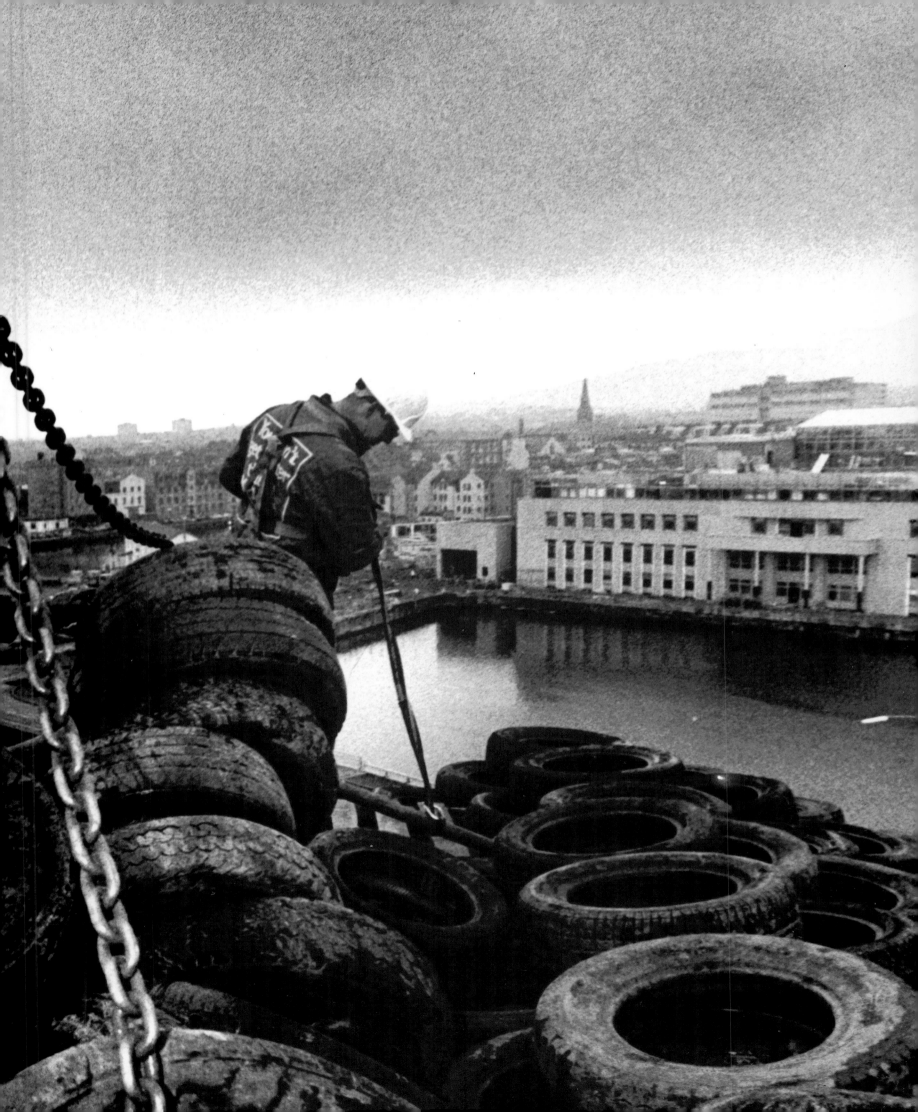

**Chronicle Flanders and
The Netherlands**

Frank Kauffmann on Museum Light
Bart Verschaffel on Jan Fabre
Lex ter Braak on Museums
and Kunsthallen
Mondrian: Unpublished Reflections

# kunst & museumjournaal

**volume six, number one 1995**

6 issues per annum £29;
single copy £3.60
please call or fax
to PVO Subscription services
tel: 3116157901 fax 3116152913

# ART & CULTURAL DIFFERENCE

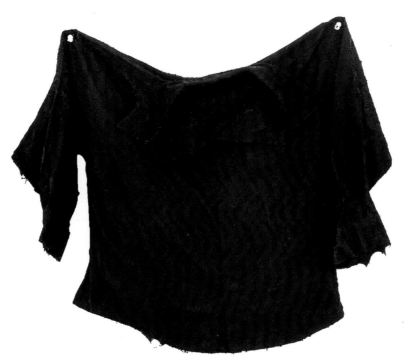

*Jimmie Durham,* Dirt and Hair on Canvas, *1994, 35.6 x 38.1cm*
*(Nicole Klagsbrun Gallery, New York)*

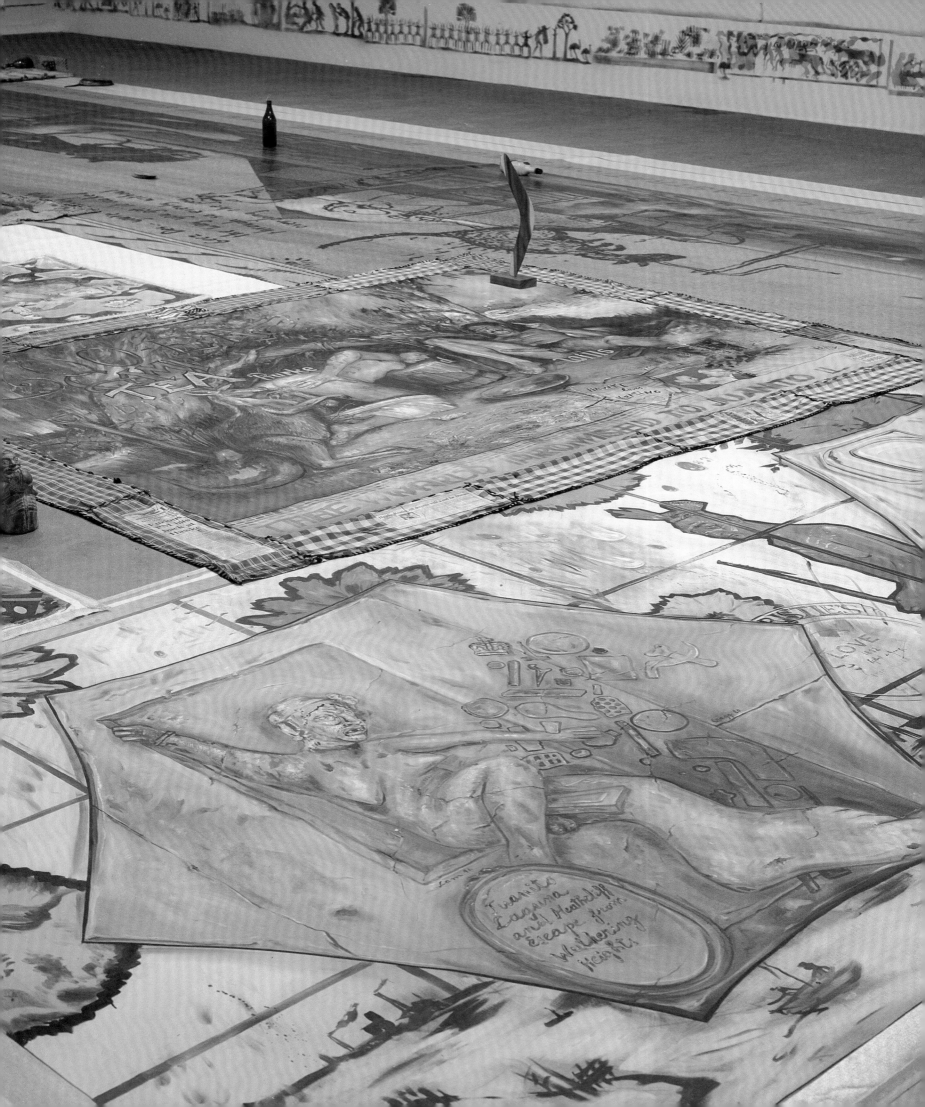

Art & Design

# ART & CULTURAL DIFFERENCE
## HYBRIDS AND CLUSTERS

OPPOSITE: Juan Davila, Juanito Laguna, *Chisenhale Gallery, London, 1994, installation detail;*
ABOVE: Constanze Zikos, *Fake Flag, 1994*

ACADEMY EDITIONS • LONDON

# Acknowledgements

We would like to thank all the contributors to this issue and especially Nikos Papastergiadis, our guest-editor, for putting together such an inspiring collection of work. Our credits are as follows: **And** *pp6-8*: p8 image from Jochen Gerz and Esther Shalev-Gerz, *The Harburg Monument against Fascism,* Hatje, Germany, 1994; **A Girl Like Antigone** *p9* and **A House Designed by Le Corbusier** *pp64-65*: from a collection entitled *Photocopies* by John Berger to be published by Bloomsbury, Berger's new novel *To the Wedding* will be published by Bloomsbury on 14th September 1995 at £13.99; **The Politics of Multiculturalism** *pp10-16*: this is an edited version of a chapter from *Unthinking Eurocentrism: Multiculturalism and the Media* by the same authors, Routledge, 1994; **Juan Davila** *pp17-19*: images courtesy of the Chisenhale Gallery, London; **Zona Di Transito** *pp20-29*: courtesy of the artists; **Kathy Temin** *pp30-35*: p30 (below), p33, p34 (below), p35 Anna Schwartz Gallery, Melbourne; p30 (above), p34 (above) the artist and Roslyn Oxley 9 Gallery, Sydney; **Rethinking Identity** *pp36-40*: translated by Anna Ransom; **Kunjamma** *pp44-45*: courtesy of Victor Anant; **Jimmie Durham** *pp46-55*: all images courtesy of Nicole Klagsbrun Gallery, New York, apart from p52 Galerie Micheline Szwajcer, Antwerp; **Encounters** *pp56-63*: this essay forms part of the catalogue 'Fleeting Encounters', an exhibit of paintings and chronicles of the First Fleet, opening in June 1995 at the new Museum of Sydney, on the Site on First Government House, we would like to thank Martin Pulsford of the Natural History Museum Picture Library, London, for his help in obtaining the images; **David Medalla** *pp66-75*: all images courtesy of the artist; **Rita Donagh** *pp76-83*: first published in *Rita Donagh, 197419841994: Paintings and Drawings,* Cornerhouse, Manchester, Camden Arts Centre, London, The Irish Museum of Modern Art, Dublin, all images courtesy of the artist, p78, p79 courtesy of the Tate Gallery, London, p83 courtesy of Granada TV, Manchester; **False Endings** *pp84-89*: images courtesy of George Legrady; **Constanze Zikos** *pp90-95*: images courtesy of the artist.

*FRONT AND BACK COVER: Jochen Gerz and Esther Shalev-Gerz,* Monument Against Facism, *Harburg, 1986-93*
*INSIDE COVERS: David Medalla,* Kinetic Mudra for Piet Mondrian, *Neon, 1995*

EDITOR: Nicola Kearton SUB-EDITOR: Ramona Khambatta
ART EDITOR: Andrea Bettella CHIEF DESIGNER: Mario Bettella DESIGNER: Phil Kirwin

First published in Great Britain in 1995 by *Art & Design* an imprint of
ACADEMY GROUP LTD, 42 LEINSTER GARDENS, LONDON W2 3AN
Member of the VCH Publishing Group
ISBN: 1 85490 226 1 (UK)

The Publishers and Editor do not hold themselves responsible for the opinions expressed by the
writers of articles or letters in this magazine
Copyright of articles and illustrations may belong to individual writers or artists
*Art & Design* Profile 43 is published as part of *Art & Design* Vol 10  7/8 1995
*Art & Design* Magazine is published six times a year and is available by subscription

Distributed to the trade in the United States of America by
ST MARTIN'S PRESS, 175 FIFTH AVENUE, NEW YORK, NY 10010

Printed and bound in Italy

# Contents

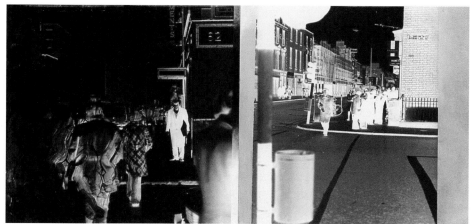

*Rita Donagh,* Newspaper Vendor, Talbot Street, Dublin, *1978*

ART & DESIGN PROFILE No 43

## ART & CULTURAL DIFFERENCE

### Guest-Edited by NIKOS PAPASTERGIADIS

# AND

## AN INTRODUCTION INTO THE AESTHETICS OF DETERRITORIALISATION

*Nikos Papastergiadis*

(And*) signals a simple addition, the apposition of one term with the other, nothing more. Auerbach turns this into the characteristic of 'modern' style, paratax as opposed to classical syntax. Conjoined by and, phrases or events follow each other, but their succession does not obey a categorical order . . . Joined to the preceding one by and, a phrase arises out of nothingness to link up with it. Paratax thus connotes the abyss of Not-Being which opens between phrases, it stresses the surprise that something begins when what is said is said. And is the conjunction that most allows the constitutive discontinuity (or oblivion) of time to threaten, while defying it through its equally constitutive continuity (or retension) . . . Instead of and . . . there can be a comma, or nothing.*

Jean-François Lyotard

From Brussels to Buenos Aires, Melbourne to Montreal, bureaucrats and politicians are attempting to incorporate the amoeba-like concepts of cultural pluralism and multiculturalism within the framework of the nation state. From *Magiciens de le terre* (1989) to the *Whitney Biennale* (1992), the mainstream institutions of art have, in varying degrees, responded to a variety of social and cultural issues relating to the problematic of difference, hybridity and marginality. This is not to suggest that the codes of entry in the art world are marked by the same criterion as the rules of citizenship. The tests of loyalty and utility are not equivalent, but the challenge to address plurality does cut along similar diagonals. Deep contradictions are being exposed. The institutions of the state which were born with the drive to create a single nation are facing the needs of peoples which have at least two incommensurable identities at hand. Similarly the institutions of art which have all been structured in the image of the nation are grappling with redemptive narratives in order to re-house the nomadic existence and peripatetic sensibility of artists and writers. Somewhere between the confusion, guilt and excitement that surrounds this activity lies a conviction that the time of the 'other' in art has arrived. The headings to symposia and exhibits worldwide suggest a certain level of curiosity in something that was previously deemed insignificant, irrelevant or outright backward. Attending such events is an ever expanding list of histories and subjectivities that legitimately demand to be heard and seen. The strategies that guided these responses reflected a need to make visible groups of artists, national traditions, social themes, and processes of interaction that were previously excluded from the canon of modernism. Revision and extension forms the common principle of acceptance. Who would dare to disagree with that?!

At face value these gestures signify a radical change. However, the commitment to change needs to be measured not just by the occasional inclusion of new names within the dominant institutions but also in the willingness to innovate the structures of representation. Otherwise this invitation will serve no other purpose than to legitimise the expansion of the institutional ambits. The promises of altered sensibilities have yet to deliver a transformation in even the protocols of hospitality and acknowledgement. Throughout the debates in political economy on the structured racism within state and society, radical proposals were put forward that demanded the wholesale revision of the principles which govern everyday life. At the very least, this led to the emergence of ethno-specific and parallel institutions. For instance, the emergence of the Black art movement in Britain was part of this contestatory groundswell. Despite the contradictions and fickleness of state support, and a number of unbalanced attempts to form umbrella organisations, this movement posed fundamental questions about the relationship between the dominant structures and the margin. If the recent cultural debates on multiculturalism in international fora continue to overlook the jagged histories of minorities within the existing national structures, and fail to challenge the binarisms of 'modern/primitive', 'rational/irrational' that underpin the segregation of artists from the West and the non-west, then they will have barely touched the edges of the complex rubric of migration and globalisation. Another cultural ghetto regulated by the centre, or new declarations of universality which posit a false continuum of sameness will neither succeed as a strategy nor suffice as a container for the representation of difference.

Clearly we need to rethink the models for explaining how identity emerges out of the centre – periphery dynamic. The migration of peoples across borders, the technological changes in circulating symbols, and the reorganisation of the means of production have produced a sequence of changes that Néstor García Canclini calls deterritorialisation. Like a number of other critics, he has urged us to question the paradigms which singularly bind the identity of an individual and a community to a specific place. It is one of the paradoxes of this age, which is so deeply marked by mobility and rupture, that the metaphors of identity place such exclusive value on a sense of 'rootedness' to the place of origin. The two extreme associations – displacement and transcendence – that trail mobility have implications for how we understand the position of the artist in a multicultural scene. As Guy Brett has noted, the institutions of art tend to construct antagonistic alternatives: an artist is either marginalised or placed within the mainstream, leaving no space for a third position. However, even in cases where mobility was not an option, the aspiration of the artist is not confined to either

distanciation or assimilation but rather a form of 'critical independence'.

But perhaps there is more work to be done on the permissiveness and neutrality of our 'tolerant' spirit. With what resources will accommodation be made available? By what means is translation between such different languages possible? Can the 'other' be named, coded, exchanged and valued without a modification in the rules of the game? In short, in the absence of a universal code, with what sort of critical framework will the judgement across difference be made?

These questions cannot be posed without implicating the very aim and structure of this collection. How did the groundswell shift to make this a theme that would be attractive to such an audience? On what basis was this 'mongrel crowd' assembled? Without decades of heated discussions on the specificity of indigenous and immigrant cultural formations, and without my own involvement with other artists/activists/editors like Rasheed Araeen at *Third Text* and George Michelakakis at *Chronico*, and my own sense of oscillating between and against the coordinates of Greece-Australia-Britain – this situational identity which has sharpened my awareness of the constant process of translation and negotiation between the foreign and the familiar has informed both the appreciation and governed the selections in this collection. This collection was arranged without appeal to the conventions which routinely muster together a variety of artists and writers. The contributors to this volume were selected, neither because they share a common practice of formal techniques, nor due to a shared origin to a specific geo-political region – the possibility of a theme can only be hinted at from the recognition of a critical sensibility formed in their practice which is associated with the exilic dynamism of our age. There is no flag, no counter manifesto, no fixed traditions which define the trajectory of this volume, it is more like a collage of unstructured but not arbitrary encounters. The multiplicity of perspectives, forms and sources to be found here are not just testament to the cumulative traffic of modernity, but also to the tensions that lurk between the not entirely forgotten memories and the yet to be named signs of our times.

The question of identity, in all its bitter-sweet forms, returns to us incessantly. There seems to be no final answer that can be given to it, and the requests for clarification may point towards new levels of connectedness just as the demand for designation can seem stultifying. Why should we stress our hybridity in all its dark, shadowy and well lit form, if not for the fact that the identity of the nation has been so heavily garbed in the costume of purity and exclusivity. These narratives and counter-narratives of authenticity which deny the uneven histories of exchange, censor the dialogue with others, and show disrespect to the multiplicity of our being are the curse in the eyes of hybrids. A hybrid is anything of mixed origin. Identity, insofar as it is a reactive response to the putative identity of the other, is always formed on the basis of difference. There is no primordial essence which governs our origin or determines destiny. Hybridity in culture and in identity is not only reactive in the process of formation but also dualistic, at the very least, in terms of consciousness and perspective: aware of the differences in the bits of its making,

while looking forward to the difference that can be made.

By returning to the question of identity, our intention is to neither reinstate the formal goals of purism in early modernism which bracketed the cultural dimension as it celebrated a very abstracted form of individualism, nor reduce culture to a symptom of the socio-economic base. Appeals made to the context of cultural production are not made in the spirit of mechanistic determinism. The hybrid is neither a symbol for this stage of our modernity, nor an emblem for a community that has somehow remained outside the present. Rather we wish to present 'work in progress' on the discursive and structural conditions in which identity is articulated on both a global and a local level. The encounters referred to in this collection demand interpretation at a number of interconnected levels, this is not just a catalogue of experiences, nor a survey of a pre-determined field. What is being mapped in this collection is the way both artists and writers, working within their specific genre, respond to common questions and anxieties. The aim is not to profile the work, nor to document suffering, but rather to consider the energy that is in the practice of working and the meanings of displacement.

Considerable research has already been conducted in critical theory on both the 'politics of recognition' and the 'processual formation' of identity through discourse. We would like to test and extend some of the claims in these debates by considering the structural conditions within both the production and interpretation of art. By focusing on the structures of representation, rather than privileging only the artists we hope to overcome the pitfalls and dead-ends of 'politically correct' art. When the artist is reduced to performing the expected role of victim where response is restricted to pre-programmed pity, then such an encounter will hardly modify the terms of engagement. As Irit Rogoff argues, a simple minded politics of cultural inclusion needs to be counter-balanced by a structural transformation and a perspective that accommodates both the 'curious eye' and the 'responsible gaze'. We wish to consider how the various attempts to develop a critical framework within art practices that deal with cultural difference not only requires the exercise of 'discovering' the unknown, forgotten or ignored artists, but also involves the task of re-thinking the conditions under which we know, remember and appreciate art. This implies a shift from classification according to commonality in either national origin or technical practice, to a re-definition of the complicity between identification of certain aesthetico-political concerns and the way we understand both the machinations of subjectivity and the production of knowledge. Broad horizons, such as these, may only be invoked with some caution.

At this end of the century, as the concept of the nation state undergoes another crisis, it is the domain of 'new internationalism' which is once again raised as a possible site for cultural integration. However, the notion of internationalism has never been purely innocent and benign. Humanist sentiments with internationalist dimensions have often been woven into the most profoundly anti-human projects. We are by now well aware of the devastation and suffering that was ruthlessly executed in the name of modernisation. Colonial rule may now be formally dismantled, but as Ngugi Wa Thiong'o reminds us, decolonising

the mind is far from complete. It is also worth noting that the current committee that discusses issues of migration for the European Union is also the same group that is set up to advise on the threat of terrorism and drug smuggling. By keeping the issue of migration in the same frame as these other forms of violent transgression it maintains a continuum with the so-called 'histrionic tendencies of social life'. The stigmata of migration is deeply engrained in the political imaginary. The ongoing complicity between globalisation and eurocentrism only adds new levels of insecurity to the new modes for interaction and integration in the world economic and communications system. Such challenges are inevitably at the forefront of the way we understand artistic production.

Given the perils of the 'New World Disorder', and the sting in the resurgent and emergent collectivities born out of collapsed

models of secularism and revolutionary politics, what sort of structures will we conceive for our futures? Is it not time to think beyond the contradictions of subjectivity, and hint at the possibilities for new spatial forms of incorporation? Consider a field in which various participants gather – in the process of assembly the respective identity of each member is respected, but at the same time both a motion, shape and energy is heightened by their very proximity to each other. A semi-porous boundary is formed and new sets of possibilities are established. Within such a space it might yet be imaginable to hold together a number of differences simultaneously, to arrange them in multi-directional and fluid orders, and most importantly not to reduce the other as the negative of identity. It is possible to observe such clusters at various moments in the cultures of art.

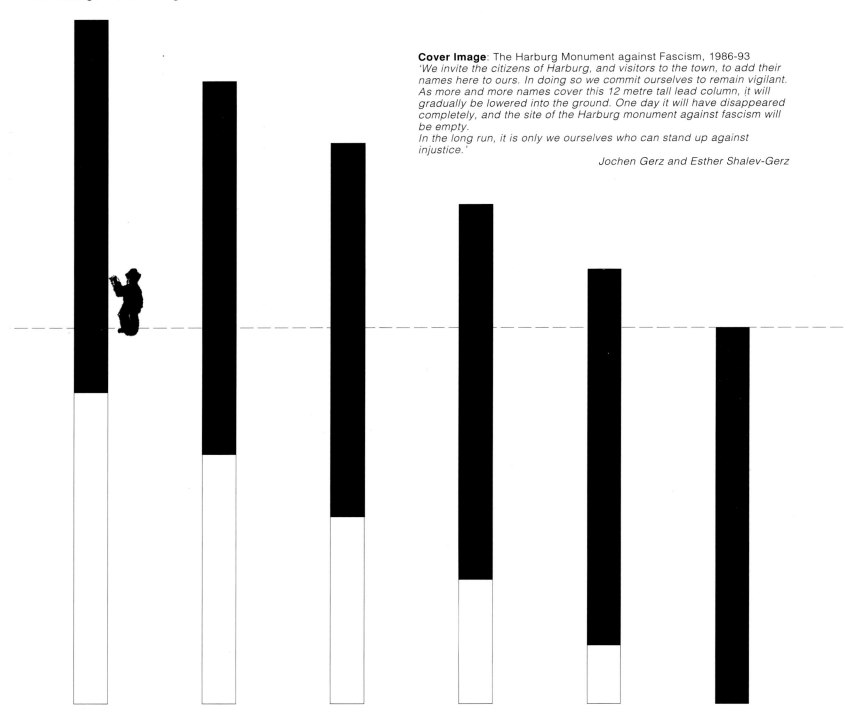

**Cover Image**: The Harburg Monument against Fascism, 1986-93
'We invite the citizens of Harburg, and visitors to the town, to add their names here to ours. In doing so we commit ourselves to remain vigilant. As more and more names cover this 12 metre tall lead column, it will gradually be lowered into the ground. One day it will have disappeared completely, and the site of the Harburg monument against fascism will be empty.
In the long run, it is only we ourselves who can stand up against injustice.'

*Jochen Gerz and Esther Shalev-Gerz*

# A GIRL LIKE ANTIGONE

*John Berger*

It measures, I guess, 80cm x 200cm – more or less the size of what you sleep on if you take a railway couchette. Not made of oak, but probably of pearwood which has a warmer colour. On it is a table lamp, also in wood, of a vaguely Bauhaus design, perhaps dating from the 1920s, when the family first moved into the apartment. A modest, functional lamp looking almost hand-made, but insistent in its promise of modernity – a promise which she never for a moment believed in.

The table is in the room where she worked and slept when she was at home. In her vagrant life she must have spent more time reading and writing at this table than at any other.

I have never met anybody who knew her. I have looked at many photographs. I drew a portrait of her from a photograph. Perhaps this is why I have the strange impression that a long time ago I set eyes on her. I can recall the mixed feelings she inspired in me: a physical antipathy, a sense of my own inadequacy, a certain exhilaration at the opportunity she appeared to offer of loving. A love, as in Plato's *Timée*, whose mother is Poverty. She was disconcerting, no question.

I saw the table in Paris last week. Behind it are some bookshelves and on them some of the books she read. The room is long and narrow, like the table. When she sat behind it, the door was on her left. The door gives on to a corridor: opposite which was her father's consulting room. When she walked down the corridor towards the front door she would have passed the waiting room on her left. The sick, or those who feared they were sick, were immediately outside her door. She could have heard her father saying good-bye to each patient and then greeting the next one: Bonjour Madame, sit down and tell me how you are.

On the right of this table is the window. A large one facing north. The apartment is on the sixth floor and the Rue Auguste Comte is on a slight hill, so there is a view over Paris, from the Luxembourg Gardens just below, to beyond the Sacre Coeur. You stand at the window, you open it, you lean against the railing of the balcony on which no more than four pigeons could land, and you fly in your imagination over the roofs and history. It is the exact height for flights of the imagination: the height of birds flying to the far edge of the city, to the walls, where the present ends and another epoch begins. In no other city in the world are such flights so elegant. She loved the view from the window, and was deeply suspicious of its privilege.

'There is a natural alliance between truth and affliction, because both of them are mute supplicants, eternally condemned to stand speechless in our presence.'

She began writing at the table when she was at the Lycée Henri IV preparing to enter the Ecole Normale. She had by then already begun the third notebook of the journal she was going to keep all her life.

She died in August 1943 in a sanatorium in Ashford, Kent. The coroner's report gave the cause of death as 'cardial failure due to myocardial degeneration of the heart muscles due to starvation and pulmonary tuberculosis'. She was 34 years old. The verdict was suicide because she stopped eating.

What is special about her handwriting? It is patient, conscientious – like a student's – but each letter, whether Roman or Greek, has been formed (almost drawn) like an Egyptian hieroglyph, so much did she want each letter of each word to have a body.

She travelled to many places and she wrote wherever she was lodged, yet everything she wrote might have been written here. Whenever she had a pen in her hand, she returned in her mind to this table in order to begin thinking. Then she forgot the table.

If you ask me how I know this, I have no answer.

I sat at the table and read a poem which had marked a turning point in her life. In her hieroglyphic handwriting she had copied out the poem in English and learnt it by heart. At moments when she was overcome by despair or the pain of a migraine behind her eyes, she used to recite it out loud, like a prayer.

On one such occasion, whilst reading it, she felt the physical presence of Christ and was astonished. Visions, like the miracles of the New Testament, put her off; she found them too easy. '. . . in this sudden hold that Christ had on me, neither my imagination nor my senses played any part; I simply felt across the pain, the presence of love, similar to that which one can read in a smile on a loved face'.

Fifty years later, as I read the sonnet by George Herbert, the poem became a place, a dwelling. There was nobody there. Inside it was shaped like a stone beehive. There are tombs and shelters like this in the Sahara. I have read many poems in my life but I have never before visited one. The words were the stones of a habitation which surrounded me.

In the street below, above the entrance to the apartment block, (today you need to tap a code to get in) there is a plaque which reads: Simone Weil, philosopher, lived here between 1926 and 1942.

# THE POLITICS OF MULTICULTURALISM
## IN THE POSTMODERN AGE

*Ella Shohat and Robert Stam*

The decline of revolutionary utopian hopes over recent decades has led to a remapping of political and cultural possibilities. Since the 1980s one finds, even on the left, a self-reflexive and ironic distance from revolutionary and Third Worldist rhetoric. A language of 'revolution' has been largely eclipsed by an idiom of 'resistance', indicative of a crisis of totalising narratives and a shifting vision of the emancipatory project. The idea of a vanguardist takeover of the state and the economy, associated with the politics of Lenin, has long since given way to the resistance to hegemony associated with Gramsci. Substantive nouns like 'revolution' and 'liberation' transmute into a largely adjectival opposition: 'counter-hegemonic', 'subversive', 'adversarial'. Instead of a macro-narrative of revolution, the focus is now on a decentred multiplicity of localised struggles. Though class and nation do not completely disappear from view, they lose their privileged position, being both supplemented and challenged by categories such as race, gender and sexuality.

### Self-Representation and the Politics of Identity

Today's political culture has to take into account an atmosphere dominated by identity politics and issues of self-representation, issues fraught with personal political tensions about who speaks, when, how, and in whose name. The politics of identity call for the 'self-representation' of marginalised communities, for 'speaking for oneself'. And while poststructuralist feminist, gay/lesbian and postcolonial theories have often rejected essentialist articulations of identity, and biologistic and transhistorical determinations of gender, race and sexual orientation, they have at the same time supported 'affirmative action' politics, implicitly premised on the very categories elsewhere rejected as essentialist,[1] leading to a paradoxical situation where theory deconstructs totalising myths while activism nourishes them. Theory and practice, then, seem to pull in apparently opposite directions. The 'constructionist' view has been instrumental in combating racism, sexism and homophobia, but when stretched it seems to imply that no one can really speak for anyone (perhaps including even oneself) or, conversely, that anyone can speak for anyone. Identity politics, on the other hand, suggest that people belong to recognisable social groups, and that delegated representatives can speak on their behalf. But is permission to represent a given community limited to card-carrying, epidermically suitable representatives of that community? Does the experience of oppression confer special jurisdiction over the right to speak about oppression? Could only an African-American have directed *Malcolm X* as Spike Lee has argued? Should Paul Simon not have made *Graceland*? Would it have been better if Stevie Wonder had made it? When does the fear of 'appropriating' turn into a form of mental segregationism and the policing of racial borders, a refusal to recognise one's co-implication (Chandra Mohanty's term) with otherness? How can scholarly, curatorial, artistic and pedagogical work 'deal' with multiculturalism without defining it simplistically as a space where only Latinos would speak about Latinos, African-Americans can speak for African-Americans and so forth[2] with every group a prisoner of its own reified difference? To what extent can a member of one minority group speak for another? How can we avoid the twin traps of 'ethnic insiderism' (Paul Gilroy) in which only the Yoruba can speak for the Yoruba, and of facile appropriation in which any tourist who spends a week in Yorubaland can speak for the Yoruba? How do we not prolong the colonial legacy of misappropriation and insensitivity towards so-called minorities (including, in the academic sense of the politics of prestige and citation) without silencing potential allies? Even talk of anti-essentialism and hybridity does not completely allay the anxiety concerning who speaks, about what, for whom, and to what end.[3]

Gayatri Spivak's celebrated question 'Can the subaltern speak?' might be reversed to ask: 'Can the non-subaltern speak?' To begin to answer, we may note that these anxieties about speaking are asymmetrical. Those who have been traditionally empowered to speak feel relativised simply by having to compete with other voices. Made aware of their own complicity in the silencing of others, they worry about losing a long taken-for-granted privilege. The disempowered, or newly empowered, however, seek to affirm a precariously established right. 'Disempowered' and 'empowered', furthermore, are relational terms: people occupy diverse positions, being empowered on one axis (say class) but not on another (say race and gender). Instead of a simple oppressor/oppressed dichotomy we find a wide spectrum of complex relations of domination, subordination and collaboration. At the extreme ends of this continuum, certainly, are groups respectively empowered along all the axes, and groups empowered along none of them. But even here there are no guarantees, for one's ancestral community does not necessarily dictate one's politics. Given the contradictory character of the socially situated psyche, individuals are traversed by dissonance and contradiction, existing within a constantly shifting cultural and psychic field in which the most varied discourses exist in evolving multivalenced relationships, constituting the subject (like the media) as the site of competing discourses and voices. Thus, the individual may identify upwards or downwards; a person empowered on all the axes may identify with and, more importantly, affiliate with the disempowered, just as the disempowered may identify with the powerful and feel that the powerful represent their interests.[4] The self becomes a matrix of multiple discursive

forms and identifications – which is in no way to deny realities of race, class, gender, nation but only to complicate and dialecticise them. That is why the recent academic fashion of identifying all speakers by their ethnicity – 'Hopi artist . . . white critic . . . ' is problematic. While on one level correcting the unilateral inscription of ethnicity and the surreptitious encoding of Whiteness as norm, on another level it does not go far enough because it encodes only the most superficial indices of ethnicity – colour, origins – while eliding issues of ideology, discourse, identification, affiliation. Thus, if one were really to pursue such labelling, one might produce interminable hybrid characterisations such as 'Chicano-identified feminist heterosexist, anarchist Anglo artist'.

Given all this, should one expect an epidermically 'incorrect' speaker whose community has not been directly marked by oppression, no matter how critical of the hegemonic system and how immersed in minoritarian perspectives and struggles, to dissolve into nothingness at the first appearance of subaltern? (Such an idea might provoke a kind of subaltern envy.) No one should be ashamed of belonging to the identity categories into which they happen to have been born, but one is also accountable for one's active role or passive complicity in oppressive systems and discourses.[5] 'It Ain't Where You're from', as Paul Gilroy, quoting the rap musician Rakim (W Griffin) puts it, 'It's Where You're at'.[6] At the same time, it would be an act of bad faith to expect 'minorities' to be colour-blind towards the ethnically privileged, attentive only to their discourse and disregarding their affiliations. No one need perpetually apologise for the crimes of remote ancestors, but it would also be a crime to ignore benefits accrued over centuries, especially when those benefits 'bleed into' contemporary situations of structured privilege. And although individuals may not for the most part fall neatly into oppressor/oppressed slots, there are also clear patterns of power and advantage. Discourses themselves are enunciated by persons bearing different community accents and intonations, ethnic codes of speech, body language, and self presentation. To be conversant with the discourse of community, and even to be able to defend it eloquently, is not commensurate with the 'experiential authority' (in bell hook's words) of those daily stigmatised by racial and colonial oppression.[7]

Antiracist and anti-Eurocentric pedagogy sometimes provokes a paralysing guilt on the part of members of the dominant group. And while guilt is on one level a perfectly appropriate response to genocide, slavery, racism and discrimination, it is on another level counter-productive. Guilt has a tendency to 'curdle', to turn into a sour resentment towards those 'provoking' the guilt. It leads to 'compassion fatigue', premised on the self-flattering presumption of initial benevolence and the assumed luxury of a possible disengagement. Guilt can be narcissistic, leading to orgies of self-abuse. (Speak ill of me, goes the show-biz maxim, but speak of me.) We would therefore distinguish between a personalistic, neurotic guilt on the one hand, and a sense of collective and reciprocal answerability on the other. Qualities more productive than guilt, we would suggest, are anger, lucidity, self-awareness, outrage. For privileged participants in multicultural coalitions, the challenge is to be aware of social positioning, and to accomplish a 'disaffiliation'[8] – an opting out of the country club of Euronarcissism and privilege – that is neither a neurotic rejection of self nor an opportunistic appropriation of the other, and that is at the same time a reaffiliation. Relatively privileged people have many possible roles besides wallowing in self-regarding guilt: they can fight racism in their own milieu, work to restructure power, and serve as spies and allies for marginalised people.

Speaking for oneself, by the same token, is not a simple act but a complex process, especially since women, minoritarian and Third World peoples speak today in a theoretical context where the notion of a coherent subject identity – let alone a community identity – seems epistemologically suspect. (We find here the same process of poststructuralist dissolution that we found in relation to other categories such as 'narrative' and 'truth'). Third World feminist frustration with this (dis)articulation of the subject is eloquently summarised by Debra P Amory:

> Doesn't it seem funny that at the very point when women and people of colour are ready to sit down at the bargaining table with the White boys, that the table disappears? That is, suddenly there are no grounds for claims to truth and knowledge anymore and here we are, standing in the conference room making all sorts of claims to knowledge and truth but suddenly without a table upon which to put our papers and coffee cups, let alone to bang our fists.[9]

Amory denounces the arrogance with which metrocentric theory announces the demise of what others hold dear – nation, narrative, subjecthood.[10] In this sense, much of postmodern theory constitutes a sophisticated example of what Anwar Abdel Malek calls the 'hegemonism of possessing minorities' – its denial of the reality of marginalising is a luxury only those not marginalised can afford.[11] The centre proclaims the end of its privileges, ironically, just when the periphery begins to lay claim to them. As Elizabeth Fox-Genovese writes:

> Surely it is no coincidence . . . that the Western White male élite proclaimed the death of the subject at precisely the moment at which it might have had to share that status with the women and peoples of other races and classes who were beginning to challenge its supremacy.[12]

Thus thinkers from the centre, blithely confident in national power and international projection, denounce non-metropolitan nationalisms as atavistic and passé. Metropolitan writers announce the 'death of the author' just as 'peripheral' writers begin to win their Nobel Prizes. All these 'divestitures' reflect a privilege available only to the already empowered, for the proclamation of the end of margins does not shortcircuit the mechanisms that effectively disappropriate peoples of their culture or nations of their power.

How, then, should the struggle to become subjects of history be articulated in an era of the 'death of the subject'? Should Third Worldist notions of becoming 'subjects' of history be dismissed as a pathetic lure and mystification? And does the decentring of identities mean that it is no longer possible to draw boundaries between privilege and disenfranchisement? At least provisionally, identities can be formulated as situated in geographical space and 'riding' historical momentum. 'Identities' are not fixed essences expressing a 'natural' difference; they emerge from a fluid set of historically diverse experiences, within overlapping,

polycentric circles of identities. That identity and experience are mediated, narrated, constructed, caught up in the spiral of representation and intertextuality does not mean that all struggle has come to an end. Diana Fuss distinguishes between 'deploying' or 'activating' essentialism, and 'falling into' or 'lapsing into' essentialism. To insist that essentialism is always and everywhere reactionary is indirectly to buy into essentialism, to 'act as if essentialism has an essence'.[13] What Spivak calls 'strategic essentialism' and what Hall refers to as 'the fictional necessity of arbitrary closure', of 'putting a period to the sentence', are crucial for any multicultural struggle that hopes to allow for communities of identification, even if those communities are multiple, discontinuous, and partly imaginary.

Attempting to avoid falling into essentialist traps and being politically paralysed by deconstructionist formulations, we would argue that it is precisely the overlapping of these circles that makes possible intercommunal coalitions based on historically shaped affinities. Rather than asking who can speak, we should ask about how to speak together, and more importantly, about how to move the plurilog forward. How might we interweave our voices, whether in chorus, in antiphony, in call and response, or in polyphony? What are the modes of collective speech? While it is dangerous to imagine that one can speak for others (that is, paradigmatically replace them) it is something else again to speak with or alongside others in the sense of forming alliances. In this sense we are less interested in identity as something one 'has', than in identification as something one 'does'. The concept of crisscrossing identifications evokes the theoretical possibility and even the political necessity of sharing the critique of domination and the burden of representation. It even involves making representation less of burden and more of a collective pleasure and responsibility. Coalitions are not conflict-free spaces, of course; alliances are often uneasy, dialogue can be painful and polyphony can become cacophony. But cultural polyphony would orchestrate a multifaceted polylog among all those interested in restructuring power in more egalitarian ways. It would promote a mutually enriching proliferation of emancipatory discourses, transcending a mere coexistence of voices to foster a mutual adoption of other voices and accents, much as the members of a versatile jazz ensemble might exchange instruments and play the other's part. Thus strong voices can play off against one another; a flute becomes more of a flute when foiled by a guitar. In political terms this would imply the cultivation of what Charlotte Bunch has called 'one-person coalitions'; that is, a situation in which not only Blacks but Whites would address issues of racism, where men as well as women would address issues of gender, where heterosexuals would speak against homophobia, the able-bodied about the disabled and so forth.[14] It would be an issue not of speaking 'for' but rather 'in relation', within intercommunal coalitions joined in shared struggles.

## Negotiating Spectatorship

The media plays a role in shaping identity in the postmodern era. By experiencing community with people never actually seen, consumers of electronic media can be affected by traditions to which they have no ancestral connection. Thus the media can normalise as well as exoticise other cultures, and can even fashion alternative communities and identities. Although film spectatorship can shape an imperial imaginary. There is nothing inherent in either celluloid or apparatus that makes spectatorship necessarily regressive. The strong 'subject effects' produced by narrative cinema are not automatic or irresistible, nor can they be separated from the desire, experience and knowledge of historically situated spectators, constituted outside the text and traversed by sets of power relations such as nation, race, class, gender and sexuality. Media spectatorship forms a trialog between texts, readers and communities existing in clear discursive and social relation to one another. It is thus a negotiable site of interaction and struggle: for example, the possibility of 'aberrant' or resistant readings, as the consciousness or experience of a particular audience generates a counter-pressure to dominant representations.

In its quasi-exclusive focus on sexual as opposed to other kinds of difference, and in its privileging of the intrapsychic as opposed to the intersubjective and the discursive, film theory has often elided questions of racially and culturally inflected spectatorship. And although recent media theory has productively explored the sociologically differentiated modes of spectatorship, it has rarely done so through the grid of multiculturalism. The culturally variegated nature of spectatorship derives from the diverse locations in which films are received, from the temporal gaps of seeing films in different historical moments and from the conflictual subject-positionings and community affiliations of the spectators themselves. The colonial situation in which colonised Africans and Asians went to European-owned theatres to watch European and Hollywood films, for example, encouraged a kind of spectatorial schizophrenia or ambivalence in the colonised subject, who might on the one hand internalise Europe as ideal ego and on the other resent (and often protest) offensive representations. Some of the major figures articulating anticolonial and postcolonial discourse symptomatically return in their writing to colonial spectatorship as a kind of primal scene. The 'cinema stories of fabulous Hollywood', writes Kwame Nkrumah, 'are loaded. One has only to listen to the cheers of an African audience as Hollywood's heroes slaughter Red Indians or Asiatics to understand the effectiveness of this weapon. For in the developing continents, where the colonialist heritage has left a vast majority still illiterate, even the smallest child gets the message'.[15]

The Martiniquian revolutionary theorist Frantz Fanon, the Ethiopian-American filmmaker Haile Gerima, and the Palestinian-American cultural critic, Edward Said, have all registered the impact of *Tarzan* on their impressionable young selves. Gerima recalls the 'crisis of identity' provoked in an Ethiopian child applauding Johnny Weissmuller as he cleansed the 'dark continent' of its inhabitants: 'Whenever Africans sneaked up behind Tarzan, we would scream our heads off, trying to warn him that "they" were coming'.[16] In *Black Skin, White Masks*, Fanon too brings up *Tarzan* to point to an instability within cinematic identification:

Attend showings of a Tarzan film in the Antilles and in Europe. In the Antilles, the young Negro identifies himself *de facto* with Tarzan against the Negroes. This is much

more difficult for him in a European theatre, for the rest of the audience, which is White, automatically identifies him with the savages on the screen.[17]

Fanon's example points to the shifting, situational nature of colonised spectatorship: the colonial context of reception alters the very process of identification. The consciousness of the possible negative projections of other spectators triggers an anxious withdrawal from the film's programmed pleasures. The conventional self-denying identification with the White hero's gaze, the vicarious performance of a European selfhood, is shortcircuited through the awareness of being looked at in a certain way, as if one were being 'screened' or 'allegorised' by a colonial gaze within the movie theatre. While feminist film theory has spoken of the 'to-be-looked-at-ness' (Laura Mulvey) of female screen performance, Fanon's example calls attention to the 'to-be-looked-at-ness' of spectators themselves, who became slaves, as Fanon puts it, of their own appearance: 'Look, a Negro! . . . I am being dissected under White eyes. I am *fixed*'.[18]

On the other hand, spectators can also return the gaze through critical comments or hostile looks. An active exchange of words and looks, whether in colonial Egypt or India, or in present-day Times Square movie theatres, turns public spectatorship into a discursive battle zone, where members of the audience actively negotiate 'looking relations' (in Jane Gaines' phrase) between communities. In *Alexandria Why . . . ?* (1979) the movie theatre literally becomes a space of ideological combat between an Australian soldier and Egyptian nationalists, while the Egyptian protagonist, lost in a Hollywood dream, watches a sequence (Helen Powell's 'Red, White, and Blue' staged in front of battleship guns) that encodes its own nationalist agenda. Social contradiction, as such cases make clear, is alive not only in media texts but also within the audience. In the 1970s James Baldwin contrasted his own experience of watching Hollywood films, where almost no one looked like he did, with his attendance at Harlem performances of Orson Welles' all-Black *Macbeth* (1936), where Macbeth was 'a nigger, just like me . . . where I saw the witches in church, every Sunday'.[19] Baldwin also recounts the racially differentiated reaction to *The Defiant Ones* (1958), a film that for him was rooted in a profound misunderstanding of the nature of racial hatred. Recounting the reaction of a Harlem audience, Baldwin wrote:

> It is this which Black audiences resented about *The Defiant Ones*, that Sidney was in company far beneath him, and that the unmistakable truth of his performance was being placed at the mercy of a lie. Liberal White audiences applauded when Sidney, at the end of the film, jumped off the train in order not to abandon his White buddy. The Harlem audience was outraged, and yelled 'Get back on the train, you fool!'[20]

Sidney jumps off the train, Baldwin concludes, in order to delude White people into thinking that they are not hated. The film's 'liberal' gesture of inventing the imperial and masculinist rescue trope (here the Black man rescues the White), its proposal of a utopia of interracial male camaraderie, still maintains the Black in a subservient space. It fails to imagine the historical depths of a Black consciousness unimpressed by such 'heroism'. Audience reactions thus can divide along racial lines, as in cases where a historical film (such as *Ganga Zumba*, 1963) shows a Black rebel killing a slave-driver, where it is not uncommon for Black spectators to applaud, while Whites (even radical Whites) hold back. In such cases, the socially differentiated reactions of spectators become obvious. Applause, sighs, gasps, and other expressions of audience affectivity render palpable the visceral feelings that lurk behind abstract phrases like 'spectatorial positioning'.

The ethnically hybrid character of most world metropolises, meanwhile, turns cinema-going into a revealing multicultural experience: screenings of 'foreign' films for mixed audiences in New York or London or Paris, for example, can create a gap between cultural 'insiders' who laugh at the jokes and recognise the references, and the 'outsiders' who experience an abrupt dislocation. Not conversant with the culture or language in question, they are reminded of the limits of their knowledge and indirectly of their own potential status as foreigners. Thus First Worlders in their own countries come to share an experience common to dislocated Third World and minoritarian audiences – the feeling that 'this film was not made for us'.

If spectatorship is on one level structured and determined, on another it is open and polymorphous. The cinematic experience has a ludic and adventurous side as well as an imperious one; it fashions a plural, 'mutant' self, occupying a range of subject positions.[21] One is 'doubled' by the cinematic apparatus, at once in the movie theatre and with the camera/projector and the action on screen. And one is further dispersed through the multiplicity of perspectives provided by even the most conventional montage. Cinema's 'polymorphous projection-identifications' (Edgar Morin's term) on a certain level transcend the determinations of local morality, social milieu, and ethnic affiliation.[22] Spectatorship can become a liminal space of dreams and self-fashioning. Through its psychic chameleonism, ordinary social positions, as in carnival, are temporarily bracketed.

Contemporary spectatorship and media pedagogy must also be considered in the light of changing audio-visual technologies. These technologies make it possible to bypass the search for a pro-filmic model in the world; one can give visible form to abstract ideas and improbable dreams. The image is no longer a copy but rather acquires its own life and dynamism within an interactive circuit. Electronic mail, meanwhile, makes it possible for a community of strangers to exchange texts, images, video sequences, thus enabling a new kind of international pedagogy. Computer graphics, interactive technologies, and 'virtual reality' carry the 'bracketing' of social positions to unprecedented lengths. Within cybernetic paraspace, the flesh-and-blood body lingers in the real world while computer technology projects the cybersubject into a terminal world of simulations. Such technologies expand the reality effect exponentially by switching the viewer from a passive to a more interactive position, so that the raced, gendered sensorial body can be implanted, theoretically with a constructed virtual gaze, becoming a launching site for identity travel. Might virtual reality or computer simulation be harnessed, one wonders, for the purposes of multicultural pedagogy, in order to communicate, for example, what it feels like to

be an 'illegal alien' pursued by the border police, or a civil rights demonstrator feeling the lash of police brutality in the early 1960s? Yet it would be naive to place exaggerated faith in these new technologies, for their expense makes them exploitable mainly by corporations and the military. As ever the power resides with those who build, disseminate, and commercialise the systems.[23] All the technological sophistication in the world, furthermore, does not guarantee empathy or trigger political commitment. The historical inertia of race, class and gender stratification is not so easily erased. Nor should an antiracist pedagogy rely on empathy alone. A person might 'sample' oppression and conclude nothing more than: 'C'est la vie' or 'Thank God it wasn't me!' The point is not merely to communicate sensations but rather to advance structural understanding and engagement in change.

Within postmodern culture, the media not only sets agendas and frame debates but also inflects desire, memory, fantasy. By controlling popular memory, it can contain·or stimulate popular dynamism. The challenge, then, is to develop a media practice and pedagogy by which subjectivities may be lived and analysed as part of transformative, emancipatory praxis.[24] The question of the correctness of texts, we have argued, is less important than the question of mobilising desire in empowering directions. PC ignores desire, the intersubjective relations between people, and between text and audience. The question then becomes: given the libidinal economy of media reception, how do we crystallise individual and collective desire for emancipatory purposes? An anti-Eurocentric pedagogy, in this sense, must pay attention to what Guattari calls the 'production machines' and 'collective mutations' of subjectivity. As right-wing forces attempt to promote a superegoish 'conservative reterritorialisation' of subjectivity, those seeking change in an egalitarian direction must know how to crystallise individual and collective desire.

A radical hermeneutics of the mass media would heighten awareness of all the cultural voices they relay. It would point both to the 'off-screen' voices of hegemony and to those voices muffled or suppressed. The goal would be to discern the often distorted undertones of Utopia in the mass media, while pointing to the structural obstacles that make Utopia less realisable and at times even less imaginable. (By 'Utopia', again, we refer not to totalising 'progressive' metanarratives, but rather to 'critical utopias' generated by the dissatisfactions of everyday life and aiming at a reimagining of the possible.)[25] Such an approach would combat the selectivity of hearing promoted by mass culture. It would recover the critical and utopian potential of mass-mediated texts, even when this potential is half-denied or repressed within the text itself. The issue is not one of imposing an interpretation, but rather of bringing out the text's muffled voices; like the work of a sound-studio mixer who re-elaborates a recording to tease out the bass, clarify the treble and so on.

We would also argue for a kind of pedagogic jujitsu, in the form of the classroom hijacking or *détournement* of media texts. With the help of a VCR, teachers and students can raid the mass-media archive. Eurocentric texts can be snapped out of their original context to be re-read and even rewritten by teachers and students. Rather than remaining passive spectators, students

can 'decanonise' the classics, rescripting or re-editing films according to alternative perspectives. Students might write a paper or produce a video imagining *Imitation of Life* (1934), for example, from the perspective of the Louise Beavers or the Freddi Washington character, rather than that of the White character played by Claudette Colbert. They might imagine a film from the perspective of an apparently minor subaltern character; for instance, the 'squaw' in *The Searchers* (1956). Whole genres could be revised: the Western could be rewritten from a Hopi or Cheyenne perspective; the Hollywood musical from an African-American perspective; and the 'Raj nostalgia' film from an anticolonialist perspective. Video-editing techniques – split frame, voice-over against image, freeze-frame, new voice-overs, changed music – could stage, on an audio-visual level, the clash of perspectives.

The techniques of Augusto Boal could also be adopted for a mixed-mode pedagogy. In *Theater of the Oppressed*, Boal distinguishes between three models of theatre: an Aristotelian model where the spectator delegates power to the character, who thinks and acts in his or her place; a Brechtian model, where the spectator retains the power to think but relinquishes the power to act; and Boal's model, where the spectator exercises the power both to think and to act. The goal is to turn spectators into 'spect-actors'. The classroom can become a theatrical space, where students can interrupt film clips to act out their suggestions of how one of the characters might better have dealt with socially generated oppression. (It does not matter that the action is fictional, Boal stresses; what matters is that it is action.)[26]

Film and media pedagogy can also deploy the social heteroglossia of the classroom itself to call attention to the students' own ideological assumptions and affective investments. Rather than an act of self-indulgence, spectatorship might become an act of self-confrontation. One of Adrian Piper's videos, for example, informs the 'White' spectator that he/she is in all probability part Black, since after 400 years 'there are no genetically distinguishable White people in this country'. And 'Now that you know you're Black', she asks provocatively, 'aren't you eager to enjoy the benefits that blackness brings?' and 'If racism isn't just "our" problem, but equally "yours", how are you going to solve it?'[27] By coaxing Whites into a realisation both of their hybridity and of their privilege, as Judith Wilson puts it, 'Piper exposes the actual flimsiness of the categories that preserve white power'.[28] At the same time, Piper undercuts the comfortably voyeuristic premises of the classic scene of 'Whites' watching 'Black' performance.

A media-based pedagogy could at the same time empower 'minorities' and build on privileged students' minimal experience of otherisation to help them imagine alternative subject positions and divergent social desires.[29] An experimental pedagogy could thus embody multicultural ideas in symbolic form. Since cultural identity, as Stuart Hall has pointed out, is a matter of 'becoming' as well as 'being', belonging to the future as well as the past,[30] multicultural media studies could provide a nurturing space for the playing out of the secret hopes of social life, a laboratory for the safe articulation of identity oppressions and utopias, a space

of community fantasies and imagined alliances. Media pedagogy of this kind parallels the realm of 'indigenous media'. Faye Ginsburg's speaks of 'indigenous media' as a means for 'reproducing and transforming cultural identity among people who have experienced massive political, geographic and economic disruption.[31] Alex Juhasz, extending Ginsburg's conception to First World alternative media, sees AIDS activist video as a form of 'indigenous media', where victims of 'massive disruption' counter their oppression.[32] Speaking of the camcorder activism of the Kayapo in Brazil, Terence Turner stresses how their video work concentrates not on the retrieval of an idealised pre-contact past but on the process of identity construction in the present. The Kayapo use video to communicate between villages, to record and thus perpetuate their own ceremonies and rituals, to record the official promises of Euro-Brazilian politicians (and thus hold them accountable) and to disseminate their cause around the world, in a 'synergy between video media, Kayapo self-representation, and Kayapo ethnic self-consciousness'.[33] Just as people all over the world have turned to cultural identity as a means of mobilising the defence of their social, political, and economic interests, multicultural media activism and pedagogy might serve to protect threatened identities or even to create new identities, a catalyst not only for the public sphere assertion of particular cultures but also for fostering the 'collective human capacity for self-production'.[34] We might see media in this sense as exercising a tribalising power, as potentially increasing the *aché* (Yoruba for 'power of realisation') of an emergent community or coalition.

A radical, polycentric multiculturalism, we have tried to suggest, cannot simply be 'nice', like a suburban barbecue to which a few token people of colour are invited. Any substantive multiculturalism has to recognise the existential realities of pain, anger and resentment, since the multiple cultures invoked by the term 'multiculturalism' have not historically coexisted in relations of equality and mutual respect. It is therefore not merely a question of communicating across borders but of discerning the forces which generate the borders in the first place. Multiculturalism has to recognise not only difference but even bitter, irreconcilable difference. The Native American view of the land as a sacred and communal trust, as Vine Deloria points out, is simply not reconcilable with a view of land as alienable property.[35] The descendants of the slave ships and the descendants of the immigrant ships cannot look at the Washington Monument, or at Ellis Island through exactly the same viewfinder. But these historical gaps in perception do not preclude alliances, dialogical

coalitions, intercommunal identifications and affinities. Multiculturalism and the critique of Eurocentrism, we have tried to show, are inseparable concepts; each becomes impoverished without the other. Multiculturalsim without the critique of Eurocentrism runs the risk of being merely accretive – a shopping mall boutique summa of the world's cultures – while the critique of Eurocentrism without multiculturalism runs the risk of simply inverting existing hierarchies rather than profoundly rethinking and unsettling them.

Central to multiculturalism is the notion of mutual and reciprocal relativisation, the idea that the diverse cultures placed in play should come to perceive the limitations of their own social and cultural perspective. Fanon speaks of the necessary decision to accept 'the reciprocal relativism of different cultures, once colonialism is excluded'.[36] Each group offers its own exotopy (according to Bakhtin), its own 'excess seeing', hopefully coming not only to 'see' other groups, but also, through a salutary estrangement, to see how it is itself seen. The point is not to embrace the other perspective completely but at least to recognise it, acknowledge it, take it into account, be ready to be transformed by it. By counterpointing cultural perspectives we practice what George Marcus and Michael Fischer call 'defamiliarisation by cross-cultural juxtaposition'.[37]

At the same time, historical configurations of power and knowledge generate a clear asymmetry within this relativisation. The powerful are not accustomed to being relativised; the world's institutions and representations are tailored to the measure of their narcissism. Thus a sudden relativisation by a less flattering perspective is experienced as a shock, an outrage, giving rise to a hysterical discourse of besieged civility and reverse victimisation. Disempowered groups, in contrast, are not only historically accustomed to being relativised – they often display a highly relativising, even disdainful attitude towards the dominant cultures. Those who have known in their bodies the violence of the system are less inclined to be deluded by its idealisations and rationalisations. But what we have been calling polycentric multiculturalism is not a favour, something intended to make other people feel good about themselves; it also makes a cognitive, epistemological contribution. More than a response to a demographic challenge, it is a long-overdue gesture towards historical lucidity, a matter not of charity but of justice. An answer to the stale, flat and unprofitable complacencies of monoculturalism, it is part of an indispensable re-envisioning of the global politics of culture.

## Notes

1  Among the concerns of the Society for Cinema Studies Taskforce on 'Race', established in 1988, for example, was not only to engage in minoritarian discourse but also to promote 'minority' participation in the discipline.

2  Trinh T Minh-ha makes a similar point in 'Outside In Inside Out,' included in her *When the Moon Waxes Red: Representation, Gender and Cultural Politics*, Routledge, New York, 1991.

3  In art it is not always clear who is speaking. Countless cases of artistic reception contradict the view of literary texts as transparently conveying the unmediated experience of an originary identity. Often, Henry Louis Gates Jr argues, readers and critics have been fooled, attributing 'authenticity' where it was not and damning 'inauthenticity' where it did not exist. The bestseller *Education of Little Tree*, the 'true' story of a Native American, orphaned at the age of ten, who learns Indian ways from his Cherokee grandparents, was hailed by critics as

'deeply felt' and 'one of the finest American autobiographies, ever written'. Yet, the book was, in fact, written under a pseudonym by Asa Ear Carter, a Ku Klux Klan terrorist and anti-Semite who actually penned Governor George Wallace's notorious 1963 'Segregation Forever' speech. But *Little Tree* was just the latest in a long chain of ventriloqual racial narratives (for instance, *Confessions of Nat Turner*), racial impersonations, and ersatz slave narratives. Readers of Frank Yerby's historical romances or Samuel R Delaney's science fictions, conversely, rarely imagine that both authors are Black.

4 The White male Jewish lawyer William Kunstler, for example, is affiliated with disenfranchised communities and strives to empower them, whereas it can be argued that the Black male judge, Clarence Thomas often seems to work against the interests of his own people.

5 A number of feminist writers have argued against the idea that correct politics 'flow from identity'. See Chandra Talpade Mohanty's Introduction to Chandra Talpade Mohanty, Ann Russo, and Lourdes Torres, (eds), *Third World Women and the Politics of Feminism*, Indiana University Press, Bloomington, 1991. Kathryn Harris refers to the practice of fixing 'a woman along a pre-determined hierarchy of oppressions in order to justify or contest a political opinion by reference to a speaker's identity'. See her 'New Alliances: Socialist Feminism in the Eighties', in *Feminist Review*, No 31 (1989). See also Linda Briskin, 'Identity Politics and the Hierarchy of Oppression', *Feminist Review*, No 35 (Summer 1990).

6 Paul Gilroy uses Rakim's lyrics as the titles of his essay 'The Dialectics of Diasporic Identification', *Third Text*, No 13 (Winter 1990-91).

7 Just as feminist theory has de-essentialised the gendered subject, postcolonial discourse has placed race in 'quotation marks' to see it as a socially constructed trope. Nevertheless, 'male bonding', as feminist theorists like Elaine Showalter and Jane Marcus point out, can at times excercise a cohesive force stronger than theoretical enmities, a point that applies by extension to the possible 'ethnic bonding' of Euro-American filmakers and academicians. (The Old Boys' Network criticised in feminist and gay/lesbian writings is not less an ethnic/racial network).

8 We are indebted to Caren Kaplan for the term 'disaffiliation' and for her very precise formulation of these questions in her presentation on Whiteness at 'Cross Talk: A Multicultural Feminist Symposium,' organised by Ella Shohat and the New Museum of Contemporary Art's Education Department (directed by Susan Cahn), New York City (June 1993). Selection from the papers is edited for *Social Text* by Ella Shohat, forthcoming Autumn 1995.

9 Debra P Amory, 'Watching the Table Disappear: Identity and Politics in Africa and the Academy,' a paper given at the African Studies Association (1990).

10 Henry Louis Gates Jr, in a similar vein, argues that the Western male subject has long been constituted historically, while the subaltern have to explore and reclaim identity before critiquing it. Henry Louis Gates Jr, 'Canon Formation and African-American Tradition,' in Dominick LaCapra (ed), *The Bounds of the Race*, Cornell University Press, Ithaca, New York, 1991.

11 Anwar Abdel Malek, 'Orientation in Crisis', *Diogenes*, No 44, Winter 1963, pp107-8.

12 Elizabeth Fox-Genovese, 'The Claims of a Common Culture: Gender, Race, Class and the Canon,' *Salmagundi*, No 72, Autumn 1986, p121.

13 See Diana Fuss, *Essentially Speaking*, Routledge, London, 1989,

pp20-21.

14 See Charlotte Bunch, 'Making Common Cause: Diversity and Coalitions,' *Ikon*, No 7, Spring/Summer 1987.

15 Kwame Nkrumah, *Neo-Colonialism: The Last Stage of Imperialism*, Nelson, London, 1965, p246.

16 Haile Gerima, interview with Paul Willemen, *Framework*, Nos 7-8, Spring 1978, p32.

17 Frantz Fanon, *Black Skin, White Masks*, Grove Press, New York, 1967, pp152-53.

18 *Ibid*, p112-16.

19 James Baldwin, *The Devil Finds Work*, Dial Press, New York, 1976, p34.

20 *Ibid*, p62.

21 See Jean-Louis Schefer, *L'Homme Ordinaire du Cinéma*, Gallimard, Paris, 1980.

22 See Edgar Morin, *Le Cinéma ou L'Homme Imaginaire*, Gonthier, Paris, 1958.

23 Anne Friedberg, *Window Shopping: Cinema and the Postmodern Condition*, University of California Press, Berkeley, 1992.

24 See Rhonda Hammer and Peter McLaren, 'The Spectacularization of Subjectivity: Media Knowledges, Global Citizenry and the New World Order,' *Polygraph*, No 5, 1992.

25 Tom Moylan, *Demand the Impossible: Science Fiction and the Utopian Imagination*, Methuen, New York, 1986, p213.

26 Augusto Boal (ed), *Theatre of the Oppresed*, Theatre Communications Group, New York, 1979.

27 See Maurice Berger, 'The Critique of Pure Racism: An Interview with Adrian Piper', *Afterimage*, October 1990, p5.

28 See Judith Wilson's brilliant discussion of Piper's work: 'In Memory of the News and of Our Selves: The Art of Adrian Piper', *Third Text*, Nos 16/17, Autumn/Winter 1991. The University of Washington Press will be publishing a book on Piper, featuring essays on her work along with a set of audio and videotope works.

29 Charles Ramirez Berg makes this suggestion in his extremely useful essay 'Analyzing Latino Stereotypes', in Lester Friedman and Diane Carson (eds), *Multicultural Media in the Classroom*, University of Illinois Press, Urbana, 1992.

30 Stuart Hall, 'Cultural Identity and Cinematic Representation', *Framework*, No 36, 1989.

31 Faye Ginsburg, 'Indigenous Media: Faustian Contract or Global Village', *Cultural Anthropology*, Vol 6, No 1, p94.

32 Alexandra Juhasz, 'Re-Mediating Aids: The Politics of Community Produced Video,' PhD dissertation, New York University, 1991.

33 Terence Turner, 'Defiant Images: The Kayapo Appropriation of Video', Forman Lecture, RAI Festival of Film and Video, Manchester, 1992.

34 Terence Turner, 'What is Anthropology that Multiculturalist Should Be Mindful of It?' Unpublished paper, presented at the American Anthropological Association, San Francisco, 1992.

35 Interview with Vine Deloria in the film *Savagery and the American Indian*, 1989.

36 See Frantz Fanon, *Toward the African Revolution*, Monthly Review Press, New York, 1967, p447.

37 George Marcus and Michael MJ Fischer, *Anthropology as Cultural Critique: An Experimental Moment in the Human Sciences*, University of Chicago Press, Chicago, 1986, p157.

# JUAN DAVILA

Dear A ≠ D reader,

It is ironic to refer to the cultural representation of minorities from the pages of a magazine that has never been seen in chile, the place from where I write to you. The art publications, bureaucrats, curators, institutions, etc. invite the likes of me, now that the previous standards of Western "taste" have been abandoned in favour of the marketing of "identity". a process that Mari Carmen Ramírez calls "cultural brokering". Now we have the quality control of ethnicity and identity. although we now can "appear" in the Western art circuit, our representations remain under tight control. Our identity is "constructed" for us by the cultural mediators. We have to explain who we are and what is our own. The curator never explains his identity. They just cross borders and not once feel obliged to explain, to choose between conflicting identities.

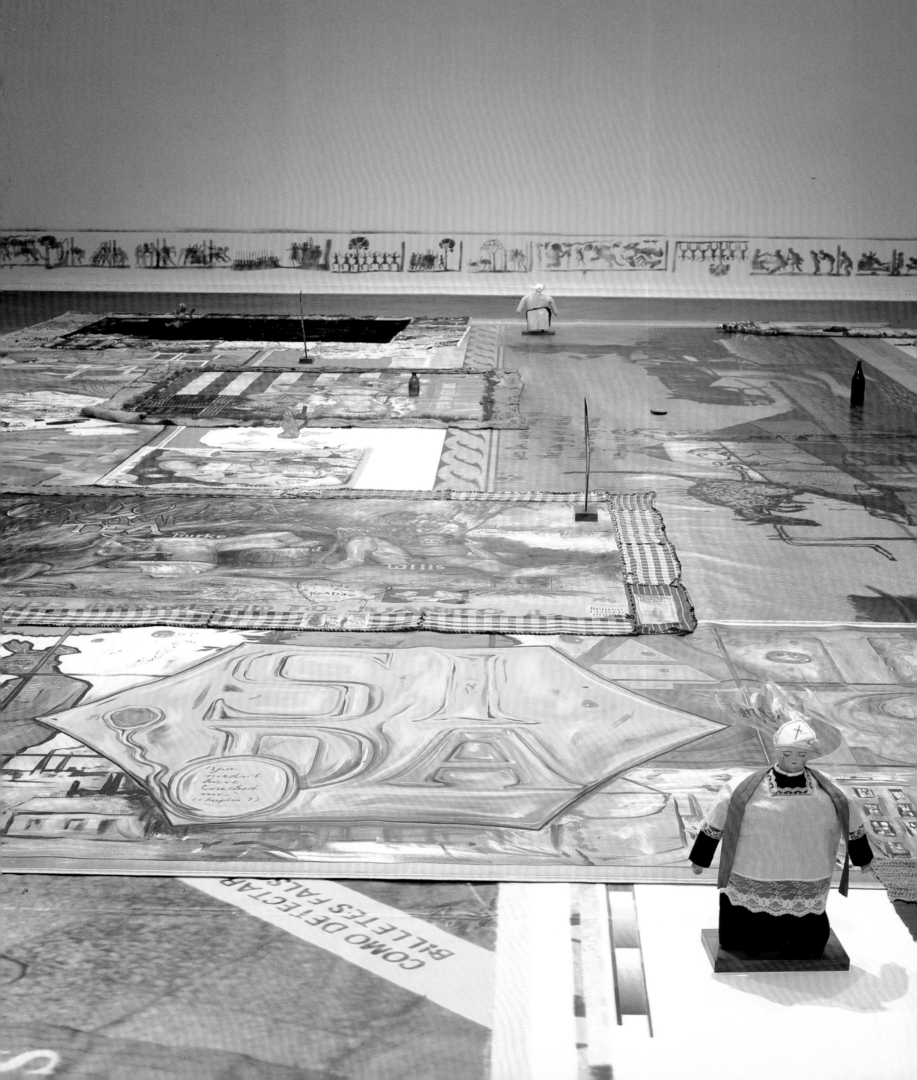

The mise-en-scene of identity is today a well paid job. Since resistance and transgression are the replacements of taste, how can we deflect this construct? We can think - against the great narratives - of particular places, of non-permanent places. We can refuse to become the etnographers for the centre. We can insist in the impossibility of translation of our language, our places and histories. We can denounce hibridity as a privileged notion through which our cultures are being curated (silenced) by the centre. We can insist on ambivalent identity. We can insist on "zones of silence" against the current dictatorship of the masks of identity. We can reinstate the desiring subject. What about the things that cannot be named?

yours sincerely,

Juan Dávila

Juanito Laguna, *details of installation at the Chisenhale Gallery, London, Nov-Dec 1994*

# scenario URBANO

*Dennis Del Favero, Tony MacGregor,*
*Derek Nicholson and Eamon D'Arcy*

**Scenario URBANO** is a collaboration of artists and designers engaged in the production of multi-media projects for museums, radio and urban sites, along with more speculative projects. The group was initiated by the Italo-Australian artist Dennis Del Favero. The projects centre on exploring how space and subjectivity are constituted by sexual and cultural difference. Zona Di Transito was a project which examined the experience of the refugee – the experience of dispossession, of being 'in transit' between a place called Home and somewhere else, a twilight beyond relationships. The departure point for this exploration was 'baggage' and the architecture of despatialisation which traverses it.

**Zona Di Transito** was presented as two site specific works:

a) **Pietà**, a multimedia installation for the Adelaide Festival of the Arts in an abandoned warehouse in Adelaide, Australia, February 1994. The installation consisted of a series of rooms dealing with two intersecting narratives: *Rooms 1 and 3* evoked the memory of a Bosnian refugee woman found wandering the streets of Sarajevo with her only baggage, the head of her son, and *Room 2*, the voices of refugees recalling their material baggage and the baggage of memory.

b) **Diaspora**, a radiophonic documentary feature broadcast nationally on March 21, 1994 in *The Listening Room,* the contemporary performance and audio art programme of the Australian Broadcasting Corporation. *Diaspora* was made up of fragments of interviews with refugees played across a text by Nikos Papastergiadis against a shifting soundscape of (remembered) sounds.

# ROOM ONE: *LOSS*

**Sarajevo**...Esma Brkovic, a sixty year old Bosnian refugee from Bihac was questioned here today by UN officials after a bandaged human head was found in her possession. The woman explained that the head was that of her son, executed by invading forces after they had dragged him from his hospital bed. She had recovered the head in order to prevent it from being used for target practice. Church authorities allowed Mrs Brkovic to bury the head in the Catholic cemetery. She has no surviving relatives.
*Reuter*

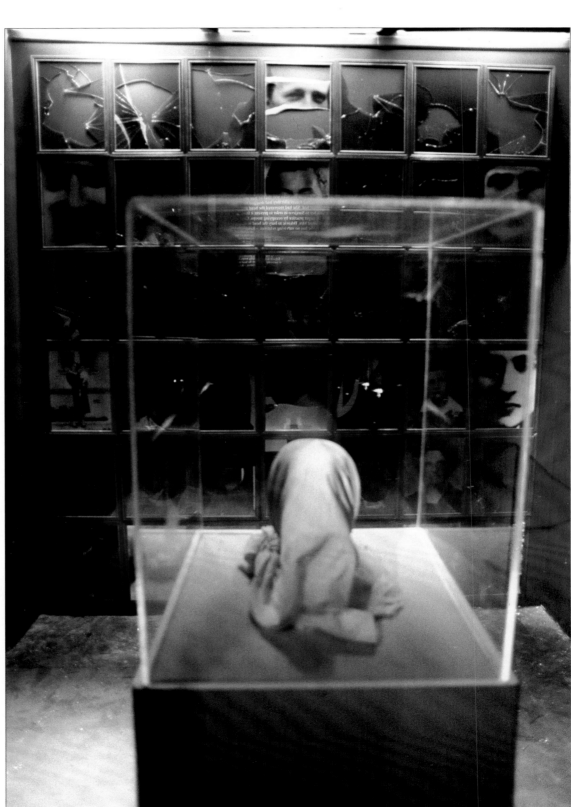

## ROOM TWO: *POSSESSIONS*

**Ivana**: I took my memories, the memories of my childhood, of my friends, my 16 years of living . . . My family didn't take much with them, maybe what they had on, nothing else. They didn't even take the photos. I thought if they at least took the photos, at least we could show some photos of our house to anyone else, or family or something . . . but nothing, they didn't take anything, they weren't able to take anything. I was the luckiest one, I took some clothes . . .

**Fariba**: I was looking at all the things we had . . . they were our life . . . in fact everything that I had from our wedding, from our parents, from when I was girl . . . I had some things I had kept for years . . . but I had to leave them because we knew we could not take all these things . . . we had to take as little as we could because we had to cross the border on horses, or asses – on donkeys . . . then . . . it was very sad . . . I took two plates . . .

**Michael**: Probably luggage is the last thing you think about. Of course, there were some banal things, like toothbrush, toothpaste, shaving gear, a few socks, T shirts, a compass . . . binoculars, some food and medicine. I didn't think too much in terms of clothes and what I am taking with me because I had a lot of books to bring here, and this was the main, the most important part of my luggage . . .

**Braco**: We brought nothing . . . but inside us we brought a whole mass. We brought actually 29 years of wonderful life and one year of hell . . . Ahh, I wish I could – I could say something nice about that year, about some nice people I met in that year, but you know, all scenes that we saw in that year are horrible scenes – dead people, seriously wounded people . . . children with amputated arms, legs . . . All that suffering, it was horrible.

**Stephen**: I wore a track suit, two pairs of pyjamas, a pair of ski pants, I would say a couple of lumberjackets, scarves – I think I looked like a spaceman. The only thing we carried was a small suitcase, with lots of cigarettes and small bottles of rum in anticipation of being stopped by Russian patrols, to bribe our way out . . .

**Nadem**: My father was convincing me I should take his leather gloves, but I knew he needed those gloves. It is so cold there, and he is supposed to carry water from the pump and if some water falls on his hands, they might freeze – but he was still convincing me to take those gloves . . . When I left my home I found those leather gloves in a pocket of my jacket, and I still feel very sorry for I've taken them – it was too late to give them back, I had to go . . .

## ROOM THREE: *TRACES*

# KATHY TEMIN
## THE PROBLEM IS . . .
*Andrew Renton*

'The problem is . . . .' she says, 'I remember that place only too well, but I have since had to piece together my memories, such as they are.

'I forgot everything, but I had taken notes. I carry some with me still. In time I chose not to remember, but at the time I could not help myself. I took notes but hardly recognise my own writing.'

(Scant memory of those times or that place, save the evidence carried upon her person as residue or witness.)

An interim period, or silence.

'Yes,' she says, 'I am beginning to remember. To some extent'.

The problem is . . . There are fewer places than journeys in-between. Sites are marked by exchange upon arrival rather than territorial claims, since those claims do not mean very much without the process of translation from one culture to another.

Here we are speaking of a work so thoroughly placed. It is hard to say so, it is barely acceptable to say so. But it must be spoken of as being of one particular place or another, even though it is never (to be) sited in that place. Place, the name of the place – any place – is that metaphor of journeying and of exchange. It is less of a defined range of borders than a deterritorialised mental space which we inhabit in part. We do not inhabit it to the exclusion of all other places, but we cannot help but think of that place as our constant point of reference.

No apologies, but a trope of cultural accumulation and dissemination.

So where is this place? And what is the problem?

We could, in certain circumstances, in a tentative, hesitant mode, call it 'Europe'. We might use the name as an example, although many other names might serve equally well. But Europe is a useful term insofar as it resists territorial definitions. It is not land mass. In all the talk of Europe, it can hardly be determined on a map.

We are speaking of a problem we never knew we had. The problem has always already existed, and it is not simply a new correctness which renders it visible; the problem is . . .

The problem is, in part, the question of how to look, how to look and see one thing, turn away and, with the same eyes, look again, and see something else again.

We might call this process unresemblance: the unseeing (and undoing) of an object or cultural attribute in favour of something else. As we stand in a strange, unfamiliar place, it becomes our 'Europe' again. It is metaphoricised into what and where we once were.

The problem is . . . That we all know the objects so well. We all possess them, share them, have a stake in what they mean. We have a collective purchase on these objects; they mean nothing at all without accumulation, perceptions and positions. There are no objects except those with positions taken in relation to them. Dry, unencumbered objects, should they be conceivable, exist in a virtual stasis, seeking perspective.

So they are always translated objects or, more interestingly, mistranslated objects. From one place to another, the object could hardly be said to stay the same. But become what? It somehow goes wrong on the way, loses functionality. At its point of arrival, the viewer looks for a sign of liability or a guarantee that it may be returned to sender in case of damage or dysfunction.

But it will always be dysfunctional – doubly so if returned to sender. So it must be stopped for a while, contemplated, and eased back into its surroundings.

Out of sorts. The object is always out of sorts with its point of origin. Out of sorts and indebted. That indebtedness may give our place a name but it does not specify site. It speaks of a thread which connects the object to somewhere else. For an object does not come out of nowhere.

Whatever cultural isolation, there is no absolute vacuum. In an absolute vacuum, not only does the object have no meaning, there is no object. It is a figment.

Of the imagination?

Imagination is sufficient in the hypothesised impoverishment of context, but there is never an absence of context.

It is not simply that things look like something else, look like they belong elsewhere, but that they also do not want to be placed, or stilled. Objects are condensed into perpetual motion.

Indeed, there is little to be gained by making specific correlations. The connecting threads are too complex, too knotted, for a true reading.

The problem is . . . From one angle the object has value imposed upon it, and from another a whole series of new values. Not such a problem, perhaps. After all, the multi-faceted nature of the work is what sustains its obligation to continuance. The work of art is defined in terms of continuity, rather than instantaneous solution. It is linked to a form of desire repeatedly deferred. We would wish to stabilise, to possess the image before us, but our very desire for possession is generated by the object's inability to be possessed.

Perhaps it is an artist who does the displacing, because she is displaced herself. If we name that imaginary place, for the sake of convenience, Europe, we could name her, in equally hesitant, tentative mode, 'Jew'.

. . . Because she, too, in whatever name or guise she chooses,

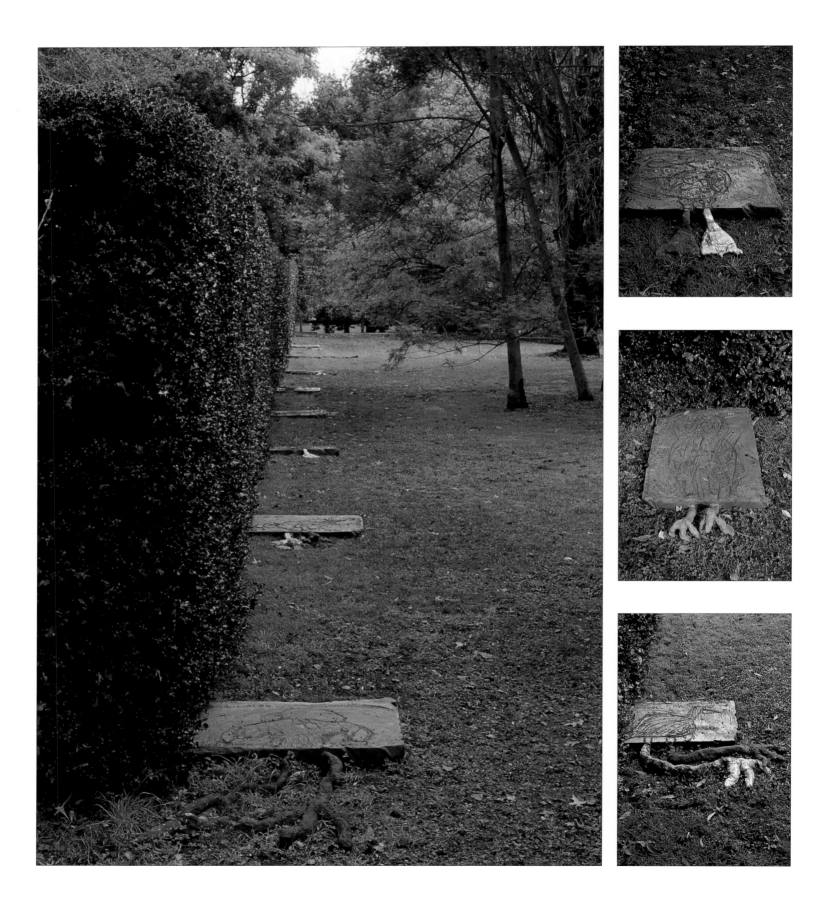

A Monument to the Birds, *1994*

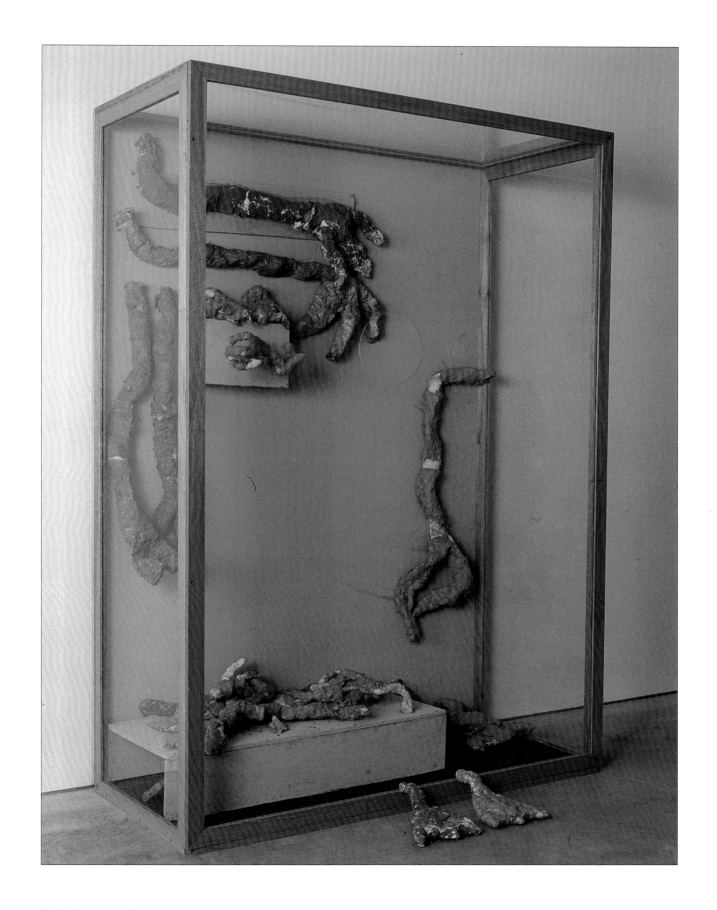

Bird Dis-play, *1994, mixed media*

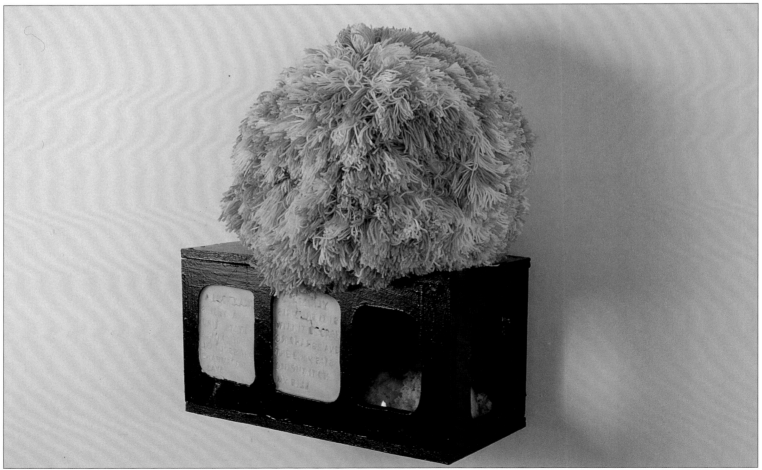

*FROM ABOVE:* The Duck-Rabbit Problem, *1991, mixed media, 120 x 184 x 85cm, photo Peter Akbiyilc;* Bill Problem, *1994*

is out of sorts. She is always out of sorts with her point of origin. Out of sorts and indebted. That indebtedness yields the name, but it appears to specify in the negative. It speaks of a thread which connects her to somewhere else. For she does not come from nowhere, but return is always deferred.

Speak in the name of . . .

Imperative or interrogative? How to speak in the name of something? How to make in the name of something? What to make, if it will always come to leave you?

The problem is . . . How to admit to the name and the place?

. . . Because she does not announce herself in so many words. She cannot. She speaks neither literally nor metaphorically. The metaphor, the naming, comes from outside of her.

And she has not been able to speak this way for some time; since the last catastrophe or disaster. Always after the voice is lost for words. Rendered speechless.

Rendered or restricted. Restricted into speechlessness. She holds her silence dear. But through other conduits the unsaid insists. And through inversion.

'No poetry after [some place]', some other would say.

And the *ease* of her inversion:

'No [some place] after poetry.'

How could she?

And yet the critique gently dislodges a monumental lack as immovable as the memory with which it is burdened.

Her memory will undoubtedly fail her again, and when it does, she will begin to speak, as if she has never spoken. The problem is . . . How not to remember? How not to resemble? To some extent. How not to remember or resemble to some extent?

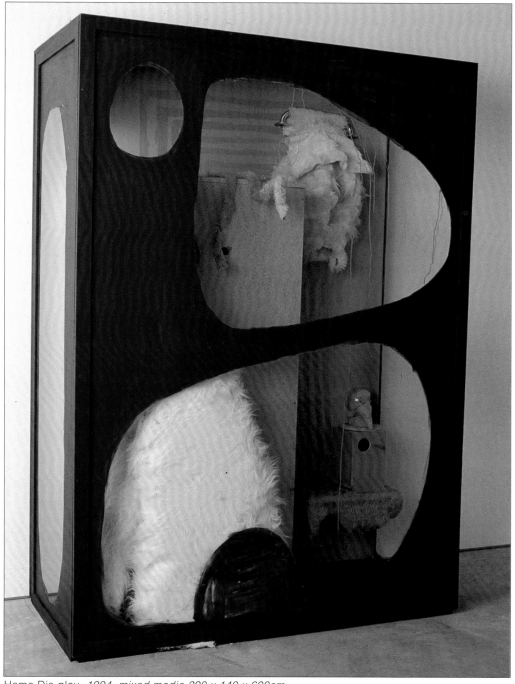

Home Dis-play, *1994, mixed media 200 x 140 x 600cm*

# RETHINKING IDENTITY
## IN TIMES OF GLOBALISATION
*Néstor García Canclini*

*The following paper by Néstor García Canclini was written for presentation at a conference held in August 1994 in San Salvador de Jujuy, Argentina. The theme of this meeting was* Identity in the Andes *and it was sponsored by the National University of Jujuy and the Centre for Andean Regional Studies, Bartolomé de las Casas, an organisation based in Cuzco, Peru. It was the sixth such meeting on the history and anthropology of the Andes attended as always by a large contingent of scholars from the hosting nation and various interested international scholars. García Canclini was present on both counts. Born in Argentina, he has lived in Mexico since 1976 and now teaches in the Anthropology Department of the Universidad Autónoma Metropolitana of Mexico City. Despite this institutional base, he is renowned as an interdisciplinary cultural critic with a particular interest in the links between the state, culture, the plastic arts and communication on which he has published widely.[1] His area of ethnographic expertise is Mexico rather than the Andes but the commentary on this piece, also presented in Jujuy, is by an Andeanist, Penelope Harvey from the Anthropology Department in the University of Manchester.*

This text aims to deal with some 'paradoxes' which arise from current conceptual reflections and empirical research on identities. Perhaps the most visible contradiction, at first glance, is the fact that studies connected with this subject developed, especially in anthropology, in relation to local cultures, while the most radical redefinition of identity results from globalisation.

The theoretical analysis I am about to propose emerges from studies carried out in various Latin American countries, particularly in Mexico. Let me 'invoke', by way of an epigraph, what happened in that country at the beginning of this year. On January 1, 1994, the North American Free Trade Agreement [NAFTA] between Mexico, the United States and Canada came into effect. The same day an indigenous revolt erupted in Chiapas which, besides challenging the exploitation and injustice suffered by the ethnic groups and peasants of that region, demanded the annulment of NAFTA. As José Emilio Pacheco wrote: 'On the day we were going to celebrate our entry into the first world, we stepped back a century . . . We thought we were, and wanted to be, North American, and we were brought face to face with our Central American destiny'.

I shall deal with the tensions to which this contrast alludes under three headings. The first one refers to the opposition between constructivism and fundamentalism. At a second stage, I shall examine the changes in the cultural referents that make up identities and in relation to which subjects develop their identity narratives: from folklore and classical national arts to the multimedia audiovisual space. Lastly, I shall propose a model to distinguish the effects of globalisation in different areas of the social structure.

### Academic Constructivism vis-à-vis Political Fundamentalism

A first paradox can be found in the conflicting orientations of the narratives on multiculturalism offered by academic theories and sociopolitical movements. The social sciences and humanities conceive of identities as being historically constituted, imagined and reinvented, undergoing processes of hybridisation and transnationalisation which weaken their old territorial roots.[2] On the other hand, many social and political movements give absolute importance to the primal territorial framework of ethnic groups and nations, dogmatically stressing biological and telluric characteristics associated with those origins, as if they were somehow unaffected by historical vicissitudes or contemporary changes. In inter-ethnic and international conflicts, we find that tendencies stubbornly persist in seeing each identity as a hard and compact nucleus of resistance; therefore demanding absolute loyalty of the members of each group and demonising critics or dissenters. From Bosnia to Peru, from Algeria to Germany, the obsession with purity imposes itself in many countries on modern currents that seek to play down the specifics of each ethnic group and nation so as to fashion democratic forms of coexistence, complementarity and multicultural ways of governing.

In fact, this opposition between the constructivist discourse of cultural studies and the fundamentalist doctrines of ethnic or national movements is a recent one. If we trace the links between literature, philosophy, anthropology and fundamentalism in the last two centuries, we find strong complicities. Folkloric romanticism and political nationalism came together to order the traditions of ethnic and sociocultural groups into less than two hundred juridico-territorial packages which they called nations. It was established that the inhabitants of a particular space must belong to a single homogeneous culture and therefore have a single, distinct and coherent identity. Each culture would evolve in relation to a territory and organised conceptually and practically through the accumulation of objects, texts and rituals which served to reinforce the signs that distinguished each group.

It was established that to have an *identity* was equivalent to being part of a nation, a spatially delimited *entity* where everything shared by those who inhabited it – language, objects, customs – would clearly differentiate them from others.[3] Those – historically changing – referents of identity were embalmed by folklore at a 'traditional' stage of their development and declared essences of the national culture. They are still today exhibited in

the museums, relayed by schools and the mass media, dogmatically asserted in religious and political speeches, and defended, when they falter, by military authority.

This model was so persuasive that it succeeded in structuring culture, knowledge, sports and other areas within the confines of national units. The histories of art and literature, for example, have been written as histories of national arts and literatures. Even the avant-gardes, who have tried to transcend sociocultural conventions, are identified with particular countries, as if the national profile served to define their projects of renewal: that is why one speaks of Italian Futurism, Russian Constructivism and the new French novel.

Many literary and anthropological studies have already revealed the fictional and arbitrary nature of the multicultural 'solutions' rehearsed by such nationalistic doctrines. I will limit myself to just two literary examples. Josefina Ludmer showed that 'criollismo', while retrieving the voice of the gaucho from illegitimacy and creating a collection of oral signs in culture and politics, also excluded Indians, Blacks and immigrants from its definition of nationality.[4] Antonio Cornejo Polar maintains that each definition of what constitutes the legitimate body of Peruvian literature, first as Hispanic literature (Riva, Aguero and Prado), then as Mestizo literature (Luis Alberto Sánchez and others), also expelled important constituents from the historical process in the attempt to harmonise the conflicting currents of modern Peru within a homogeneous system 'sufficiently differentiated to merit the description of national'.[5]

Anthropological deconstruction of nationalist and regionalist discourses has led to similar findings. The 'puna' is an invention, says Alejandro Isla, a symbolic construction that varies according to whether the homogeneisation is undertaken by the historico-cultural anthropologists of the Museum of La Plata, or by the current which he calls Merlino-Rabey. In the first case, social heterogeneity is denied by subsuming the differences in a common cultural tradition, with the landscape as its unifying basis; in the second, the Andean peasants would constitute a 'homogeneous sea' thanks to the mechanisms of reciprocity and exchange and their harmonious integration into the national society. A deconstructive glance allows one to be more attentive to the differences, the fragmenting conflicts and negotiations linking the inhabitants of the 'puna' to the national and transnational market: combining what is left of production for self-consumption with sales abroad, monetary transactions with barter, the migration of one part of the family with the entry of other members into public administration.[6]

It is true that a large part of artistic and literary production and sociopolitical discursiveness still continues as an expression of national traditions circulating only within a given country. Music, sculpture, literature and the arts and crafts remain sources of the imaginary nationalist, scenarios for the consecration and transmission of signs of regional identity. But increasingly the creation, dissemination and reception of art is carried out in a deterritorialised way. Many writers who are promoted by cultural diplomacy and the market as 'the great national artists' (the 'Boom' writers Cortázar, Fuentes, Vargas Llosa) reveal a cosmopolitan sensibility which contributes to their international resonance.

I wonder if, with the displacement of national mono-identities towards global multiculturalism, fundamentalism may not be attempting now to survive as Latin Americanism. There continue to exist, as we have mentioned, ethnic and nationalist movements in politics which seek to justify themselves through a supposedly distinctive national and symbolic heritage. But it appears that the operation which has achieved the greatest verisimilitude is Macondo-type fundamentalism, which freezes the notion of 'Latin American' as a sanctuary of pre-modern nature and sublimates this continent as the place where social violence is bewitched by the emotions. It assembles the texts of very diverse countries, from Carpentier's to García Márquez's, from Isabel Allende's to Laura Esquivel's, and channels them into a single paradigm of reception, which is also one single way of situating Latin American heterogeneity within cultural globalisation.[7]

By giving 'consistency' to this exaltation of the irrational as the supposed essence of what is Latin American, the folklorising intervention of the market and of a large part of the critical establishment contributes today to the continuing opposition between fixed fundamentalist notions of identity and constructivist readings of multiculturalism, ignoring the imagined, polyphonic and hybrid character of identity. I therefore see it as a key task of cultural studies to attempt to understand how cultural industries and urban mass markets manage to preserve local cultures while promoting the greatest opening and transnationalisation of these cultures ever known in history. In other words, how the ideologies represented and solemnised by these two movements, fundamentalism and cosmopolitanism, manage to coexist.

## The Change of Cultural Identity

We propose to analyse identity not as an atemporal essence that is expressed, but as a construction that is narrated. What theoretical and methodological consequences does this redefinition imply? The first would be to move the focus of study away from the subjectivity of individuals or groups, from their 'nature' or self-definitions, and endeavour to understand, too, the more or less objective referents in relation to which individuals construct their narratives. This implies a disciplinary displacement: if identity is not something spiritual contained in people's souls, then philosophy and psychology are not enough to discover how it is formed and transformed; we need cultural studies (anthropological, sociological and communicational) that analyse the symbolic structures of social development and the practices which situate the actors in relationship to them. I do not overlook the importance of philosophical, psychological and literary approaches to identity, and that is why I devote the first pages of this paper to them. But these disciplines should apply a de-idealised redefinition to the object of their study and place it within the sociocultural conditions of production, circulation and reception, which I can only hint at here.

What I am interested in highlighting is the way in which the modernisation, massification and globalisation of identities is associated with a change in sociocultural referents. We said that globalisation weakened the importance of founding events and territories which sustained the illusion of ahistorical and self-absorbed identities. Today, identity referents are formed less in

the arts, literature and folklore, which for centuries provided nations with distinctive signs, than in relation to textual and iconographic repertories supplied by the electronic communication media and the transnationalisation of urban life.

Where, then, do identities reside? How are they produced and renewed? In order to respond, we shall confront classical anthropology's definition of identity with the conditions in which it is formed in our day. If anthropology, the social science which more than any other has studied identity-forming processes, finds it difficult today to contend with transnationalisation and globalisation, it is because of its practice of regarding the members of a society as belonging to a single homogeneous culture and hence possessing a single distinctive and coherent identity. This unified vision, consecrated by classical ethnographies and many national museums organised by anthropologists, is inadequately equipped to grasp intercultural situations.

The 'cultural contact' theories have almost always studied the contrasts between groups only by what differentiates them. The problem resides in the fact that most multicultural situations are configured today not only by the *differences* between separately developing cultures but by the *unequal* ways in which the groups appropriate elements from various societies, combine them and transform them. When an increasingly free and frequent international circulation of people, capitals and messages connect us daily with many cultures, our identity can no longer be defined by exclusive membership of a national community. The object of study must therefore be not only difference but also hybridity.

From this perspective, nations are transformed into multi-determined scenarios, where diverse cultural systems intersect and interpenetrate each other. Only a social science which is able to perceive heterogeneity, the coexistence of various symbolic codes within the same group and even within a single subject, as well as cultural borrowings and transactions, will have something significant to say about identity processes in these times of globalisation. Identity today, even within broad sectors of the population, is polyglot, multi-ethnic, migrant, composed of cross-elements from various cultures.

One proof of the extensive and cross-class character of globalisation is the transnationalisation of the goods which identify both upper and lower population sectors. The 'cultivated' arts and crafts are loaded with signs from other cultures, or with the icons of the dislocated imagination broadcast by the mass media. It is above all this media – cinema, TV and video – which stages the process of deterritorialisation. Even films which talk about specific communities, Buenos Aires or the Bronx, Madrid or Tijuana, achieve significance in the market and at international festivals, insofar as each can be seen as a 'transcultural meeting'.[8] Not only do Wim Wenders' films traverse several cultures, but they are journeys to the end of the world. Bernardo Bertolucci, who, to continue the aesthetic exploration he began with his Italian social epics, made a joke to Spielberg which is conceivable only at the end of this century: he said that *Schindler's List* deserved the 1994 Oscar, but for best foreign film, because it was made as if it were a Polish or an Eastern European film.

Just as identities were the object of display in national museums in the past, so the economic transnationalisation of the second half of our century, and the very character of the latest communication technologies (television, satellites and optical networks) give pre-eminent space to culture-worlds presented as multimedia spectacles. To the cultural and technical reasons already mentioned, can be added the economic argument: no contemporary 'national' cinema is able to recoup the investment in a film simply through the network of outlets in its own country. It must deal with multiple sales channels: satellite and cable television, video networks, laser discs, etc. All these transnationally structured systems encourage the 'de-folklorisation' of the messages that circulate within them.

In the light of the survival difficulties that face the cinema, there is a tendency to emphasise transnationalisation and eliminate national and regional aspects. A 'world cinema' is being promoted which seeks to utilise the most sophisticated visual technology and *marketing* strategies to insert itself into a world-scale market. Coppola, Spielberg and Lucas, for example, construct spectacular narratives based on myths that are intelligible to all viewers, regardless of culture, educational level, national history, economic development or political regime. World cinema, says Charles-Albert Michelet, 'is closer to Claude Lévi-Strauss than to John Ford'.[9] It is about constructing a spectacle so dazzling as to persuade television viewers that it is worthwhile leaving their sofa once or twice a year to occupy that other, less comfortable seat in the darkened room.

And, at the same time, regional cultures persist. Even the global cinema of Hollywood leaves a certain space for Latin American, European and Asian films which capture the interest of multiple audiences by the way in which they represent local problems. I am thinking of how, in the 70s and the first half of the 80s, Brazilian cinema broadened its impact massively both within Brazil and abroad, by combining testimonies on the identity and cultural internationalisation of that country with an imaginative and parodic treatment: from *Macunaíma* to *Doña Flor and Her Two Husbands*, or *Xica de Silva*. One could mention the re-readings of Argentine history – somewhere between detective and political stories – made by Adolfo Aristiraín; or the historical narratives told from the intimacy of daily life in Mexico that are suggested by *Red Dawn* and *Like Water For Chocolate*. The latter film, which was seen by more than one-and-a-half-million viewers over a period of a few months in its own country alone, is perhaps no more than an unusually well-made soap opera; but in some way its success is associated with other, less conventional, Mexican films – *The Task*, *Benjamín's Wife*, *The Bundle* – which rework, with irony and irreverence, without complacent nostalgia, the identity crisis of the family and national political projects.

Such films reveal that identity and history – local or national identities – still have their place within cultural industries that are subject to the demand of high financial returns. In parallel with the deterritorialisation of the arts, there are strong reterritorialising movements, represented by social movements which affirm local values and mass-media processes: regional radio and TV, the creation of micro-markets in music and traditional goods, the 'demassification' and 'mestisation' of consumption, which generate differences and localised forms of rootedness.[10]

Nations and ethnic groups continue to exist. The problem

appears to be not the danger that they might be obliterated by globalisation, but how we might understand the reconstruction of ethnic, regional and national identities in the process of intercultural hybridisation. If we conceive of nations as multidetermined scenarios where diverse symbolic systems intersect and interpenetrate each other, the question then is what kind of cinema and television are able to narrate heterogeneity and the coexistence of several codes within the same group and even within a same subject.

We can summarise the challenge of these changes to theory and research by saying that it is now a matter of trying to understand how modern identities articulate with others which we might call postmodern, though the term sits increasingly uncomfortably. *Modern identities are territorial and almost always monolingual*. They were fixed by subordinating regions and ethnic groups to a more or less arbitrarily defined space called nation, which was opposed – in the form of its state organisation – to other nations.

*Postmodern identities*, on the other hand, *are transterritorial and multilingual*. They are structured less by the logic of the State than by that of the market; instead of being based on oral and written traditions which covered personalised spaces and were realised through close interactions, they operate through the industrial production of culture, its technological transmission, and a deferred and segmented consumption of goods. They demand the coupling of the *sociospatial* definition of identity with a further, *sociocommunicational* one.

### 3 Identity as Co-production and Multidisciplinary Work

We conclude from the above that present-day reflection on identities must consider various cultural supports besides merely folkloric or political discursiveness, as was the case with the nationalisms of the 19th and early 20th centuries. It needs to encompass the various artistic repertoires and communication media that contribute to reformulating identities. For this reason, their study cannot be undertaken by a single discipline (anthropology or political sociology) but must be a transdisciplinary task, involving the input of communication specialists, semiologists and town planners, in addition to which it would also be useful to include the participation of other experts such as economists and biologists, who are concerned with the decisive scenarios for today's recomposition of identities.

Multimedia and multicontextuality are the two key notions for redefining the role of the cinema, other communication systems and culture as a whole. Just as the prospect of the revival of the cinema depends on it being repositioned within a multimedia audiovisual space (television and video), so national and local identities may be able to endure only insofar as we re-situate them within multicontextual forms of communication. Energised by this process, identity will not simply be a ritualised narrative, the monotonous repetition expected by fundamentalism. Insofar as it is a narrative that we are incessantly reconstructing, and reconstructing together with others, identity is also co-production.

But this co-production is carried out in unequal conditions by the various actors and powers involved in it. The processes of

cultural globalisation, and economic integration on a regional level, indicate the need for national economies and cultures to soften the customs barriers which separate them, as well as change the asymmetrical way in which agreements are concluded. Given that this asymmetry is accentuated by the liberation of commerce and the integration of supranational regions, it must take into account the various ways in which these are recomposed within the unequal circuits of production, communication and appropriation of culture. I would like, finally, to offer the outlines of an analytical model of how national societies are reorganised by cultural and economic globalisation, which I formulated in a study on the effects of NAFTA in Mexico.[11]

We must distinguish a first circuit: that of the *historico-territorial culture*; that is to say, the accumulation of ethnic or regional information, customs and experiences which continue to be reproduced within the boundaries established in the course of centuries. Within this space, the effects of globalisation are not so significant. The historical patrimony, artistic and folkloric production, and some areas of peasant culture experience a limited opening because investment yields less and symbolic inertia is more prolonged. However, as several analysts of the indigenous and peasant question in Mexico have noted, NAFTA's demand that productivity be internationally competitive has led in some regions to the reordering of the working life of traditional groups. In regions where agriculture has for centuries been organised in a diversified way in order to achieve self-sufficiency in food production, peasants are being forced to specialise in crops that yield the highest profits, or otherwise they are pressured into selling their lands.[12] This situation was one of the triggers of the social explosion in Chiapas. We should make clear, however, that the Chiapas conflict was not a simple confrontation between traditions and modernisation. Neo-Zapatism is a feature of contemporary indigenous movements which are energetically calling for cultural and political autonomy, while at the same time demanding to be fully integrated into modern development: they demand that indigenous languages be taught in the schools and that justice be administered by the people according to their customs and traditions, while asking at the same time for their lands to be returned with 'agricultural machinery, improved seeds, fertilisers, insecticides and technical advice', 'roads, transport and irrigation systems', 'the building of hospitals which include specialised doctors' and 'full surgical service'; they demand electric energy and telephones for their people, and 'an indigenous radio managed by *indigenous people*', which will provide them with 'reliable information on what goes on at a local, regional, state, national and international level'.[13]

In a second circuit, that of the *mass media* concerned with broadcasting entertainment and information to majorities (radio, television, video), some peripheral countries, like Brazil and Mexico, command sufficient technological, economic and human resources to continue generating national production with a degree of autonomy, as well as expanding internationally. But in most Latin American societies, dependence is increasing, not so much on global culture as on US production. In addition, the issue is not confined to ownership of the communication media,

which of course conditions the proportion of national and foreign referents in the evolution of identities. It has to be said that cultural transnationalisation positions itself in the space left by the dwindling traditional elements of identification. The search for a sense of belonging and community is rooted less in social macro-entities (nation, region, ethnic group), especially on the part of young people, and is directed more at religious groups, sports organisations, generational solidarity and mass-media leisure. A common feature of these atomised 'communities' is that they are centred more around symbolic consumption than productive processes. Economic solidarity re-emerges only in cases of extreme need: strikes, soup kitchens, aid during natural disasters. Civil societies look less and less like national communities, understood as territorial, linguistic and political units. Instead, they express themselves as *hermeneutic communities of consumers*; in other words, as collections of people with similar tastes in, and readings of, certain goods (gastronomical, sporting, musical) which provide them with shared identities.

The blurring of national and regional identities is greater in the third circuit, involving computers, satellites, optical networks and the other *information technologies* associated with decision-making and the most widespread and profitable forms of entertainment (video, video games, etc). Research has scarcely begun into the effects of this technological and economic globalisation on the reformulation of identities at work and in consumption. Contemporary discourses on competitive productivity, the rituals of integration between workers and companies, and the subordination of the iconography of entertainment to de-localised codes, are some of the processes through which local identities are being remodelled according to global matrices. Many traditional customs and beliefs survive in these spaces and make for distinctive styles in each country, even in the most technologised forms of production and consumption. But it is evident that by working under a global competitive logic, by watching television and informing ourselves through electronic means, and by using computing systems in many of our daily practices, identities which used to be based on local traditions are being reformulated according to 'cultural engineering' criteria.

The study of how relationships of continuity, rupture and hybridisation unfold between local and global, traditional and ultra-modern systems of cultural development, is today one of the greatest challenges in rethinking identity. Not only co-production, but conflicts result from the coexistence of ethnic groups and nationalities in the areas of work and consumption, which is why the categories of *hegemony* and *resistance* continue to be useful. But the complexity and nuances of these interactions also demand the study of identities as processes of *negotiation*, insofar as they are *hybrid*, *ductile* and *multicultural*.

Bearing in mind the *social* conflicts that accompany globalisation and multicultural changes, it is clear that what is happening with the symbolic industries is not limited to what we observe in media representations. It seems necessary, then, to elucidate our opening statement: identity is a construction, but the artistic, folkloric and communicational narratives which form it are realised and transformed in relation to socio-historical conditions which are not reducible to their staging. Identity is theatre and politics, it is acting and action.

## Notes

1 1977 *Arte y sociedad en America Latina*, Mexico; 1979 *La produccion simbolicva*, Mexico; 1982 *Las culturas populares bajo el capitalismo*, Mexico; 1987 (ed) *Politicas Culturales en America Latina*, Mexico; 1989 *Tijuana: la casa de toda la gente*, Mexico; 1990 *Culturas hibridas: estrategias para entrar y salir de la modernidad*, Mexico (to be published in English, *Hybrid Cultures: Instructions for Entering and Exiting from Modernity* by the University of Minnesota Press).

2 The founding text of this current is that of Benedict Anderson, *Imagined Communities: Reflection on the Origin and Spread of Nationalism*, Verso, London, 1983.

3 In the following paragraphs I pick up, with some changes, on the theoretical discussion I attempted on these questions in *Hybrid Cultures: Strategies to Enter and Retreat from Modernity*, Grijalbo-CNCA, Mexico, 1990.

4 Josefina Ludmer, *The Gaucho Genre. A Treatise on the Motherland*, Sudamericana, Buenos Aires, 1988.

5 Antonio Cornejo Polar, 'Peruvian Literature: A Contradiction Totality', *Magazine of Latin American Literary Criticism*, Year IX, No 18, Lima, 1938, pp31-50.

6 Alejandro Isla, 'Juruj This Century. Research Strategies', *Society and Articulation in the Highlands of Jején. Terminal Crisis of a Development Model*, Ecira-Asal-MLAL, San Salvador de Jujuy, 1992.

7 The risks of homogenising what is 'Little American' in the metropolises are noted by analysts of literature and the plastic arts. See interview by Carlos Dámaso Martínez, 'Jean Franco: Multiculturalism and the Power of the Centre', *Spaces*, No 12, Buenos Aires, June-July 1993, pp37-40; Mari Carmen Ramírez, 'Image and Identity in Latin Art in the United States', *The Working Week*, 228, Mexico, 24 October 1993, pp18-25; and George Yúdice, 'Globalisation and New Forms of Cultural Mediation', paper presented to the seminar *Identities, Politics and Regional Integration*, Montevideo, 22-23 July 1993.

8 I take the expression from the volume *Art from Latin America: The Transcultural Meeting*, which accompanied the exhibition of the same name at the Museum of Contemporary Arts, Sydney, 10 March-13 June 1993, curated by Nelly Richard.

9 Charles-Albert Michelet, 'Reflexion sur le rôle de drame du cinéma mondial', *Cinéma Action*, 1988, pp156-161.

10 Two recent studies on this question: Arman Mattelart, *La communication-monde*, La Découverte, Paris, 1992; Stuart Hall, 'The Local and the Global: Globalisation and the Ethnicity', in Anthony D King (ed), *Culture, Globalisation and the World System*, State University of New York at Bringhampton, New York, 1991.

11 Néstor García Canclini, 'Museums, Airports and Garage Sales', *Publicar*, No 1, Buenos Aires, 1993; and Gilberto Guevara Niebla and Néstor García Canclini (eds), *Education and Culture Vis-à-Vis the Free Trade Agreement*, Nueva Imagen-Nexos, 1993.

12 Guillermo Bofil Batalla, 'Cultural Dimensions of the Free Trade Agreement' in G Guevara Niebla and N García Canclini, *op cit*, pp157-78.

13 This list of demands is taken from the Communiqué submitted by the Zapatists National Liberation Army in its talks with the Mexican Government. See *Perfil de la Jordana*, 3 March 1994.

# POSTSCRIPT ON 'RETHINKING IDENTITY IN TIMES OF GLOBALISATION'

*Penelope Harvey*

Néstor García Canclini's paper offers us some important and challenging ideas for rethinking identity in these contemporary times of globalisation. Particularly suggestive is his idea of identity as co-production. These co-productions beyond and outside the established hierarchies of the film industry, are acted out on less certain territories, without contractual securities. These are co-productions in which inequalities are in process, continually established, negotiated, challenged. To understand or even begin to describe these processes we need to evoke a simultaneous sense of continuity, rupture and hybridisation. It is the simultaneity that I would stress, the fact that people regularly participate at the same time in the distinct circuits that Canclini has described. Once we allow the possibility of such simultaneity, it also becomes self evident that people might, as is the case with the people of Chiapas in Mexico, assert their claims to cultural and political autonomy while at the same time demanding full integration into the modern world. This situation is only paradoxical if we expect people's social practice to be unidimensional. In other words the paradox, if there is one, is of our making not theirs. The focus on simultaneity also has a theoretical pay off. If, for example, we focus on the fact that people can be active on any or all of the communicative circuits that Canclini enumerates, we are freed from the necessity to draw distinctions between social structures and social practice and the struggle to account for their relationship. These circuits are not abstract structures, they are networks composed of concrete social relationships.

To continue with the theme of simultaneity, I would like to look first at the complicity between academic constructionism and political fundamentalism. Canclini refers to the survival of fundamentalisms but there are much stronger complicitous links than mere survivalism between academic anthropology (in its current constructivist phase) and political fundamentalism. The relationship between feminism and anthropology provides an apt analogy through which to illustrate this link.

In the 1970s the link between anthropology and feminism, in the English language literature at least, was one of open complicity. Feminists searched and found in anthropological writings evidence to support their theories of the universal domination of women. These theories were founded on women's supposed association with the natural world through their reproductive biology. And even those who criticised the theory of universal subordination, continued to maintain a commitment to it, and to the universal and natural category 'woman'. Instead of looking at how this category was naturalised, scholars began to study the variety of ways in which concepts of gender were constructed symbolically. By the mid 80s a new feminist politics and a new anthropology became more concerned with the deconstruction of the category 'woman'. People had begun to address the problem of the erasure of differences within and between women, and to accept that a male/female dichotomy was not universally understood as either natural or explanatory of social difference.[1] However, Strathern has drawn attention to the continuing link between anthropologists and feminists engaged in deconstruction, a link which centres on the fact that both groups continue to work with the basic assumption of culture as construct – as something built or made from what still remain as implicit natural differences.[2] The assumed existence of such differences is what enables anthropology to engage in comparative projects, they provide the universals that lend coherence to the discipline. These natural differences on which both academic constructionism and fundamentalist politics depend are the basic distinctions on the basis of which modernity established its terrain – ie the dichotomies of nature/culture, science/politics, reality/construct.

It is interesting in this regard that recently both feminists and anthropologists have had recourse to the idea of the hybrid, a powerful metaphor invoked to confound these dichotomies.[3] But we should distinguish between hybrids. Let us take just two examples: there are the hybrids of the 18th century, the plants and animals selected and adapted to become natural entities developed by human cultural activity; and there are the cyborg hybrids of the 20th century, mixtures of human and non-human animals and machines, who inhabit not only the pages of science fiction but also are increasingly visible in our daily lives thanks to the possibility of trans-species organ transplants for example, or the genetic engineering of the new reproductive technologies. The emphasis for those who work with the idea of the hybrid is to move away from a focus on origins and preconditions and to look instead at effects. Thus, instead of assuming gender difference they might ask instead how and to what ends is gender difference produced: the topic is very important for work on ethnicity in the Andean region as well. In the Cuzco region of Southern Peru, peasant and mestizo identities operate simultaneously as fundamentalist discourses and as contextual effects, the negotiated outcomes of social relationships. There are important parallels here with Canclini's idea of identity as co-production. I simply want to add that academic constructivism implies a complicity with the differences, or naturalised dichotomies, on which the idea of cultural as construct depends. Furthermore it is what happens in the world beyond the academy that permits us to make such analyses – but more of this later.

My second question is linked to this first observation – I want to question the validity of thinking of tradition, modernity and postmodernity as stages in a temporal sequence. If we change

our analytic emphasis from precondition to effect; if we refuse to ascribe a natural difference to the distinction between tradition and modernity, we can begin to see how tradition is also an effect of the co-productions of modernity. Canclini writes that 'today identity is polyglot, multiethnic, migratory and made from a combination of elements from different cultures'. In the first place it is important to remember that it was always thus. It is modernist discourses which impose the idea of a radical break, particularly those discourses surrounding the nation state and its associated monolingual, territorial identities. The Incas in their time dislocated Andean peoples, and developed a process of ethnic redistribution which by the end of the colonial period had all but removed any trace of pre-Inca or pre-Hispanic ethnic groups in the Peruvian Andes. Contemporary ethnic differences in Peru are not residual survivals but the outcomes of these processes.

Tradition is itself an effect of modernity.[4] If modernity posits rupture it also hides continuities. As it emphasises purification so it plays down the potential for hybridisation that these classificatory strategies actually enabled.[5] There is no deterritorialisation without territorialisation, no hybrids without natural kinds.

This brings me to the relationship between cultural difference and hybridity. How do these two ideas co-exist? To my mind anthropology's commitment to cultural relativism, and to the possibility of incommensurability is extremely important here. With contemporary awareness of the relationship between difference and inequality, many anthropologists seem unwilling to attribute difference for fear of colluding in the perpetuation of discriminatory politics. However, to deny the possibility of basic cultural difference is also to assume that all peoples must somehow reflect our image of the world. In terms of identity this is particularly problematic. I would like to argue that not all people necessarily have concepts of culture, nor identity, nor society. These are particular ideas of extreme importance in the development of Western thought, they are basic to our concepts of the autonomous individual and ultimately the source of what we now consider to be human rights. And, given the history of the Andean region these ideas are not alien there either. But their historical and cultural specificity is hidden by the Western propensity to universalise.

When we look at the processes of hybridisation or the co-productions to which Canclini refers, we need to ask whether the foundational propositions of the social actors we are comparing, are in fact commensurable – are the parties to the co-production working with the same idea of what they might be producing? Is *identity* necessarily what people are trying to produce in their social interactions? The concept of identity carries with it the idea of a degree of coherence, even for the hybrid subject. What would happen if the project were one of the disconnection, a project to create difference, separation or to produce aspects of self rather than a new totality: if, instead of working with an ontology of difference and culture that constructs identities, we were to have an ontology of totalities and cultural practices directed to their disarticulation or the separation of entities as they appear to have in Papua New Guinea.

In this sense it seems to me that the hybrid is a somewhat ambiguous metaphor. Is it an image that enables us to imagine new identities, or is it an image that disrupts the notion of identity altogether? To what extent does it help us to question the invisible presuppositions of our own culture, obsessed with the construction and representation of the construct?

Finally, an important question for our contemporary world of globalisation, of new communications technologies, and a widely disseminated consumer culture. What kinds of difference are we talking about when we refer to different nations or ethnicities? This question arises out of some work that I have been doing on the Universal Exhibition that took place in Seville in 1992.[6] There I was looking, among other things, at how the nation state tries to represent itself as a social entity with its own cultural identity – or to put it another way, at how nation states differentiate themselves. On one level it is clear that differences have not been eliminated by contemporary processes of globalisation. 112 nations exhibited at the Expo, and represented themselves both through exhibits of local culture and with reference to transnationalism. They used national art traditions, folklore (dances and costumes) films of landscapes, historical exhibitions and technological displays. However, the interesting thing was that (with the exception of a visible difference between nations over who had access to the most recent technologies) the participants all produced images of their cultural particularity in exactly the same way. The visitor did not have to confront different concepts of the nation state nor different notions of culture in the journey around the imaginary Expo world. There was a great deal of difference but these differences were reproduced to the point where difference became simply more of the same. This is the homogenising diversity of consumer culture. And it is interesting, in the light of what Canclini has said, that it was achieved above all through the use of cinema technology and the spectacle of multi-media. What the Expo demonstrated was that the hybrid entity that is the nation and the market, is a rather sinister hybrid and far from emancipatory for its new citizens/consumers.

With this small example, I just wanted to say that we should not be ingenious about what makes these redefinitions of identity or modernity available to us today. The alliance of state and market is very strong and is produced through metaphors and concepts which we are barely keeping pace with. For example, at the Expo the nation state was clearly produced as a key social entity for the contemporary world, but at the same time it was openly deconstructed. On arriving at the Swiss pavilion, the visitor was faced by a large placard which read 'Switzerland does not exist'.[7] The thing is that in these new alliances ambiguity no longer matters. Today the transnational companies use national identities like logos. Or if it is more convenient, they affirm cultural difference as something that can simply be chosen, as Benetton have done in their recent global promotion campaigns. They promote a multiculturalism without responsibility, with no inequality and no fundamental difference.[8]

The danger of the metaphor of the hybrid is that it does not only create possibilities for new alliances but also a language of easy comparison which hides precisely those specific social relations which help us to distinguish between the many hybrid entities.

With this I do not want to take up an oppositional position to

that of Canclini. I simply want to point out that we should not begin with the theory, or hope that theory itself is going to help us to understand either historical specificity or the profound cultural differences which our empirical work throws up – above all when these theories are so closely linked to those modern cultures that depend so closely on representative practices to show themselves their own reality.

**Notes**

1 For a more developed rendition of this argument see the P Harvey and P Gow (eds), *Introduction to Sex and Violence: Issues in Representation and Experience*, 1994, Routledge, London.

2 M Strathern (ed), 'Between a Melanesianist and a Feminist', *Reproducing the Future: Anthropology, Kinship and the New Reproductive Technologies*, Manchester University Press, Manchester, 1992.

3 See particularly the work of Donna Haraway, *Simiens, Cyborgs and Women: The Reinvention of Nature*, Free Association Books, London, 1991.

4 Akhil Gupta and James Ferguson, 'Beyond "Culture": Space, Identity and the Politics of Difference', *Cultural Anthropology*, vol 7, no 1 (6-23), 1991.

5 Bruno Latour, *We Have Never Been Modern*, Harvard University Press, Cambridge, Mass, 1993.

6 See P Harvey (forthcoming) *Hybrids of Modernity: Anthropology, The Nation State and the Universal Exhibition*, Routledge, London.

7 This was an artwork by Ben Vautier.

8 Celia Lury (n d) *The United Colours of Diversity: Benetton, Branding and Cultural Essentialism*.

# KUNJAMMA AND THE HOODED CAMERA
*Victor Anant*

*For Jean Mohr*

Photographs terrify me. They are, if I may coin a phrase, lightmares. By which I mean that they illuminate what is already visible to me, and, at that same instant, turn my eyes into sockets.

They terrify me in the same way in which the stuffed head of a lion or a tiger on a wall terrify me. I can wrench myself awake, screaming, sweating, from a nightmare in which, for example, I am being castrated, and I can breathe myself back into my own body. When I look at a photograph I see death as a taxidermist: I see my own body stuffed with sunlit cock and balls of woven fire.

The photograph is death at first sight.

Come, die with me, as I died with the first photograph I saw taken: grandmother, Kunjamma, little mother. Come into a small one-room and kitchen tenement flat in the suburbs of Bombay. The hooded cobra-camera, 1936?

She had borne 17 children and had seen 11 of them die. I once asked her about the dead ones, and she narrated, as if counting the beads on her rosary, without naming any of the eleven, 'snake bite, drowned, cholera, plague, diarrhoea, snake bite . . . ' Their passage through her was the pilgrimage of a clan, our Brahmin clan.

There was not a single picture, calendar, image, not even a mirror in our ancestral home in a village in Kerala, where I grew up with aunts and uncles and a dozen or so cousins. All the sounds, events, images, fleeting scenes of marriages, religious rituals, even smells like sandalwood paste are contained in her.

She could see in the dark. And she gave me her eyes. In the early hours of the morning she would wake me up and lead me through the vegetable patches, past the banana groves and the boathouse, to the exact spot where she had heard, in her sleep, a ripe honey-mango fall. If it was left until dawn the crows would peck it clean.

She was jackfruit with its hardened nipple seeds and its river bed of sweet flesh. She was the huge copper cauldron at the back of the kitchen in which rice was boiled for kanjee for our peasant labourers and the household. She was the well from which she alone drew water. She ruled, with her shaved widow head and her elephant ear breasts and peering eyes. She was everywhere. She was the planet of my discovery of existence.

All the horoscopes of our clan, engraved on dried coconut sheaves, were kept in the wooden casket of her belly, just as all the jars of pickled mango and chillies, and fried banana and tapioca chips, were stored in huge teakwood chests in the dark pantry to which only she had right of access. All the wisdom of our Brahmin ancestors was sealed in the shell of her scalp.

Why did she finally consent to come and stay with us for a few days in the small railway flat to which my father was entitled in a junction town near Bombay?

I think he threatened her. I think he told her that if she did not come to us he would never take us on our annual summer pilgrimage back to our village in the deep south of India. Such a threat was, for her, living absence, unacceptable, she who had ground death between her thighs and spoke of it as an accomplice of life. I think it was also because she had a premonition: she was ready to leave, and she wanted to see every place on earth where she had left a little of herself. My father had left the village for work in the city of gold, and to give his children the chance of an education to live in modern times.

From the day she arrived, Kunjamma had created a turmoil. First, she had been horrified that there was no river running through the flat. 'Water in chains', she screamed, looking at the taps in the kitchen and the bathroom, 'water like mice hidden in the walls? You expect me to wash with water that is perhaps not even wet?'

Although we laughed, and father collected water in a bucket and said she could make the water run over her like a stream, she would have none of it.

The next melodrama was enacted in the lavatory in the flat, which was a hole in the floor of a small white-tiled room. 'No, no, no', she shouted, 'I will only squat on earth'.

With great patience my father eased the situation by taking her two miles away, across the main road, through winding alleys, to a small Hindu temple which had a water-tank and some wild vegetation around its walls.

Finally, there was the electric lighting. She called it the 'light with false teeth'. He decided that during her stay with us we would only light the brass lamp in the kitchen and would place earthenware, oil-wick bowls around the living room.

Father kept it a secret from us that he had asked a photographer to make a portrait of Kunjamma for our flat.

The evening when the photographer came my father met him outside our flat and asked him to wait in the open yard at the back of the tenement block. He told him to select the spot where he wanted her to sit, if possible under the jambul tree where the light was good at that time. 'Set up your equipment, I will give you a chair to focus. Be ready when I bring her out. She is a very obstinate woman. Do not tell her what you will be doing. If she does not agree I will, of course, still pay you.'

The cameraman was a Brahmin, with a sacred thread across his bare chest, ash lines of our caste on his forehead, arms and torso. Oiled hair, parted in the middle, the very smell of sanctity. He

mounted his camera on his tripod, placed the chair at the distance he wanted, and waited. Soon he was surrounded by a babble of servants, children, parents and passersby in the neighbourhood.

My father ushered grandmother out of the flat. He used a ploy. He told her that the neighbours were seeking *darshan* – audience – because they had heard she was from a venerated Brahmin family. It would take only a few minutes, he reassured her. She could sit on a chair.

Giving audience is a role to which she was not only accustomed but is also a Brahmin obligation. She came out in her transparent Mysore silk wraparound, her oiled brown skin glowing in the evening light. For a moment, after she sat on the chair facing the eager eyes of the children and our neighbours, there was tension.

'What is he doing?' she asked, pointing at the Brahmin photographer who was already bent behind his tripod, face covered by his black hood.

My father went up to the photographer and asked him to get it over as quickly as possible. The photographer crawled out from under the hood, straightened up, smiled, folded his hands in salutation to her, moved to the right of the camera, and took the cord between his fingers.

'Ask her to smile', he told my father.

'Please smile, Kunjamma', my father said.

Grandmother looked forbiddingly stern.

'Smile? What is there to smile at?'

My father's wit came to his rescue. 'They want to see your teeth', he said. It was a joke they shared.

'My teeth, here, let them look', she said, and grinned tooth-lessly.

Click. She startled at the whirr of the camera. It was done. Everyone around clapped.

'Once more, please', said the photographer. But she would have none of it. She got up from the chair and walked back into our flat, blessing the children. Two days later my father brought the portrait of grandmother home. It was wrapped in newspaper, eight inches by six, framed in black. Every wave of her body was revealed. Arms on her lap, white fingers like the butter floating to the top of the buttermilk pot she churned. Her legs firmly around an invisible clay pot. Bare feet, with toes thrust into the camera. Wraparound silk and skin on a loom of light. Toothless. Not a twitch.

My father measured a nail for the picture at about her eye-level. There was not a calendar, a picture, a photograph, even a mirror in the living room of our tenement flat. He started hammering in a nail. Then he adjusted the portrait of Kunjamma.

She was sitting in the kitchen, praying with her beads and asked, 'What is that noise? I can hear the walls cracking'.

'Come and look', my father said.

She rose. Stood in front of her portrait. Squinted. Eyes creased. Stepped back. Squinted. Eyes creased. Stepped back. Squinted again. She sat on the floor and looked up at the photograph of herself. Then she drew the same chair as in the picture and sat on it in the same way. Stared. Grinned toothlessly.

We stood around in silence. My father was clearly nervous, playing with the hammer in his hand.

'You don't like it?' he asked.

Without a trace of accusation or reprimand in her voice, Kunjamma said, 'My son, I will not die like this, before my appointed time, like this, on a wall so far away from our home, upright, in black and white, with no sandalwood fire or the smell of burning flesh. No. I will be carried as all those before us have been to the burning ghat on the river bank to join those of whose flame I am a flicker'.

My father touched her feet and turned the photograph round to the wall.

The next day we saw her off on a train from Bombay back to our village, with a servant in the third class compartment next to hers to accompany her.

She did not die until the next summer when we went back to our village for our holidays. I was there.

That morning, as usual, we went together to bathe in the river. All day she had told me stories. In the evening she lay on her straw mat and said she did not need two bananas, I could eat the other, nor a whole tumbler of milk, I could have half. Usually, at night, I assumed she would ask me to sleep beside her. That night she said, 'Go and sleep. Go'. Not, as we normally say when we part, 'I will go and come'.

I look at photographs with grandmother's eyes: as she would look at a shadow on the grass path when we went to bathe in the river, shouting, 'Who are you, *vadigan*, why do you pollute my path you untouchable?'

Photographs dis-locate me. There is not one I can look at without shuddering. The more expressive the face or landscape, the more violent the upheaval. They disgorge me, like earthmovers, crocodiles of death. They seize me with the teeth of another time. They replace where I am with where they want me to be. They banish me into an absolute past. My sense of being, being here, is caught in a noose. I get hung up.

Of course, since then, I have stepped into many little photographic booths. At street corners, railway stations, airports. I draw the screen. I read the instructions. I adjust the revolving stool. I put in coins. Sit upright, try to smile. Press the button and wait for the flash.

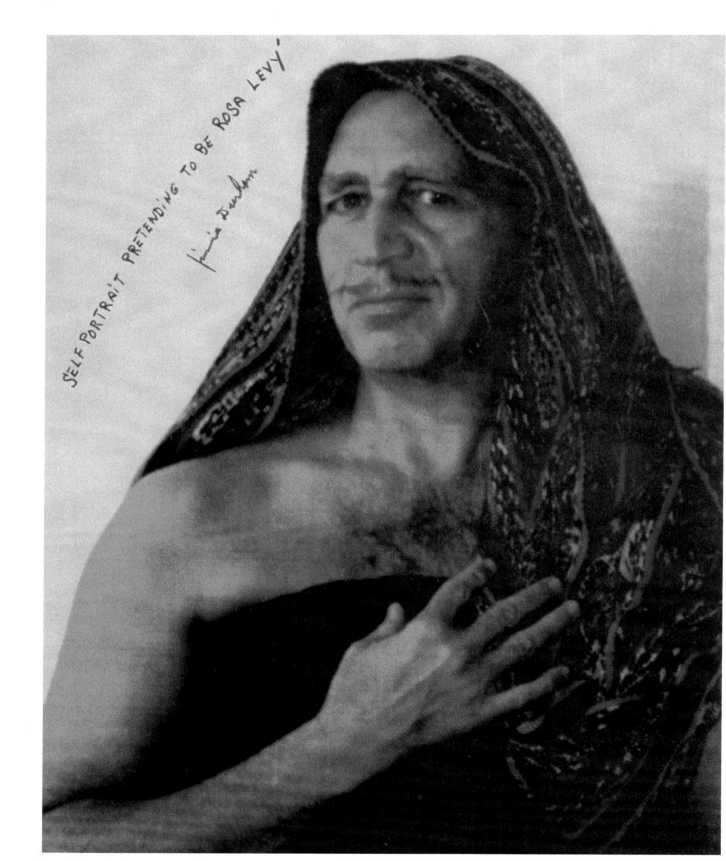

Self Portrait Pretending to be Rosa Levy, *1994, pencil, acrylic paint/colour photocopy, 51.4 x 50cm*

# JIMMIE DURHAM
## ATTENDING TO WORDS AND BONES
*An Interview with Jean Fisher*

**Jean Fisher**: I want to begin by reminding ourselves of how we met, as it does not seem quite so obvious why a 'liberal' English white woman might connect with a Cherokee artist.

When I was in New York, I was offered a job at some inscrutably obscure state university, right in the middle of Long Island, and the nearest town was called Hicksville. The job was in the department of visual arts, run by the Uruguayan artist Luis Camnitzer. Also working in the department at that time was Judith Barry, the video and installation artist, who was later to introduce you to the Klagsburn Gallery in New York, and the African-American artist Houston Conwell. Also, just prior to my arrival, Luis had invited three artists from the new Cuban art, José Bedia, Flavio Garciandía and Ricardo Rodríguez Brey, to be artists in residence; and together with the Cuban critic, Gerardo Mosquera they had been staying with you in New York City (although I did not know it at the time).

The reason I am saying all this is to emphasise that you were a part of a multicultural network long before the age of multiculturalism. This multicultural network existed at the margins before the White art institutions discovered it.

Part of my job was to run the college gallery. And I went to Luis Camnitzer and I said, 'Well, there's one show I would like to do, and it would be on contemporary Native American artists'. I continued by explaining, 'I don't know what's going on here – occasionally I see work, but mostly I see craft work'. And of course in my naiveté, I would ask such questions as: 'Why don't we see Native American art? Why is this art not discussed?' I had seen some work in the American Indian Community House in New York, but it was a gallery that was obliged, for various reasons, to show contemporary work alongside silver work, bead work, and so on. The only other place I could see Native American art was in the Kenkaleba Gallery, on the southern margins of East Village. It was run by Corinne and Joe Overstreet, two African-Americans, and was the first truly multicultural gallery I had come across. I first saw your piece called 'On Loan from the Museum of the American Indian' here.

I decided to do this show, but came to the conclusion 'I cannot do this on my own; I need to work with a Native American artist. First we need to go to someone and ask if this is a feasible idea'. And Luis said, 'Well, you could go and ask Jimmie Durham'. He gave me your phone number, and I know what you thought when I rang – you thought, 'Goddamn, here's another liberal white woman. What are we going to do with this?' I think you only became interested in my proposition when I mentioned that at one point I had studied biology!

We did that show and another show, but we had incredible difficulty interesting the art establishment in New York in contemporary American Indian art. I recount this story in order to remind us of the types of connections that existed before the official age of multiculturalism: this was in the mid-80s, Indians were not fashionable – 'other' artists were not fashionable.

**Jimmie Durham**: Maybe I should recount a parallel history to the history you just spoke of. In 1980 I left the American Indian Movement where I had been working full time, with an idea to write a history of the movement, recounting a history of the Indian struggles in this century, putting it in a context that was not just the newspaper headlines of Wounded Knee, 1973. But because I had to work at difficult jobs as I was so desperate, I did not have the time to write the book . I had put the hopes of my history into the American Indian Movement, and it collapsed. Like a lot of people in the 60s, you put your life into something radical, it falls down, and then you are left floating nowhere.

I had time on my hands in the evenings, so I started doing some artwork again, which I had not done for a long, long time. I lived with a Brazilian woman, and she was more interested in the life in New York than I was. She saw the work of a Puerto Rican painter, Juan Sánchez, and came home and told me about the work and said how great it was. And I said fine. And then she met him a little while later, and he said he was doing a show called 'Beyond Aesthetics'. This was about 1981, I suppose. And she said,

'Oh, you should meet this guy I live with, because he's very beyond aesthetics'. He visited my studio which was just my tiny little bedroom, we became good friends, and he consequently put me in his show. I then met two artists whom I had already known in the 70s, when I first came to New York, but I did not know really know them as artists. They knew me as a political activist, who had perhaps been involved in art at one time, and I knew them as people working on a special project that we were working on together against the Bicentennial of the US.

In this show I made friends again with these people that I had met in 1976, and looked at my own work in a group show with those people, and said that I did not like what I was doing. I was painting collage-type things that were not bad, they were not objectionable, but they were very polemical. They were trying to be good, energetic art, but their main purpose, as I saw it, was to use that as an attention-getter to tell New Yorkers about our political situation on the reservations. And the response to my work in that show and the very next show that Juan curated which I was also in, was very good. Political art was on the strange little edge of things in New York, at a time when Leon Golub was first getting very well-known in New York.

It was in this context that my work was well received. And when I watched New Yorkers looking at it, I felt bad. They were appreciating the atrocities on the reservation I was describing in a New York gallery situation, even though the art was in galleries most New Yorkers did not go to – nevertheless it made me feel as if I was betraying my own thoughts in some way. I was using our suffering – and in one case a situation on the Rosebud Reservation – as entertainment for the art world. This practice did not make me feel radical at all, it made me feel very bad. So I stopped. The next show I did, which was maybe in 82, coincided with the beginning of people talking about the idea of post-modernism.

Over a long period I had been doing work with animal skulls in Geneva, before moving to New York. So I thought of how to enter the discourse of post-modernism which said 'anything goes, as long as it is not modernism'. My animal skull work did not fall within the history of modernism, so I thought I would continue producing the same kind of work in New York, and by doing so, there need not be a style called 'post-modernism'. At the time there really, truly was a style of post-modernism which included long, involved text, plastic, and stainless steel. It was a very *clean look*.

Meanwhile I was doing something with myself, with my history, with the animal skulls. I was trying to make them talk to the art world in New York – a little bit arrogantly because at the time I still did not know much about the art world in New York. I did not know where SoHo was until maybe 84.

I worked with a bunch of animal skulls and called the installation 'New York Day of the Dead Festival Store'. Every piece in the installation was like a trading post on an Indian reservation, and each was on sale for $5. They were very well-made little pieces – some not so little, according to what kind of skull it was. And then there were two texts. One text read: 'Good news for art lovers. Indian artists may die'. I was about to turn 44, the average lifespan for an Indian male, I was pretty sick and my life had been threatened on several reservations. 'Therefore, statistically, your investment of $5 could gain you more money later'. The other text was about giving things away, unlike the 'free lunch' of New York. In this installation politics was involved, but it was not as polemical, it was about circumventing or refusing any confrontation that could be cause for another individual's entertainment.

The response was horrible. Everybody wanted the pieces; and a couple of people came up – educated people, not people off the street – saying that they would buy several more pieces if I would make more on the quiet, all at the $5 price. They could not see that this was not an Indian being naive and that this had nothing to do with whatever might be the price of a piece. What I was attempting to communicate was taken at face value, when I was trying to be ridiculous.

That is how I kind of began my art life in New York City. I stayed there up until 86 or 87, with two shows that made me feel very bad and like I did not have a way to talk to the New York art world, because it did not have a way to see that I might talk to them, that I might be able to talk to them with my own voice. Soon after that you called . . .

**JF**: . . . with another idea about work being made by Native Americans that did not pander to the Indian art market. Could you say something about what the Indian art market consisted of?

**JD**: In the US there is a phenomenon called Western Art – cowboy paintings basically – but because the US loves its image of American Indians, Indians doing paintings of Indians was a sub-category, and still is a very strong sub-

It's Not Like Max Ernst At All,
*1993, mixed media, 137 x 58.4 x
89.6cm*

category, of this kind of art. Then little by little in the 60s, Indian objects which were part craft and part Western art began emerging. You could then, as you can now, travel to Santa Fe or Los Angeles and find a cow skull where the horns are kind of impregnated with plastic resin and inlaid with silver, the entire skull is beautifully covered with turquoise and coral. It is just that, nothing more, and the price is $35,000. And these really sell.

Paintings of Indians, which is what is known as Indian Art in the US, has a terrifically big market and the prices for these paintings are also horrendous. I could not imagine selling a work of art at one-third of the price that these things sell for. There are works which are copies of Fritz Scholder who started out saying he was part Indian, but once he became successful, admitted, 'Well, maybe not. But I wish I was'. Scholder claimed to have been inspired by Bacon, but his paintings were only like Bacon's paintings in that he did not use accepted colours and distorted bodies. The colours Scholder used were already seen as Indian colours: pink, magenta and turquoise. Now why are these understood as Indian colours? A typical Fritz Scholder painting is of a hugely fat, distorted body of some Indian chief, his face green and magenta, and the feathers of his headdress go off into being something else. This man has made millions of dollars.

**JF**: So you could call it a kind of Indian modernism which somehow connects with the fact that Whites in the early part of this century set up Indian art schools, right?

**JD**: Yes.

**JF**: A very similar thing happened in Africa, where the art schools set up by the Whites imported and taught European styles, but what they failed to do was import the tools for developing a discourse. Thereby a European style was somehow collapsed with an Indian motif or African motif, and that constituted a modernist painting. But that was not what we were after when we decided that it was a good idea to make shows of contemporary Indian art in 1986 and 87. We were after something that was discursive in some way, that understood the different cultural spaces in which the artist operated. I suppose because we stressed the role of linguistic practice it comes to be called 'postmodernism', but it also raises the question of what constitutes authentic Indian-ness and what

constitutes an inauthentic practice. Furthermore, it opens up the question of how we should talk about cultural practice in relation to people like José Bedia and Lothar Baumgarten. On the one hand there's José who comes from a very specific cultural context, drawing on very specific cultural formations, and then the work is going out into the European/American art world, and the question is: how do those symbolic formations travel, if at all? And then, on the other hand, Lothar Baumgarten who uses indigenous formations and puts them out into the market. I do not know what you feel about these kinds of usages and shifts. What could be understood of Indian conditions by looking at Lothar Baumgarten's work?

**JD**: When I first looked at a Baumgarten, he had done a show somewhere in New York about a group of Indians in Brazil whom he had just lived with for 18 months. The period was presented in New York as kind of 'having gone through hell to produce this work for New York'. And I was a little suspicious at the idea of spending 18 months in an Indian community as hardship. I see that it might be in a certain way, in a lot of ways, but not the kind of hardship that you could market, especially if you are an outsider who suffers on the cross, and then comes to New York and explains the desperate situation of these Indians – and in the process gains a reputation as being avant-garde for doing such a thing. The story of any Indian group in Brazil is a given, we already know the story, we read the National Geographic, and the only way the story might be edited or made into more than such a story would be for one of those Indians to do something. It seems obvious. And instead we have one more white man exposing the situation and making a profit from exposing the situation.

**JF**: There is a piece by Baumgarten in the Carnegie in Pittsburg, entitled 'The Tongue of the Cherokee' where each individual square of glass is sandblasted with a letter from the Cherokee Syllabary and set in a grid in the ceiling. This positioning of the letters between sky and ground, thereby detaching themselves from life, give the work a transcendent position. Now what that actually does, of course, is select and isolate letters that should be put together to make words and sentences. This is contrary to what you do with the Cherokee Syllabary. So on the one hand there is literally, from Baumgarten, a kind of fossilisation of this linguistic system, and on the other hand there is your own practice

Forbidden Things, *1993, mixed media, 226 x 144.1 x 82.2cm*

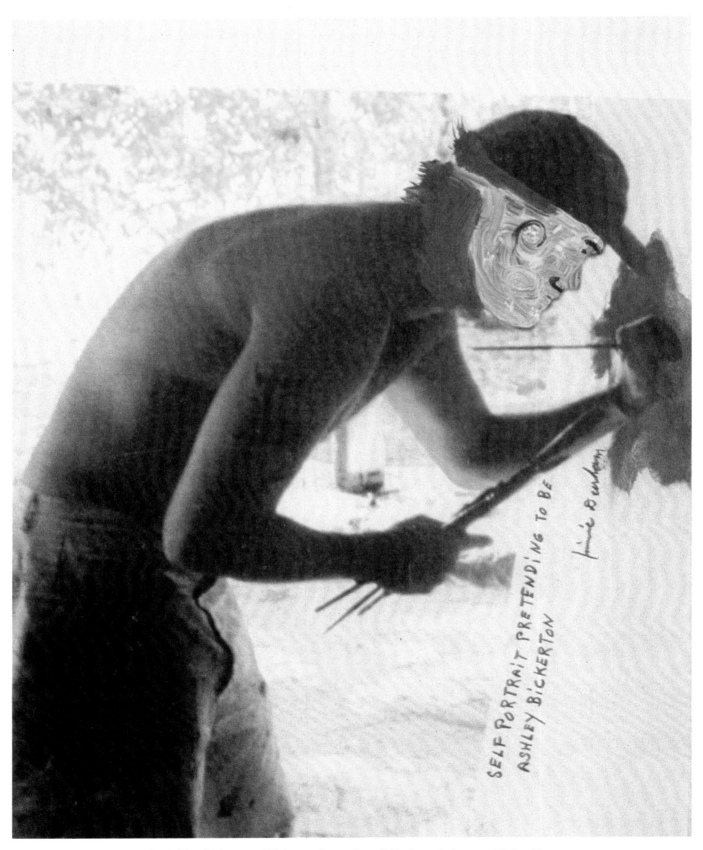

Self Portrait Pretending to be Ashley Bickerton, *1994, pencil, acrylic paint/colour photocopy, 51.4 x 42cm*

which attempts to keep it as a kind of living, ongoing thing. A similar response can also be found in the work of Edgar Heap of Birds, who also uses words relating to Indian life or Indian experience. And then Robert Houle in Canada is making a critical response to another installation that Baumgarten has done. Yet what happens? All these little gestures of dismay neither change the basic plot of the market nor determine who ultimately has the privileged voice.

Maybe we should talk a little bit about language, because you use it with great attentiveness. I do not want to suggest in any way that your work only circles around linguistic models, but there is an interesting aspect to this use of language that I think is attentive; it is possibly to do with the idea that the colonised know, or have to know, the language of the coloniser better than the latter themselves. This knowledge becomes a kind of protective strategy. But I also saw it in various Irish artists and writers who I was interested in, because I came across questions regarding colonialism in America, by way of having to engage with it in Ireland. Thinking about Irish writers, Joyce of course comes to mind, but prior to Joyce there was JM Synge – especially interesting is his play 'Playboy of the Western World'. There are two things about that play that interest me. One is that, on a thematic level, it seems to be about the fact that to deal with the political realities of the present, it is not appropriate to mythologise the past. That particular point has been taken up by two contemporary Irish artists: James Coleman and Willie Doherty, both in relation to what they see of the Anglo-Irish conflict as it is ongoing, and the way that, say, Irish nationalists are represented. So there is that thematic level. But the other is at a structural level. Synge seems to translate English by way of Celtic Irish, so there are recognisable English words, but the syntax is straight from the Celtic. These are parallel kinds of strategies to the ones that you use – there is a game with language, the parodying, which is not hybridity, it is not putting two things together and making a marriage; I would say it is more of a kind of resistance.

Parenthetically I may add as someone who was once a biologist, I have real problems with the term 'hybridity', and I wish we could find some other way of talking about this, not only in terms of context but also in terms of tactics. I mean, I am locked into the biologist's notion that hybridity signifies two essences that come together to make a third entity, so at the back of that term is always the notion of two originals, and I think that is the real snag with that term. It somehow still takes us back to essences. I think what we need to do is somehow accept Jimmie's essay 'The East London Coelacanth', and the absurdity of looking for origins. I think one can possibly use strategies or tactics that hybridise languages, but as a political tactic maybe.

The other much used term is 'syncretism', which maybe has more possibilities because it does not imply any essentialist kind of origin, but maybe implies a play, more a tactical play amongst various possible entities.

This might be a more appropriate term for your work because what you stress is that you have to learn the language of the coloniser, but for your own self-protection or respect there is a level of resistance as well. And maybe this is what the piece 'Caliban' is circling around as well. It is very much about who is owning the language and the status of representation.

**JD**: I do think a lot about language, and I have horrible memories of very strange little public schools in the US and being constantly insulted by teachers with a certain kind of insistence on how to speak correctly. Yet they themselves did not know how to speak correctly. I could see that they did not, I could see that as native English speakers (which I was not) they did not have the command of their language because they did not know how to play with it, how to be flexible with it, how to speak English; nevertheless they insulted me by using English as a weapon against me. So at an early age I began thinking about language, miscommunication, and the possibilities of translating from one language to another. Someone asked me tonight what a certain Cherokee word meant that I had written, and as usual, I replied, 'It doesn't mean anything in English; you can't say this in English'. And then, at other times someone says, 'Say some Cherokee'. And I always make the mistake in thinking they want what they say they want, they want to hear the sound of this language. Actually what they want is the performance of someone speaking Indian. So when I try to get them to say the words back, to enter into making these sounds, they really will not do it – especially an English language speaker. English is such a literal language; it is about reading the words, so that it is hard for English speakers to say a word in another language. You do not hear it as much as you see it. And to speak another language, I think you have to enter into it physically. You have to enter into it with your mouth, with your ears, and then you can learn it without

ABOVE: Untitled, 1992, wood, plastic, acrylic paint, leather, 304.8cm

51

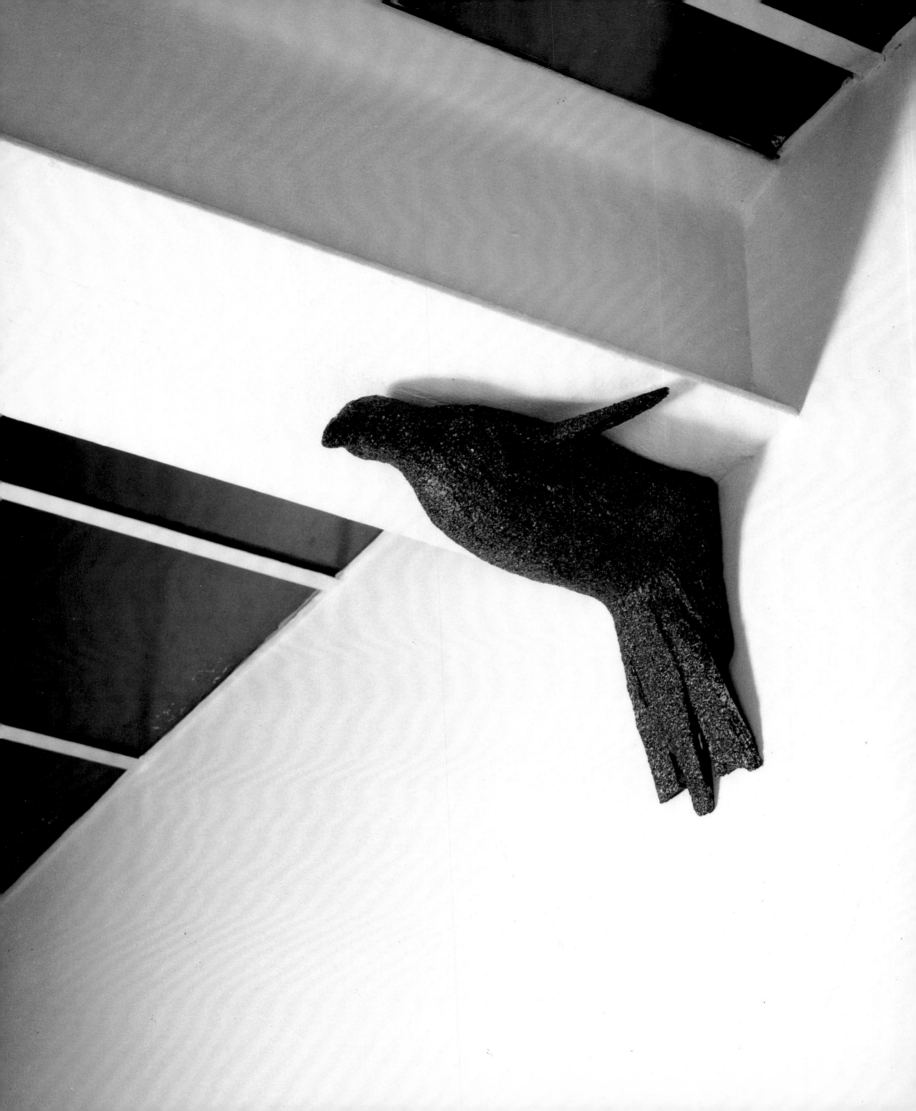

matching it up to the word in your own language. I learned English that way; I did not learn it by translating, I learned it pretty much the same way you learned it as children, by entering it.

Then there is the constant use of a foreign language as a weapon, insofar that it is a language which appears not quite real, complex and so painful; and at the same time, there is the possibility to play with it, to change it a little.

**JF**: That has led, though, to various misinterpretations of your work . . .

**JD**: Almost always.

**JF**: The use of English in your work is very ironic – this is one of the tropes that it uses – but very often the play, the parody and the irony is somehow missed, which is very curious, because the work is very direct and you would think it is very obvious, but at the same time it is not at all. I do not know whether you have read an essay by Houston Baker on Caliban. He talks about the figure in terms of the African 'other', and of course Baker picks up on the Shakespeare's line 'You taught me language, and now I know how to curse'. I think this is interesting in relation to your Caliban, because in your piece you are attacking the notion of opposites as some kind of absurdity which is the way the European philosophical tradition has tended to polarise everything into opposites. Houston Baker also picks up on Caliban in a similar kind of way, stating that Caliban knows exactly where he is, the position he has been put in, where he is from. He also knows that he has to play a game. So what he does is set up what Baker calls a 'triple play', a third space which is a kind of masquerade. Now you are sort of playing in that space too, aren't you? For example, with the self-portrait piece, and also in 'On Loan from the Museum of the American Indian', what you present is no truth about the condition of the Indian, just as the self-portrait is not you. In a funny way it is a reflection of what the White world thinks you are. Meanwhile, you are kind of playing behind that.

**JD**: I love 'Caliban' because he is written by Shakespeare, by an Englishman, and he still convinces the world. This is partly because Shakespeare was a good writer, but being a good writer does not mean that he could write Caliban well; it means something else about the language of describing the savage. He made a savage that really at the time was too absurd. I think he exaggerated even at the time. And therefore he made a believable savage, in some strange way. He made a savage that was like a little mean English boy, or rather like the English fiction of a mean little boy at the same time. This was a completely absurdist exaggeration. So to have a believable fictional character, that then became a model for other fictional savages in the history of literature (and not only in English) is too good to pass up. I have to be his brother.

**Audience**: Do you have any really strong feelings about the political correctness or incorrectness of the word 'Indian' as opposed to 'Native American' or something?

**JD**: We talked about it a lot in the 70s. On the reservations we still say 'Indian' when we speak in English, because it is the word they taught us a long time ago, and it does not have a meaning. But 'Native American' has no meaning. None of the words would have a meaning. And the problem is that we cannot be called 'Americans'. That is the trouble. The same with the Australians: they have to be called the 'Australian Aboriginals'. Whereas if you are from Africa you can be called 'the Africans'. So any word has to be an incorrect word, any word has to be an excuse to cover a lie. But the Americas are two great big continents; and this century we have tried to think of ourselves as Indians as a political tactic. It begins to work in certain ways, but in general it does not. The distance from the Mohawks around Niagara Falls to somebody out in the southwest is greater than the distance between Ireland and Yugoslavia. And I might say the Irish and Serbs are all Europeans, but there has to be specificity and not generality. So, in the 70s the Black Panthers were calling themselves 'Bloods', and we were kind of jealous, so started calling ourselves 'Skins' (short for 'Redskins') which was also a kind of funniness, because instead of blood we are skin – we are not the Redskins, just Skin, and we were doing it consciously, funnily, but we did it all the same. We called each other that as a way of avoiding words such as 'Indian' or 'Native American' or any of those unacceptable words.

**Audience**: What about the proper names?

**JD**: We are Cherokees, Creeks, Choctaws and Chicasaws. We met Europeans a long time ago, more than 400 years ago. We lived in the Southeast of the US: Georgia, Tennessee, Virginia, the Carolinas. Great waves of poor white

Corbel, *1994, papermaché, paint*

53

trash, as they were still called in the South, came as indentured servants or as just very poor people who were not part of a society here. They were workers, and they were in situations very close to slavery in the early days of the southeast of the US. Others were in the position of being poor adventurers. Those two types of people just left the White society in the colonies and started living with us, and became members of our nations. And this is hard for people to look at, because one wants to think of a history of American Indians, but there is none. There is a history of the Cherokee Nation, a history of the Sioux Nation, of the Navajo Nation and these are not the same histories. One of the Creeks' most famous militant chiefs, who fought and fought and fought, was named Chief McIntosh, and the pictures of him are of a Scottish-looking guy, with the kind of hat Scottish soldiers wore in World War II – it is not a beret exactly, but a . . .

**Audience**: . . . glengarry hat?

**JD**: I do not know, but it is a very Scottish-looking hat. That is what he wore, with a very big feather in it. His ancestors had been Scottish, and he was named McIntosh because his Scottish ancestors were so named. But he was not Scottish, he was a Creek, because he was born in the Creek Nation; the Creek language was his only language. And we from the southeast have that history. On top of that we have the history of Africans who as slaves had escaped and come to us, and had consequently become Cherokees or Creeks. So when they moved us all to Oklahoma, they accused the Creeks of being half-African, the Seminoles of being Africans and not really Indians, and our chief, who at the time was named John Ross and looks like a Scottish burgermeister of the 1820s, of being a kind of not-right-in-the-head Scots person, even though he was not Scottish. His grandfather was a Scottish trader, who himself became Cherokee.

Then when you get to the plains, this is where the names become outlandish. Most of the plains Indians were defeated in a 25-30 year period of intense warfare on the plains; the US army conquered one tribe after another, all in a quick time-span, and it was a pretty strong defeat for each of the plains nations. At the time of their defeat, their real defeat, each nation was given a set of last names by the US Army, and the last names were the first names of that generation that had been defeated; hence you have the family American Horse, named after the chief American Horse. American Horse's father was not named American Horse, but his son is named American Horse. So the Indian names that we love, that sound so Indian, the last names, are names to remind us that our history stopped and started in 1868, or 1875, or 1898. Our history stopped and started then. Our last names are the name of this chief who was defeated. That is the weapon that is used against us, not the English names that we can come by. The Sioux also have very many French last names which they were given in the same way, by traders who often were fur traders, fur trappers, who were often from Haiti, from Martinique, from the Caribbean, who were African-French themselves, not very French French. They became Sioux, or Black Feet, and then those French names remained, pronounced as though they were English names today.

**Audience**: May I ask a question about the work? It is the second time I have seen parts of this show. I have seen it in Brussels in the Palais de Beaux Arts. In that institution, which is very classical, I suppose the feeling of westerness, as a context, is abundant, but it is so here as well. And just picking up a couple of things, and one thing that you said, Jean, at one point to Jimmie, was that Jimmie was really playing with representations with a Western projection, an expectation of what an Indian is supposed to provide, and your scrambling of all kinds of possibilities. But if the representation is a screen which Jimmie is kind of playing behind, is there something that is very much behind, something untranslatable, like the Cherokee word that you were mentioning?

**JD**: I think about that often, but I never have a real answer, even to myself. There is an obvious answer, that you cannot be who you are, and you cannot really deny your history because it is who you are. I can think of myself as a very long person, if time were linear and if it stretched back behind me. I am almost 54 years long, and I stretch back through time for 54 years. At the same time, it does not have the kind of importance that we like to think it does. There is the very same problem with any communication, because every two people are so separate. We hope we will communicate, whilst in fact we almost never do. And when we do communicate, we communicate through the complicity of love more than through actual words; through the complicity of hope. We communicate by carefully, even though unconsciously, watching each other's intentions as we speak, watching each

other's eyes, facial movements, and so on. And you know very well that that is the case if you are trying to pick up some person that you are momentarily in love with, if you are trying to snag a mate for the evening or for whatever, just for that time. The two of you are sizing each other up, and you are desperately trying to communicate, you are desperately trying to hide the communication that you do not want to communicate, and that is exactly what the first person is watching. [*Laughter*]. And you see that person watching that, and so you try to fix it, and you watch that person trying to fix it on his or her part. And some communication happens in spite of the communication. So it is like we are all in that general predicament of individuals who are social beings and cannot get away from it. We want to be social beings, therefore, and we are not very social beings. So it is a funny kind of contradiction that is always doing that.

You cannot easily make something that is useful to someone else, I think, without a certain lack of tactic at the time that you are making it. As you make it, I think you would have to put away social tactics, social ambition, that you would have gathered up as part of your tools for making the thing. But as you make it, you kind of have to rely on this very long self that you have; otherwise the world would not have any use for what you made. Just like if you say something, the world cannot use it unless it is actually you saying it.

**Note**

1 The opening of Jimmie Durham's exhibition at the Institute of Contemporary Art, London, in December 1993 presented the opportunity for an interview between Jean Fisher and Jimmie Durham. This text was edited by Nikos Papastergiadis.

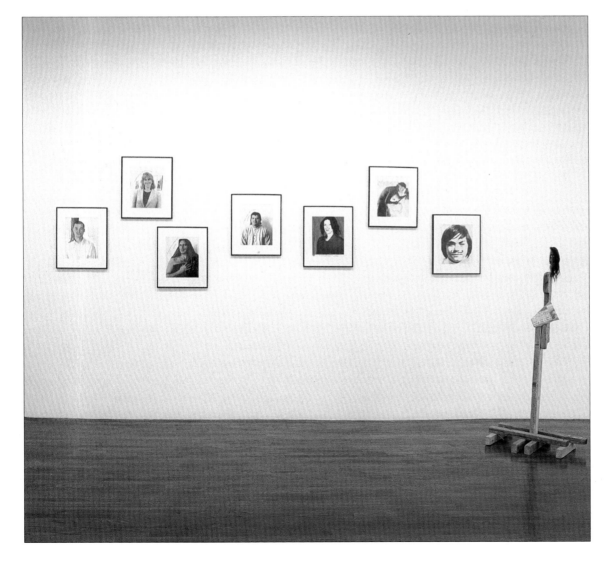

*'Ashley Bickerton, Jimmie Durham, Walton Ford, Jeff Wall', Nicole Klagsburn Gallery, New York, October 15 - November 12, 1994. Jimmie Durham's installation view.*

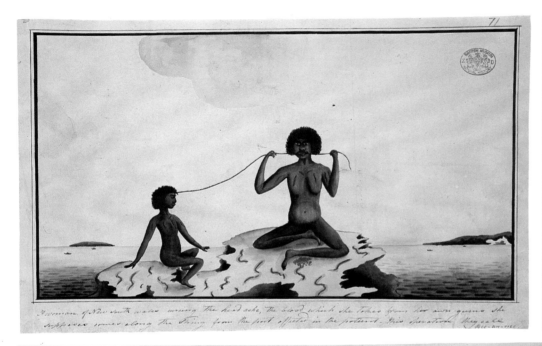

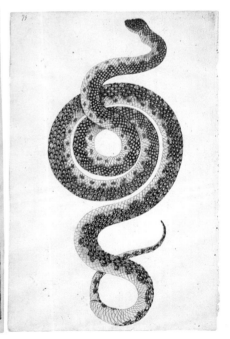

*ABOVE FROM L to R: Port Jackson Painter*, A Woman of New South Wales curing the headache. The blood which she takes from her own gums she supposes comes along the string from the part affected in the patient. This operation they call Bee-an-nee, *Watling Drawing 62, ink, watercolour, 21.7 x 34.6cm; George Raper*, Gum-plant and Kangaroo of New Holland, *1789, Raper Drawing No 56, ink, watercolour, 32.5 x 46.7cm; George Raper*, View of the Entrance into the Harbour of Port Jackson – taken in a boat under the North head, *Watling Drawing 8, ink, watercolour, 32.4 x 49.4cm; Port Jackson Painter*, Diamond Python, *Col 40, ink, watercolour*

# ENCOUNTERS

*Paul Carter*

When in December 1788 Arabanoo was captured – 'fastened by ropes to the thwarts of the boat' – in order to acquire enough English to act as a go-between in the Sydney Cove colonists' dealings with the Eora, Phillip and co had no sooner shaved and washed the man than they invited him to inspect certain pictures: a handsome print of Her Royal Highness and plates 'of birds and beasts', inviting him to gloss them, and say what they signified in his language.[1]

Choosing 'captions' for Fleeting Encounters, this episode came back to me. Captions may be excerpts – in this case drawn mainly from the First Fleet's journals, despatches, letters and miscellaneous manuscripts – but, unlike the quotation which, in Mandelstam's memorable phrase, 'is a cicada. Its natural state that of unceasing sound',[2] a caption has the effect of arresting our curiosity. Quotations stand out in the texts where they are found, disturbing the flow and liberating the imagination. Captions are selected for the opposite reason: to neutralise the disturbing uniqueness of the image, to assimilate it to the order of the ordinary. Captions suppose a seamless harmony between the visual and the verbal records; quotations, like the cicada's intrusive stridulations, unstitch this illusion, insisting on a history of provisional impressions, 'unceasing sounds' – what we might call the noise of history.

To provide the Port Jackson paintings with captions that glossed what they represented would be to give the impression that the 'artists' were indeed highly trained artists who knew what they were doing and had surrounded themselves with an impressively picturesque silence. It would be to imply that they understood the reason of the phenomena they depicted – that the face of the landscape, its streaked waters, indistinct foliages and ground patterns no longer hovered before their eyes in barred lines – that they had an adequate conceptual language to hand. The mutual reinforcement of image and text appears to prove this. In reality it merely proves that the capturing of coastlines, coves and canoes within a two-dimensional frame and the naming of these appearances in terms other

than their own were twinned processes, the offspring of the larger conceptual enclosure act which lent colonisation its rhetorical legitimacy.

To capture Arabanoo, or his longer-lived successors Bennelong and Coleby, was to train a translator – a two-way process, one might think, but the authorities understood it one-sidedly, defining the aim as 'to teach [him] enough of our language without the dangers of losing any part of his own' to render him serviceable.[3] Teaching them a grammatically regular tongue was a business analogous to clearing the ground of irregular encumbrances and enclosing it within a continuous picture frame of rectilinear roads. Trained as machines for the production of captions, as means of transporting meanings from one place to another, Arabanoo and his kin were to smooth the path of progress.

To possess the Eora by physical force was to treat them as the English did their own convicts, but to have their men, women and even children translate white words and actions into their own languages – to provide invasion with a locally acceptable gloss – was to conquer them rhetorically as well. Explaining the inexplicable, providing 'captions' that rationalised the newcomers' behaviour, the native informants were in danger of colonising themselves. If the meaning of colonisation could be captured in the local tongue, it meant that residual slippages of sense – those feelings of outrage that the colonists seemed to have no words for – must have a clinical, not political significance, symptoms of a childish attachment to the pre-rational.

The go-betweens understood their position differently. To enter the colonists' world-view, with its Newtonian logic of historical forces, their collisions and consequences, and not to be subordinated to it, it was necessary to be mentally as well as physically nimble: not to hold a mirror up to nature but a flattering looking-glass to the white man's expectations. Arabanoo did not hesitate to please his violent captors, identifying 'the elephant, rhinoceros, and several others'.[4] Did this make him an unreliable witness? Not at all. It merely meant that, like the famous Malinche, whose mediation between Cortes and

the subject peoples of the Aztecs sought to open a path for a less bloody encounter, Arabanoo intended to initiate an exchange that was 'open', like a dialogue, not closed, not pre-ordained by one party's obsession with the logic of captions.

Perhaps alone among the First Fleeters William Dawes grasped that a linguistic accommodation could not be achieved simply by writing speech sounds down and subordinating them to the hierarchically-conceived grid of a classical grammar. It must arise from a continuing, intimate dialogue, where an equality in difference facilitated an evolving feed-back process capable of keeping the situation fluid, of preventing it hardening into mutually incomprehensible definitions bound to breed fear and suspicion. Like Dawes, Arabanoo, not to mention Dawes' own informants, did not want to close down the future. Keeping ambiguities in circulation, they wanted to put off history's collapse into a heap of captions whose pseudoauthority depended on their unsettling resemblance to the last words of headstone epitaphs.

Octavio Paz reports that the Mexicans have reviled Malinche for her openness: standing in-between she has pleased neither colonial nor postcolonial nationalists.[5] The English colonists viewed the efforts of Bennelong and Coleby to ground what was happening differently with equal suspicion: because it meant breaking those continuous lines of hierarchically-forged command that defined the colonists' social identity, it meant allowing the locals to slip in and out of the picture (and the picture frame), 'promiscuously' (a term the colonists applied equally to Australian nature, the Eora's grammar and their morals) mingling with the as yet unrepresentable (because unenclosed) environment. It entailed imagining communication in terms of a distribution of voices and viewpoints that no furrow in the dirt could adequately define.

There is every evidence that Bennelong, say, wanted to draw Phillip into a relationship that would bind him without manacles to his place: to call him 'Be-anna', to seek to have his wife give birth at Government House were means of blurring the distance – not least the distance on which the false-clarity of the Europeans' hilltop views and shipboard panoramas depended.

These seamen and soldiers, surveyors to a man, wanted to see clearly; they faced instead the nimbly tactical appearances and disappearances of Bennelong and Coleby, as they orchestrated resistance between Botany Bay and Manly. And, unable to pin them down and caption them – to make them keep their identifiable clothes

on, say – the masters of monocles (telescopes, looking glasses) grew angry. At length even the 'humane' Phillip gave way, and, in a *reductio ad absurdum* of the logic of captions, ordered a military expedition out, furnished with hatchets and bags 'to cut off, and bring in the heads of the slain'. Thus was the short-cut of metonymy turned into the frontispiece of murder.

But except within the enclosure of the Sydney Cove settlement, the historical space refused to quieten down; it went on buzzing.[7] The oddly depressive works of Roper and the unnamed Port Jackson painters do not capture the scene by orchestrating it picturesquely – drowning out the dissident cicadas with chamber-music, say. They remain vulnerable, attentive, as if listening as much as seeing; seeing very little clearly unless in isolation from its surroundings. The connections of those weapons, those birds and markings with the ground – with the sounds they make singing, flying, playing – eludes them. These open-ended, curiously provisional watercolours are, after all, not captions so much as quotations, representing (if they represent anything) what the European eye cannot as yet enclose and possess.

Especially exhibited on the physical site of the first government house, the meaning of the paintings on show can be perceived to lie as much outside as inside the frame – in their lack of eloquence, in the sense they give that the environment is filled with 'noise', with visual and emotional stimuli that hover like spots before the eye. Refusing to quieten down, they draw our attention to our own unfinished business, and the prematurity of certain lines (certain designs) we have made on the ground. In this reluctance to foreclose on the future the mimic-pointillism, the topographical naif of the Port Jackson painters are cognate with the literary materials that converge on them so remarkably.

Collectively, by refusing to project a viewpoint other than their own, the First Fleet annalists open a dialogue with one another that leaves room for other views. They subtly mist over the monocular gaze of authority. Individually, too, as open-ended narratives continually reassessing first impressions, and pursuing bending paths that diverge as well as converge, they refuse history's mealy-mouthed linearism. Replete with casually surreal details, making their subject-matter the disjunction between conception and perception, gathering the fascination of portents, they more resemble journeys.

This is the double-context of the passages selected: the editorial tact of captions is (in most

exhibition contexts) like the act of physical capture and linguistic press-ganging that begins the subordination of the colonised – in fact, defines them as colonised. There is no point in recapitulating this process. Secondly, more importantly, to do so would be to misrepresent the character of the paintings on show – and of the literary materials that form their verbal matrix. Although inescapably implicated in the history of colonisation, they evoke a history that is occasional; that, by stubbornly preserving partial points of view, does not exclude what might be called the spaces in-between.

These spaces in-between – Watling alludes to one visual incarnation of them in the form of an absence of 'that beauty which arises from happy-opposed off-scapes' – do not lie outside history. They are inscribed with what Watling calls 'phaenomena'[8]; it is simply that these cannot be translated, removed from their time and place without their significance collapsing. It is the same perhaps with the selection and arrangement of these captions: occupying the blank spaces in-between paintings, they may suggest hidden resonances, the cicada-noise of quotations. The white walls are, after all, never white.

Nor, if it comes to that, were the sheets of laid paper, used by the Port Jackson painters. Age may have subtly mottled them, adding 'phaenomena' not originally there, but the physical properties that made them useful to the watercolourist meant that from the beginning brush marks, and even inked lines, fattened and bled. The creamy, loosely textured, sometimes mildly corrugated sheets were not blank surfaces but potential landscapes. They could not foresee the outlines of coasts, or the straightness of flagposts that might be scored into them, but they certainly harboured cloudforms, the 'blots' of bushes and reflected shadows.

This sense watercolour gives of composing itself – analogous to the art of macchiare, the Venetian technique of painting in oils – assumes a particular significance in our context. Art historians interested in establishing the identity (or identities) of the Port Jackson Painter have naturally focused on those aspects of brushwork and draughtsmanship that suggest individual identity; artistic merit attributed to the paintings has often been linked to the evidence they give of a self-conscious artistic personality. But this attention to stylistic signature may have obscured the significance of the mottled, flecked passages in-between – the landscapes, anatomy, or feathered/furred creatures – that are least pondered, least imprisoned within bounding lines.

The scudding, fishlike dabs that animate the sea, the wormlike fissures that squirm up the inclined plane where a woman cures 'the headache'; the flamboyant chiaroscuro of cliffs in the neighbourhood of Port Jackson; the repertoire of coloured 'macchie' or ground clouds employed to lend Sydney Cove a semblance of physical relief – it is true that these passages may provide clues to artistic identity. But this is not their importance. In a sense their value lies in their impersonality, in their minimalism, their abstraction.

If the dreamlike clarity of Raper's *Kangaroo of New Holland*, the obsessional sharpness of the adjacent Xanthorrhoea (as if the artist wanted to arrest its metamorphosis into an invisible spear) evince a self-conscious desire to capture an impression, to neutralise its disturbing strangeness, his reduction of the ground to a pallid wash of indeterminate extent, vegetation, texture and relief is equally telling. No significant connection is made between them and their environment. On the contrary, their subordination to the linear conventions of representation seems to depend on admitting that the remainder of space defies visual enclosure.

The broken lines, the dabs, the flecks, and the capacity of the coloured washes themselves to bleed across boundaries are, I would suggest, analogous to the noise of colonisation, that other history that will not settle down and be quiet. The nervous squiggles, suggesting the pain of straight lines cut in half, or the teeming shoals of darkly glittering waves, or even the 'dot and circle' mode of the diamond python seem to mimic physically the sensation of being in an environment where nothing can be kept out because nothing as yet has been enclosed – where scintillations of light burst on the pupil, and meeting no resistance, go on jabbing there, multiplying themselves like pixels on a screen.

Our artists were not students of these subliminal matters, but the calligraphic gesturalism of these in-between passages – as if the artists were improvising a kind of visual writing that disclosed mimetically the unceasing sound – may be the more interesting for being involuntary.

The medium of watercolour may have been sympathetic to 'seeing through' the linearism associated with imperial history's logic of causes and effects and its handmaiden, the majestically bounding line of representation, but it was the occasion of cross-cultural encounter that irresistibly showed the artificiality of these boundaries, the necessity to acknowledge a ground that could not be translated into linear enclosures.

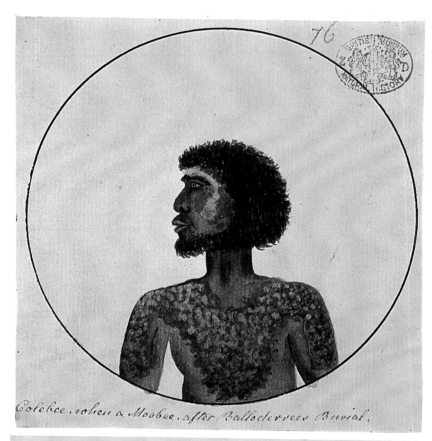

Colebee when a Moobee after Balloderrees Burial.

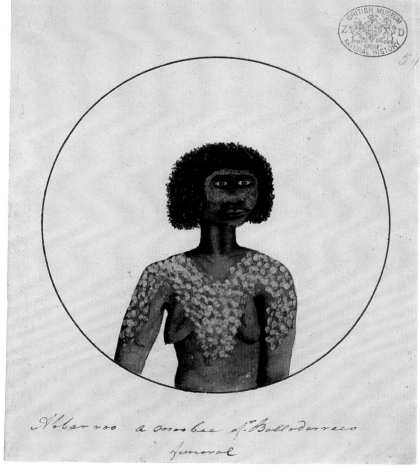

Nbarroo a moobee of Balloderrees funeral

It is not a question of saying that the Port Jackson painters imitated Eora iconography or body painting techniques – even if the historical literature has paid too little attention to the fact that the mimicry of Eora and European was mutual – and mutually esteemed as keeping open pathways of peaceful, even playful, exchange. But there is little doubt that some hybridisation of style occurred. Abaroo or Coleby's milky way of white dabs may be one of the earliest instances of artistic plagiarism recorded here, but it carries over imaginatively into the same artist's treatment of speckled water or vigorously emu-plumed foliage or his almost totemistic response to the gum tree.

More subtly, the Europeans' preoccupation with Aboriginal weapons, and their susceptibility for seeing their metamorphosed forms or preliminary outlines everywhere is not simply scientific or military: it is an admittedly self-interested curiosity about a culture that expresses itself most characteristically through a class of objects that defies the eye and commands the ground by 'jabbing' at the animated beings that occasionally, and swiftly, make passage across it. It is in the broadest sense a poetic interest.

To frame a telescopic tondo with Aboriginal weapons that in turn frames an Aborigine carrying a slender weapon, is to dramatise this double vision most eloquently. Just as Arabanoo was invited to frame himself, so is the fisherman isolated and picturesquely classified. But it is acknowledged that other, more mobile perceptions of space exist which the monocle's fixed and glassy eye cannot enclose, ways of seeing that, to judge from the care with which the 'musical instruments' are reproduced, suggest some affinity is felt for a people who, unacquainted with 18th-century opera's melodic lines, its musical picturesque, cultivated the staccato of dotted rhythms.

Recognition that the inventory of native figures, indigenous fauna and flora and navigationally useful coastlines presupposed another environment – one that was open, mobile and fleeting – stemmed not only from the encounter with the Eora: it also had a geographical dimension. In the paintings of the Port Jackson painters, the decisive outlines of objects represented alternate with passages of oceanic indefiniteness. 'What we saw first', reported Collins, 'was the southwest cape of New Holland', but his previous sentence gives a different impression: 'A thick haze hanging over the land, few observations could be made of it' – a fact prefiguring perhaps the oddly edgeless cloud that spreads listlessly over so many of these painters' antipodean views.[9]

But an attention to the provisionality of outlines was not simply, say, evidence of the emergence of a newly romantic geographical sensibility[10]: it grew in part from the distinctive character of the local coastal topography, and from the mixed motives of the men coasting it for the first time. The safe passages that captains of sailing vessels looked for occurred where the sea decisively enclosed and confined the land: their beau ideal of a good anchorage was the kind of semi-circular bay exemplified by Port Hunter, Duke of York Island, conveniently located en route between Sydney Cove and Batavia. But now, as colonists bent on settlement, they appraised the coast with a different motive – not to keep safely in parallel with it, but to locate those openings where the continuous line was breached. The object of the survey was less to enclose a landmass or a body of water than to disclose their open-ended intercourse.

So the 'bay' of Botany Bay, useful to passage migrants, was superseded by a geographical form more adapted to permanent settlement – the 'cove' of Sydney Cove. But terms like 'cove' and 'harbour' are revealing. They miniaturise and domesticate a proliferating array of water passages, assimilating them to a Euclidean figure, treating them as a compilation of arcs, when in fact the fernlike fingers of Sydney Harbour's many arms suggest the alinear logic of fractals.

Less exotically, the local economy of water and land baffled the Europeans because it refused to conform to their expectation of a decisive division: the New South Wales coastline is a double coastline, its 'outer' coast ghosted by an 'inner' coast of lagoons, meandering tidal estuaries and selfdraining lakes. The people who disappeared off the beach into the 'woods' did not retreat into a primitively undifferentiated interior: they continued moving along one of the many coasts which, alternating with snakes of water, made pathways as far as one could see or imagine.

Perhaps the colonists who complained of a country where streams and rivulets sank into the ground also sensed in such paradoxes a solution to their own divisions – a resolution of the tension between the authoritarian imperative to enclose and subdue and the more rebellious desire to disclose, to yield to the changing appearance of things. In any case it is hard not to believe that the Port Jackson Painter's laconically but respectfully understated depiction of Eora everyday life contained an element of envy;

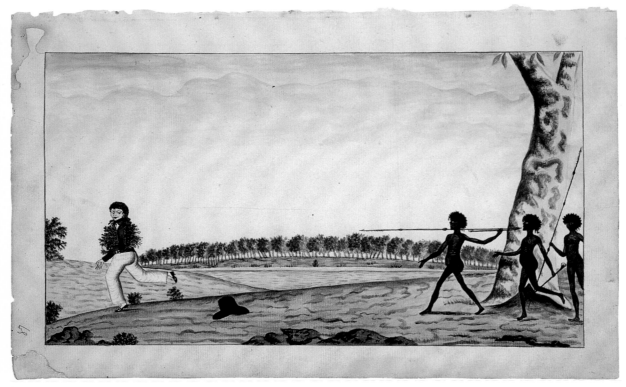

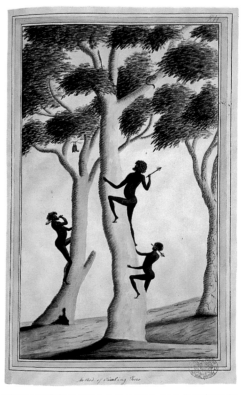

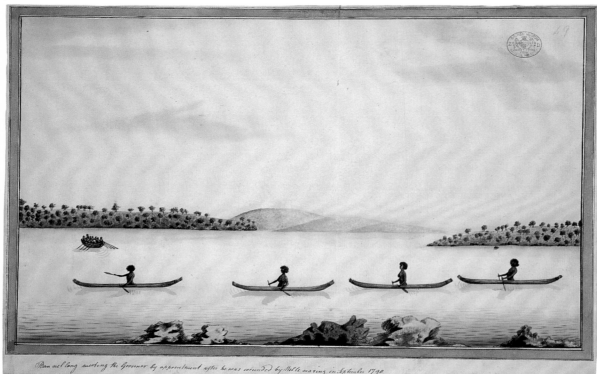

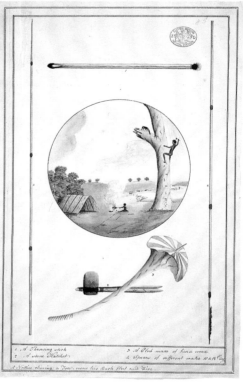

*ABOVE FROM LEFT to RIGHT: Port Jackson Painter, Painting depicts three natives attacking a sailor, Col 44, watercolour, 20.5 x 31.8cm; Port Jackson Painter, Method of Climbing Trees, Watling Drawing No 75, watercolour, 31.6 x 19cm; Port Jackson Painter, Ban.nel.lang meeting the Govenor by appointment after he was wounded by Walle Maring in September 1790, Watling Drawing No 40, watercolour, 26.3 x 40.5cm; Port Jackson Painter, A Native climbing a Tree near his Bark Hut and Fire (1. A throwing stick; 2. A stone hatchet; 3. A club made of hardwood; 4. Spears of different make, 10 to 12 feet long) Watling Drawing No 76, ink, watercolour, 34.5 x 21.8cm*

*All images included in this essay are courtesy of The Natural History Museum Picture Library, London.*

as if the Eora's ability to compose themselves without aid of picturesque props fascinated him.

The naiveté of the Port Jackson painters' compositions has baffled art historians interested in establishing their lines of descent and captioning them uniquely, and they have often disparaged their simplicities as proof that the artists were ill-equipped to represent what they saw. But what they saw, perhaps, was the impossibility of captioning the scene, of translating it smoothly into picturesque divisions of near and far. What they glimpsed instead, albeit fleetingly, was a different art or way of life.

It is hard to believe that the equilibrium of the four canoes depicted in *Ban.nel.lang meeting the Governor* is accidental. The artist, capable of expressing their elastic motion, of intuiting their minor science of gaps, may not have been a great draughtsman, but he was a musician, a student of intervals; and what is more, one still able to hear the 'unceasing sound' of an environment that had not quietened down. Across the water a rowing boat approaches, apparently spiderlike on stalks, its crew crowded together: how can we avoid comparing this forced confusion with the stately serenity of the canoeists, and drawing the conclusion that the painter intended a significant contrast?

**Notes**

1 Watkin Tench, *Sydney's First Four Years*, Sydney, 1979, p140.

2 Quoted in my 'Post-Colonial Collage' in *Living In A New Country*, London, 1992, p187.

3 John Hunter, *An Historical Journal of the Transactions at Port Jackson and Norfolk Island*, London, 1793 (reprinted Adelaide, 1968), p166.

4 *op cit*, Watkin Tench.

5 Octavio Paz, *The Labyrinth of Solitude*, London, 1971, p77.

6 *op cit*, Watkin Tench, p208.

7 In the postscript of *A Narrative of the Expedition to Botany Bay*, written in October 1788 Tench lamented, 'In Port Jackson all is quiet and stupid as could be wished' (p79). Part of this depression stemmed from the colonists' inability to make contact with the Eora.

8 Thomas Watling, *Letters from an Exile at Botany-Bay*, 1794 (reprinted Sydney, 1945), pp24-25.

9 David Collins, *Account of the English Colony in New South Wales*, 1798 and 1802 (reprint Sydney, 1975), vol1, pxxxvii.

10 In my *The Road to Botany Bay* the point is made that Matthew Flinders' attention to fleeting atmospheric phenomena distinguishes him from his mentor James Cook, and is associated with a redefinition of the scope and conditions of geographical knowledge.

# A HOUSE DESIGNED BY LE CORBUSIER

*John Berger*

André is waiting to leave his house in the Paris suburb of Boulogne-Billancourt. He has always carried this house around in his head as an image of home; and for the last 25 years he has actually lived in it. The house, however, belongs to somebody else, a question of American lawyers.

'Another Etán!' André declares, 'perhaps the last, my one-hundred-and-twenty-fourth!' *Etán* means 'transfer' in Russian. It was the word prisoners used in the Goulag when they were moved from one camp to another. Transfers were what the zeks dreaded most, yet they were frequent. The unknown seemed more threatening than the known, even when the latter was intolerable. The body, already exhausted, often found it hard to adapt to different conditions. And with each transfer the little sticks of one's identity were scattered or broken and had to be reassembled or mended.

At first André resisted the notice to quit the house in Boulogne-Billancourt and barricaded himself in. Near the heavy metal gate, which leads on to the street, he kept a short-handled Russian spade. With an instrument like this, he said, 'I've seen quite a few beheaded'.

For years he resisted. Then he changed his mind. Today he reckons that if they find him there when they come, they will destroy everything they can lay their hands on out of spite. None of it is worth selling. You could get nothing for it, he says, but to me these bits and pieces are eloquent. He winks with one of his astute almond-shaped eyes.

A removal needs to be planned like an escape, he insists, no detail, however small, is unimportant. Every day he packs papers, bits of cloth, books, drawings, letters, newspaper cuttings, spare parts of God knows what, a plastic bottle for olive oil in the form of a Greek vase which once amused his mother – into cardboard boxes which he numbers. Like this he hopes to escape with everything before the transfer. Previously he escaped eight times. And this was a fabulous record in Kolyma. From Boulogne-Billancourt it will be the ninth time. Once on the other side of the wire, he says, it is not tourism you think about! He will be moving into a single room, measuring 5 x 3 metres, on a fifth floor.

The house he has to leave was designed by Le Corbusier in 1923 for Berthe, André's mother and his stepfather, a sculptor. With its studio wall of murky glass and the crumbling concrete of its flat roof, it looks today more like an abandoned garage from which the petrol pumps were long since taken away! Nevertheless, it is a question of American lawyers.

There is a double portrait of André's mother and stepfather painted by Modigliani in 1917: Berthe, who came from Moscow is on the right and Jacques Lipchitz on the left. Sometimes I think I can see in the placing of Berthe's almond eyes a certain resemblance to André. A stranger judging by appearances could mistake André for a Renault salesman who retired last year. At 78 he is remarkably spry, wiry and young for his age.

Inside the house there is a spiral staircase leading to the living quarters. The first room which leads off it is a bedroom, made to measure for André when he was a boy. Over the bed now hangs a painting which depicts a steppenwolf in the snow. My portrait, jokes André, nodding towards the wolf.

So it is my last transfer and it makes me think of my first. Before I knew what transfers meant. I was 14. I caught the train from the Gare de Nord, accompanied by Lounatcharski, the People's Minister of Education! Mother had arranged this. When the train was leaving Berlin, the Minister's mistress suddenly remembered she had not bought all the underwear she meant to buy – ah! the secret world! – so she stood up (I was there in the same compartment) and pulled down the chain for an emergency stop. The train jerked to a halt. And the men played cards till she came back with her shopping . . . 31 years later when I had been rehabilitated and Lounatcharski was dead, I saw her on my return to Moscow, an old woman in a black dress.

After Berlin, Warsaw, Brest-Litovsk, and Minsk, I arrived in Moscow on the morning of the tenth anniversary, November 7th, 1927.

I went straight to the Red Square to watch the military march past, and to see my father for the first time in my life. He was on the podium in his General's uniform taking the salute! I stared up at him but the temperature was minus 28 and I could think of nothing except how cold I was. I was dressed as if I was going to the Lycée in Paris – my light suit with plus fours, a fashionable white raincoat with dark amber buttons and a pair of shoes with thick, spongy rubber soles. I was conspicuous and I was frozen to death.

Some officers behind the podium noticed me and took pity. At that time I did not speak much Russian. One of them approached my father and, whispering, asked him what should be done. 'Wrap him up in a tarpaulin and deliver him to my house!' he ordered. And this is what happened. They rolled me into an army-issue tarpaulin, dumped me in a sidecar and pushed me through the front door. My stepmother thought I was a new carpet! Eventually she thought she heard the carpet murmuring! Soon afterwards I moved out of their house. For two years I was a vagabond and by the winter of 1930 I was already an enemy of the people. My father the General was executed in 1937.

Around the house in Boulogne-Billancourt there are many blocks of uncarved stone and marble. Lipchitz left for America

in 1940 and never returned. By the back door there is usually a blue enamel plate brimming over with cat biscuits. 'For the birds', explains André, 'they nibble them . . . you see that cherry tree? It grew by itself one year after Mother died. When she was alive she had a habit of spitting out cherry stones from the living-room window. She particularly liked the Morello cherry'.

In 1946, when the war was over, Berthe insisted upon leaving New York and coming back to the house in Paris: 'somewhere my son's alive, I feel it', she said, 'and when he's released he'll go to the house in Boulogne to find me, and if I'm not there when he arrives, we'll never meet again on this earth'.

She came back alone, and had to wait 14 years for André to return and to sleep again in the room made to his measure when he was a boy. By that time he was 45, he had spent 27 years in the Goulag and had been transferred 124 times.

The son looked after the mother until she died. In Paris he earned his living selling life insurance policies.

One of the first things he did on his return was to put a tennis ball into a net bag and to hang it on a tree, 20 centimetres from the ground. It was for his mother's cats to play with. It is still hanging there.

Packing one of the cardboard boxes, he finds a watercolour, pauses and holds it out at arm's length. 'It's better than I thought when I did it', he says, 'do you want it?' The watercolour shows an alpine chalet in summertime. Around the chalet stand stooks of hay. It was clearly done, like a child's painting, from the imagination, not on the spot.

'Yes, I'd like it'.

'I'll sign it', he says and on the reverse side of the paper, in large loose script, he writes: 'My dear John, in recollection of my marvellous August holidays, 1905, spent in your mountain chalet – André'.

As he writes he bites his lip to stop himself laughing out loud and spoiling the joke. In 1905 none of us had been born and none of us had been transferred even once.

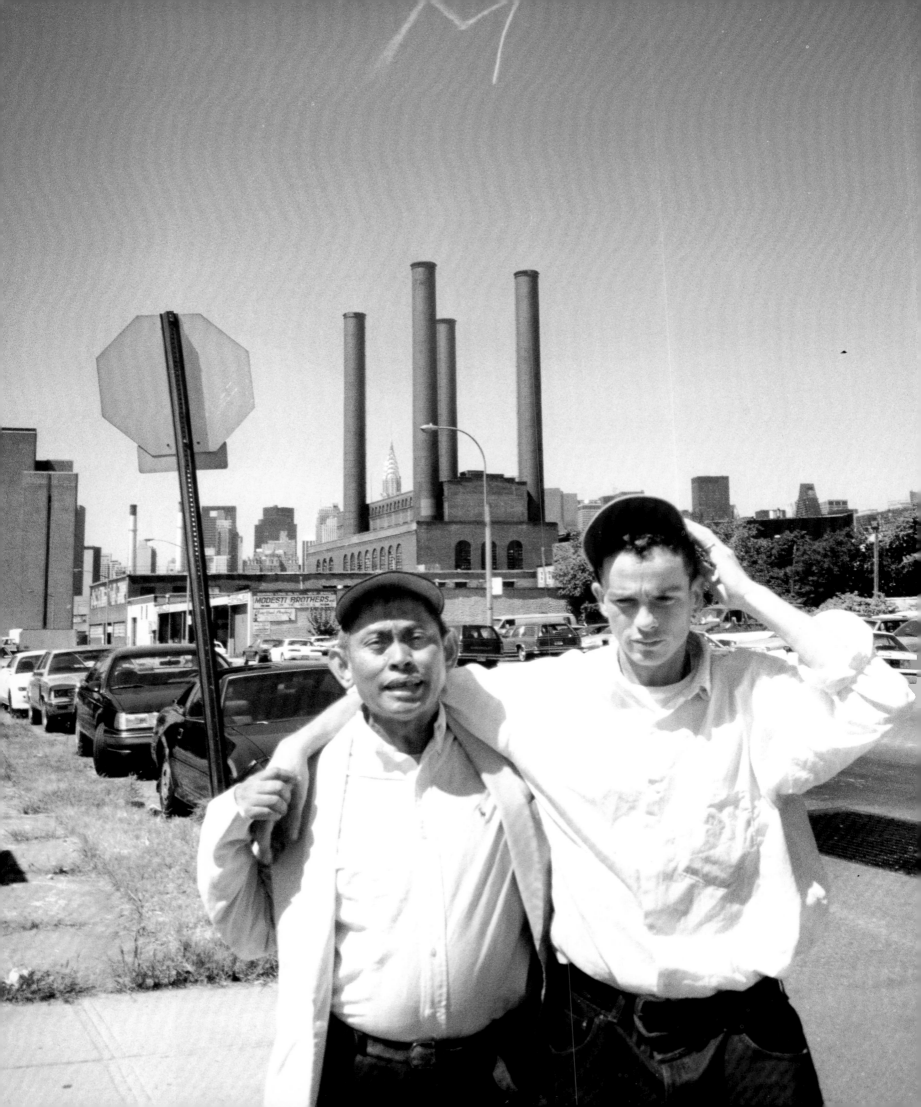

spectacle but surveillance. We are neither in the amphitheatre nor on the stage but in the panoptic machine'.[15] In other words, the stage/world, illusion/reality distinction is irrelevant in a system which incorporates everything under the rationalised surveillance of a 'super power'. But is not Foucault's model simply another image deriving from the western patriarchal myth of the God's-eye view? It seems to me that Medalla's wandering, ephemeral performances, his creation of instant stages here and there, sidestep the alternatives of both spectacle and surveillance. He recreates those categories of amphitheatre and stage freshly in the midst of life, and with a fluid, dialogic ambivalence, which defies such a crude and monolithic destiny.

But I hardly want to slip into another positivist or prescriptive definition. I am sure David Medalla would be happy to escape from all the definitions I have offered of him. Out of perversity, out of ego perhaps, or, alternatively, out of a modest understanding of the common basis from which we all begin:

I mean I'm an enigma to myself . . . I don't know why I'm here. You can always have a construct: I'm here to pay my taxes, to please my parents, to have children. Thomas Aquinas said the animals were here in order to praise God. You see, the constructs are always changing . . .
I believe art should investigate reality and bring out its enigmas.[16]

## Notes

1 Purissima H Benitez, *David Medalla: The 60s and 70s*, Master Degree thesis at the Courtauld Institute of Art, University of London, 1992, p33, unpublished.

2 The totally unpredictable and surprising list of Medalla's performance venues amounts in itself to the most elastic understanding of the notion of 'a space for art'. From the Great Hall of the Accademia in Venice to a bar in Brooklyn, from the Jantar Mantar environmental observatory at Jaipur to the Rotterdam flea-market. Two of his more unexpected events involved 'modern forms of secular exorcism' which he carried out in the former villa of the Nazi leader Hermann Goering at Villefranche-sur-Mer, outside Nice, with its parking space for a submarine (1979), and in the former mansion of Imelda Marcos in New York, with its tacky, mirror-lined discotheque, where he was invited to stay by officials of the new Philippine government after the Marcos's fall from power (1990).

3 Quoted in Catrina Neiman, 'Art and Anthropology: The Crossroads, An Introduction to the Notebook of Maya Deren', *October*, No 14, Fall 1980, New York, p15.

4 Rasheed Araeen, *The Other Story*, South Bank Centre, London, 1989, p5.

5 *op cit*, Benitez, Interview with David Medalla.

6 *Ibid*, pp2-4.

7 David Medalla, in conversation with the author, London 1976.

8 Brandon Taylor, interview with David Medalla, *Artscribe*, No 6 April 1977, London, p22.

9 Jun Terra, interview with David Medalla (part 2), *San Juan*, Manila, August 1985, p5.

10 David Medalla, 'Some Reflections on the Random in Life and Art', unpublished text, Rotterdam, 1985.

11 Guillermo Gómez-Peña, 'Hybrid America', *National Review of Live Art Bulletin*, October 1993, UK.

12 David Medalla, 'Tropical Stoicism', *The Filipino Express*, 30 July 1990, New York.

13 Medalla's series of five lectures at the Museum of Modern Art, New York, in 1990, 'The Dream of Yadwigha – The Sources in Global Cultures of Modern Art', were a contribution to this discussion.

14 Susan Hiller, interview in *Fuse*, Toronto, November/December 1981.

15 Quoted in Jonathan Crary, *Techniques of Observation: On Vision and Modernity in the Nineteenth Century*, MIT Press, Cambridge, Massachusetts, 1990, p17.

16 David Medalla, informal talk with students at Chelsea College of Art, London, April 1983, quoted in Guy Brett, 'David Medalla: from Biokinetics to Synoptic Realism', *Third Text*, No 8/9, Autumn/Winter 1989, London, p106.

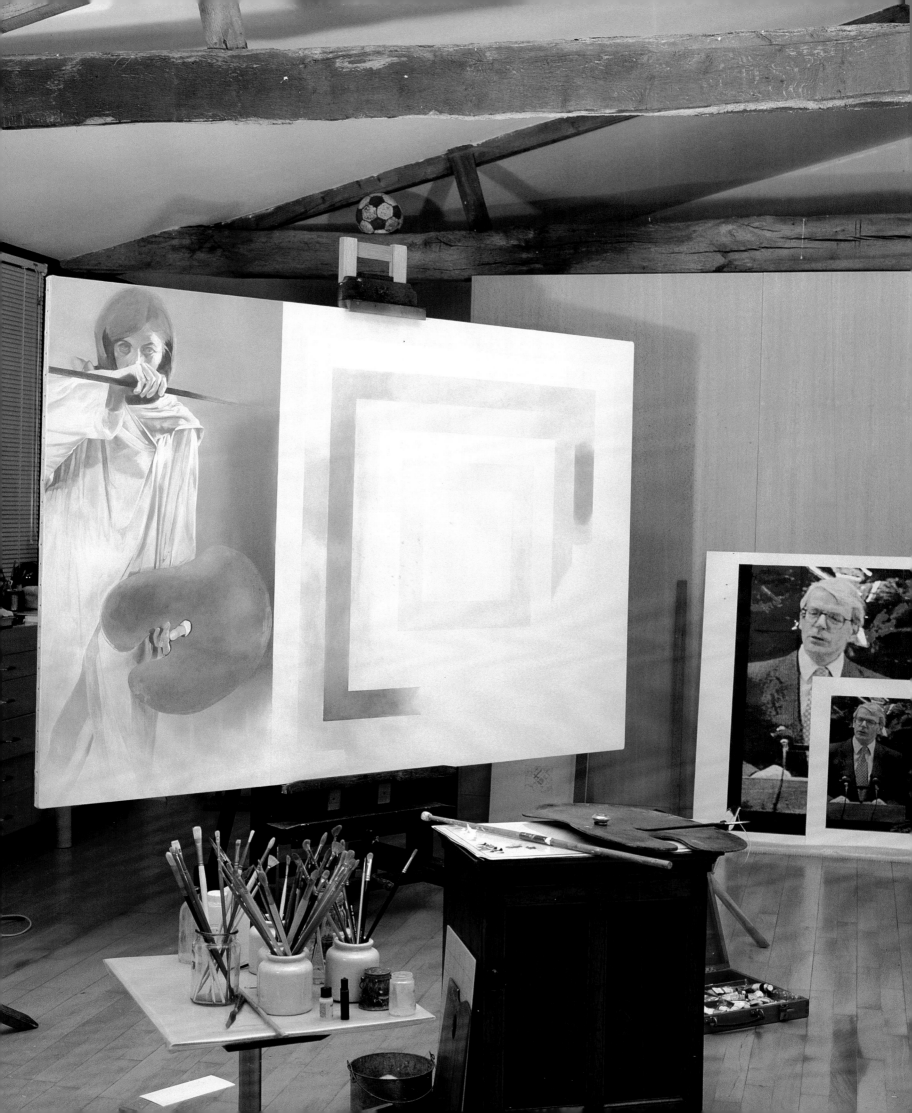

# RITA DONAGH
## TOWARDS A MAP OF HER WORK
*Sarat Maharaj*

The Association of Art Historians' Conference theme – 'History/Practice/Theory' – traces, amongst other things, terms used 12 years ago to place Rita Donagh's artwork (*Paintings and Drawings*, Whitworth Art Gallery, Manchester/ Arts Council of Great Britain, 1977). In each instance they evoke and emphasise, as we may expect, rather different meanings. In one respect, however, the terms signal the same thing for both projects: a focus on the interrelationships between our modes of thinking and picturing the world and the ways in which we live it, between our 'constructions of it' and how we come to act in it.

Her artworks take the measure of something like these interrelationships through the device of 'the map'. This is a vast, vital 'pre-text' which pervades and contains her production from the mid-1960s to the intensive, complex rephrasings of the device in *Shadow of the Six Counties, Long Meadow, Lough Neagh* and related works of the 1980s.

We encounter the map as sections of ordnance survey and contour maps, elevation views and diagrams, isometric and plan projections, profile schemes and aerial perspectives. In the less explicit, perhaps more inferred sense, the map appears as a contrivance for designing a world, a machine for fashioning its energies – as something which stands for the 'scene of all representation'.

To escape its metaphorical force is not easy. If the map 'figures out' a world for us, it is only to involve us in the matter of 'figuring it out', of learning to find our way around, of getting 'from A to B' which is also the less 'mundane' business of searching for the 'right road', the proper path of action.

Rita Donagh teases out and plays upon a particular feature of the map: the fact that, if it gives us what we tend to take for granted as an accurate account of the 'world out there', it also looks radically unlike what it represents. In everyday, common-sense terms we rarely think of the two things as in any way at odds with each other: the particular convention of representation involved has so much become second nature to us.

*1 Two columns on Rita Donagh's work. On the left, a piece from 1989: on the right, cheek by jowl, this column of annotations and jottings. The texts sneak a sideways glance at each other. They fill out and add to each other's lines even as they stand apart – a mirror for the way her paintings, drawings and installations interact and tie together?*

*No other body of work has reflected so abidingly on the 'Troubles', annotating and probing media representations of its tangled 25-year course.*

*2 Mapping the 'Troubles', or troubling the map? – with either shorthand phrase we are obliged to invert it, fold it back upon itself to describe Rita Donagh's approach, for she is not only figuring out the space of the 'Troubles' and its impact on our innermost selves, not only sizing up and squaring various accounts and versions of it, she is also exploring the nuts and bolts of representation – the means through which images of the world are charted and fashioned.*

*Teeming everyday experience, the clashes and collisions of the 'Troubles', are pared down into a ghostly spume – the flesh of historical events into spectral, shadowy traces of themselves. These distillations are pushed to their limits till they double back as reflections on perspective, proportion and pigment, on brushmark, on the act of painting itself.*

*Her work is therefore both representational and abstract, statements voiced in both public and intensely private key, as much about the outside world as about the streaming flux of inner life and states of feeling. Each term passes over into its opposite. Rita Donagh's work has been giving us the two-columned treatment all along.*

*Rita's studio in 1994, showing Slade (work in progress)*

It is, however, that fateful gap; between what the map tells us and how it goes about doing so, that her artworks open out and probe. *Shadow* (1964-65) and *42nd Street* (1965-66) chart aspects of a street-life scene, human bodies and faces through different systems of convention, elevation views, distorted perspectives, trick projections and profile reductions. If all versions seem equally persuasive, we also experience them as 'worlds apart' from one another, let alone their distance from the lush naturalism of their photographic source.

In this sense we may speak of her artwork as 'representation about representation': the map encapsulates something of the way signs relate to things – an exemplar of the systems which apply to all visual representation. A high point of this interest is reached with *Reflection on Three Weeks in May 1970* and related drawings (1970-71) which map out movements and activities in an interior space. A network of salients, trajectories, shifts in stance and orientation is pondered and plotted meticulously. Reports of action and events from the world outside, the shootings at Kent State University, are graphed in.

Images and signs assume a double-tongued character: on the face of it minimal and taciturn, they speak without pause about the processes of their making. Nothing is depicted without it referring back to the act of representing. A gap is prised open between seemingly austere, laconic signs and the volumes they speak about states of feeling and mind, and inner worlds of hesitation and dilemma.

We find her artworks arguing over and disputing the authority of whatever they make part of their representation. This used to be taken as the 'didactic' element in her approach (M Regan, Whitworth, 1977, p3). For us it has come to suggest that it is not so much that she aims at driving a message home, as 'demonstrating' how it gets driven home. Another aspect of the 'instructive' element expresses itself in her important contribution to post-1970s developments in self-reflexive approaches to studio work, to the search for more critical interplay between art theory and practice.

The concern with 'representation' does not, however, lead her work away into an involuted, formalistic realm; 'the map' remains too much of a blunt reminder that some 'data' needs to be communicated. The 'content' she elaborates springs from the map's very 'form', the way it shows us objects, things and locations by disclosing the structure and pattern of relationships between them.

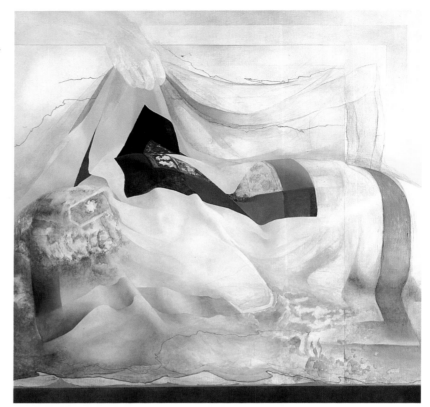

*3 Impossible cartographies. By renaming parts and provinces of Ireland, Joyce projected a grotesque, crazy-paving map:*

*'Ulcer, Moonster, Leanstare and Cannought'.*

*Skewing up place names, stretching them on a rack, he forced them to yell out their history, their suffering, their foolishness. Buckling and curling up at the edges, refusing to be flattened out, his map is a satirical planometry with its deadly signpost for Ulster.*

*How does the land lie? Rita Donagh measures and calibrates landscape and locality, cityscape, the compound and prison space sketching a map of ideas and emotions. She tussles with the impossible map – as if with a jigsaw puzzle with one piece too many or with one bit askew. How to 'fit in' the North? Where do the ancient, megalithic sites feature? A symbolic, mythical map for Lough Neagh. A swooping bird's-eye view for an ideological map of the Maze. Lines of divisions and demarcation – a tribal map for the H blocks? Rita Donagh roughs out the impossible map-making room for a diversity of perspectives, differing viewpoints, clashing positions, even blind spots; she draws us into examining the pros and cons of representation, of mulling over the choices and dilemmas involved in mapping the world. Steadily, over the years of the 'Troubles', she thus comes to unfold through her paintings and drawings what might be called an ethical cartography.*

Counterpane, *1991*

In the 'map system', lines of connection and forms of linking may be decoded as quite the opposite – as lines and forms of division and separation: what appears as connected tells a story implicitly of what has been forced apart, simply left out or opposed to another element. The artworks delve into the fact that the map's 'authority' as a system of representation seems inextricably caught up with having to subordinate or exclude something. Dry, matter-of-fact delineations and demarcations called upon simply to denote 'boundaries or borders' begin to speak of a ground of tensions, pressures, transgressive force.

In this turn of the map stratagem, her works reflect on that particular interlocking of place and position, perspective and power relations termed 'Ireland'. Whether explicitly cited or an elusive trace it stands as the central point of a knotted, painful, historical conflict. Even when we choose to overlook it, we are obliged to look over and across it in piecing together the national narrative of the United Kingdom. In her work we come to see the orders of perspective as 'surveillance', placing as a kind of policing.

Her approach strikes a similar note to emphases in some of the main theoretical currents of the day. *Shadow* and *42nd Street* were, interestingly enough, produced around the time Foucault's ideas on the 'constituting gaze and regimes of representation' were beginning to be more widely disseminated in France (*Naissance de la clinique 4, P.U.F., Paris, 1963: Les mots et les choses*, Gallimard, Paris, 1966). They were to circulate in the British art scene later, contributing to an intertextuality which stretches from Rita Donagh's artwork to something more recent like Tony Cragg's *Britain Seen from the North* (Tate, 1981).

The 'Ireland' she evokes keeps close to the particular textures of moment and place: Talbot Street, Dublin, Belfast, Long Kesh, Long Meadow, Leitrim. Not unlike the address which Stephen Daedalus scribbled down to locate himself in what were ever-widening circles to the whole universe, we move from this pavement, that street corner and lamppost to an awareness of the larger world. But the Ireland we are given as a concrete, historical area of devastation, hurt and suffering is not only a geographical location: it is also a state of mind – a troubled and troubling area of imagination and spiritual life.

It symbolises that agonising moment when, shaken by the fearfully systemic world of violence, force and violation, we find it hard to know how, or even whether, to act. Rita Donagh leads us through 'Ireland' to that other, mythic

*4* Slade. The *artist steps out of the wings into the footlights. We are slightly taken aback – we had lulled ourselves into thinking of her as someone behind the scenes, hidden from view. But* Slade *is as much a self portrait as it is scored and shot through with references to art's institutions, tradition and schooling, the act of painting, genre and gender. In the same way, she has always filtered historical and political events through the mesh of memories, recollections of family ties and emotional attachments.*

*So arranged and staged is the image that we sense in a flash that more than a portrayal of the artist's self is afoot. As if taking up a kendo stance, she holds her ground, staving off the opponent's thrust. There is a hint of defiance, of defending herself and her art practice – perhaps of keeping at bay and warding off those who admired the beauty of her paint but wished she would shed off and tone down its allusions to troubling events.*

*In* Slade *she is dressed to kill in artist's smock, wielding her brush, mahlstick and palette. The gear looks like a loose, easy-to-wear garment, a badge meant to proclaim 'the artist' at home. Or is it an encasing chadar-shroud for the woman artist's creative hopes? The painting's origins lie in an etching made in 1979 for a portfolio of prints by staff of the Slade School, and in 1990, a photograph for the student magazine (*mute4*). It is also an act*

Long Meadows, *1991*

battlefield in ancient India where other families, torn apart by arguments over land rights and identity, stand arrayed for battle. Rather than take up arms, however much in the name of justice, against cousins, sisters, elders and relatives, Arjuna's first response is to let them have their way. His cry, 'My body burns, my head spins, my hair stands on end, my mouth dries up, my limbs shiver, the bow falls from my hands: better to die than to slay', opening moments of the *Bhagavad Gita,* celebrated section of the *Mahabharata,* reverberates through the many-threaded discourse between himself and Krishna on action and inaction, the use of force and non-violent persuasion. The discourse was to shape Thoreau's *Walden,* in that 'mingling of pure Walden water' as he put it, 'with the sacred water of the Ganges'. His text forms the text of Rita Donagh's *New Bearings* and related works (1970-72).

There are at least seven versions of *Walden*: the first in 1846-47 and six others Thoreau created between 1848-54, each time he went back to amend, revise, cancel, rearrange it. Nor, it seems, had he settled for a comforting 'final one' (LJ Shanley, *The Making of Walden,* Chicago, 1957). The absence of the notion of an authoritative, definitive account feeds into the 'work in progress' spirit of Rita Donagh's New Bearings and Evening papers groups. As she intends (Whitworth, 1977, p22), it puts in visual terms the idea of a querying, circumspect, even self-doubting state of mind and feeling, an antidote, we may say, to dogmatisms and certitudes about the true version of 'Ireland'.

In its intensive redrawing of Thoreau's 1846 survey of Walden Pond, 'taking the trouble to sound it' (1970-71) captures the sense of a mind pacing through its thoughts, revising and redefining its positions. By the phrase, Thoreau meant something not unlike the meaning of mapping to Rita Donagh – unending testing and trying out of values, beliefs, responses.

He had juxtaposed two places, two perspectives of life: the stale routines of Concord against the experimental, the search for fresh perspectives on living at Walden Pond. It gives us the context of Rita Donagh's own search for new perspectives on 'Ireland', beyond worn-out, fixed ways of understanding it.

Why Thoreau? Because his reflections on spiritual balance and poise, the inner disciplines of civil disobedience, the campaign against slavery, through the prism of Gandhi's 'experiments with truth', through Martin Luther King's efforts, were to shape many of the social and

*of homage to countless women painters, often consigned to obscurity, who have depicted themselves with the paraphernalia of 'the artist' – as if in a desperate bid to be visible.*

*Laura Knight's audaciously staged* Self-portrait *(1913) springs to mind – the viewer sees not so much the artist as the artist at her job. She portrays herself as having stepped back momentarily from the canvas she is painting before adding another stroke, before sallying forth for another attack and engagement. The viewer looks over her shoulder – witness to her vigorous, independent, professional and creative life.*

*On the right-hand side of* Slade, *an 'abstract' panel. The opened-out toga-like smock or the quilt from* Counterpane *sets up a flat pictorial plane. For a second it seems as if the artist is peering out from behind it. The piece reads as an essay on approaches to life drawing, to ways of surveying, measuring and signposting the body associated with the school idiom – especially that of William Coldstream. It is no less an essay on how the gaze is constructed and how it operates – the artist depicts the activity of depicting. The viewer's gaze does not prevail: he or she becomes the object of the viewing. Facets of the gaze are played off – how space is experienced, engaged and activated, a concern throughout her work with aerial perspectives, cross-sections, panoptic, panoramic views floating high above the Maze; the viewpoints telescope into one another.*

Slade, *subtitle 'mirror and screen' – showing an image sending it back to the viewer at the same time as blocking it off. In* Counterpane *the hand is poised to whip away the coverlet to reveal the fallen body – or is it about to place it over?* Slade *stages the gaze – covering and concealing, insight and blindness. As if a footnote, a faint bleeding of colour at the bottom left hand side recalls the photo-source of the painting – over-exposure, so much light that little can be seen, the film tinges with a rainbow effect. Rita Donagh tracks the dialectic of the gaze whether it scans the body politic, the arena of representation, the lens of the media or the intimate focus on the female body.*

political movements Rita Donagh was to live through or of which she was aware in one way or another: the civil rights movement in Ireland, Black civil rights struggles, 'passive resistance' in South Africa.

Thoreau – because it is not always easy to square his stance with his support for the 'violent' John Brown, or for that matter Gandhi's satyagraha (truth-force of passive resistance) with his support for the 'violent' Subhas – a gap between ideal and action which seems untidily and exasperatingly human. However, it may well be that this, with an irony of its own, renders it less impossible to live through and make sense of the tensions and conflicting pulls signalled by 'Ireland'.

'Ireland' as place, event, moment; 'Ireland' as Arjuna's cry and timeless scene of dilemma. The history/myth activated by Rita Donagh is not unlike Eliot's use of it. He was, through Thoreau/Emerson, to summon up Arjuna's cry in refusing to take sides in the Spanish civil war (*The Criterion*, 26(63), 1937, p290), an interpretation of Arjuna's stance of detachment which has been challenged (D Donoghue, 'Eliot and The Criterion', in *The Literary Criticism of T S Eliot* ed D Newton de Molina, London, 1977, p27). In the bleak moments of the Second World War, against the backdrop of Ireland's/India's search for independence, he was to return to the motif and pose the question 'how to act?' all over again:

*I sometimes wonder if that is what Krishna meant . . .*

*'And do not think of the fruit of action, Fareforward.*

*O voyagers, o seamen,*
*You who came to port, and you whose bodies*
*Will suffer the trial and judgement of the sea,*
*Or whatever event, this is your real destination.'*
*So, Krishna, as when he admonished Arjuna*
*On the field of battle.* (The Dry Salvages)

If the text-centred quality brings to the fore something of the 'conceptualist' provenance of Rita Donagh's work, it is no less a 'pretext' through which she manages to observe and comment on the world around us, on situations, struggles and events. Her emphasis falls on the search for critical awareness, on how meanings are made, rubbed out, revised. She avoids the forthright, full-voice address associated with art in the programmatic, committed mode.

By mid-century, these modes came to seem, as Adorno noted, in the ashen, 'other' perspective of 'Auschwitz', all too affirmative, too vehemently positive to ring true. It was to lead to his desperate remark 'no art at all is better than

*5 Two columns: one concerned with narrative only to be outflanked by the other's sheer painterliness? In Rita Donagh's work we never feel that meaning is a ready-made message like a fast-food package waiting to be delivered, dished up and devoured. She invites us into making meaning with her – taking the measure of states of suffering, loss and pain. She draws us in as she sifts through clips and cuttings to ascertain how a scene was depicted and reported – drawing us in step by step into the activity of painting.*

*However thin the paint, however sparse the coat of pigment she applies, an excess seeps out, spreading across the canvas, saturating it with a surplus force of its own. Julia Kristeva had observed this effect in Giotto at Assisi, in the frescos at the Basilica of St Francis that Rita Donagh had found so relevant at first sighting in 1979. The Assisi cycle is designed to narrate a Christian story. But paint and colour take charge 'shattering and pulverising meaning'. Ripples of retinal sensation, a consuming visceral pleasure takes grip, a 'jouissance' that trips up the mundane matter of communicating a message. In* Long Meadow *and* Counterpane *we pass into a 'jouis-sense', to use Lacan's phrase, an enjoyment-in-meaning and beyond as we track the flickering waves of brushmark across canvas. Mark after mark, transparent lead grey streaked with pale colour, a flow begins to well up that overshoots discursive meaning and 'Troubles' talk flooding it.* The artist

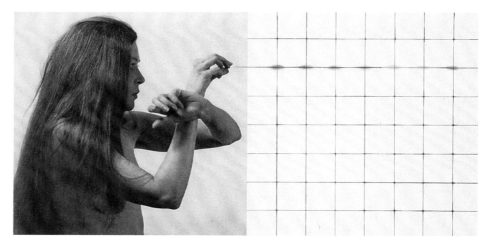

socialist realism' (*Aesthetic Theory*, RKP, [1972] 1984, p79). It is a measure of Rita Donagh's achievement that she finds a way of engaging with historical life and experience without falling back on the modes of 'engaged art'. In this she comes to contribute to that recreating of 'history painting' in which, we may say, the genre reflects upon its own impossibility.

The topos of her work, as we have seen, is the map: not without significance, a piece is called *Topography of Violence* (1974). The concern is with how 'Ireland' is reported, depicted and represented. *Evening Papers (Ulster 1972-74), Pavement, Aftermath, Car Bomb, Newspaper Vendor* and *Talbot Street* deal with how the media 'covers' and narrates such events, how it cuts, pieces together and lays out its material.

A report in *The Sunday Times*, 19 May 1974, pictures the pitiful scene of a body on a pavement 'covered by the evening newspapers'. It is the series' 'pre-text': in conceptualist mode, the term 'covered by' with all its connotations comes to frame our response. How issues are 'covered by' the media, the notion of 'news coverage', is set off against the idea that personal facts, painful moments of loss, grieving and shattering of individual lives, tend to get covered up in the interests of a larger story which has to be told; some public, national mapping of the incidents.

The drive to disclose the facts, in this sense, turns out to be a drive to cover them up since the blindingly vivid and graphic terms in which one thing is recounted renders invisible some other aspect of the story. Against rumours and reports of the fate of a boy newspaper vendor, the story is checked by Rita Donagh and found at odds; his own testimony and version of things is carefully sought out. (1977, p31). But this is not done in the spirit of an exposé: the works do not juxtapose, in some stark, simplistic fashion, 'media misrepresentations and mis-reportings' against 'the true way of picturing Ireland'.

The glimpses we catch of the map of Ireland through passages of transparent brushwork resemble at the same, a misty veil which clouds our view of it. What shows, also appears to obscure. The misty paintwork evokes something of the veil of myths through which we read Ireland and through which it is constructed. The artworks do not cut through them to arrive at a 'true account of things' somehow beyond and outside their spell. Rather, they set up the search for something like the 'true account' in and through that tangled borderland between fact and fiction, representation and misrepresentation.

*6 A flashlit scene outside 10 Downing Street, 15 December 1993. The air is thick with expectation, the prospect of settlement after 25 years, 'Peace by Christmas'. The air is also laden with the jabber of political negotiation and of matters undeclared. From such wearied, stale coinage a new way of living has to be painfully forged and put into currency. Behind the politicians stands a large Christmas tree festooned with shiny ribbons and bows of red, white and blue. We clutch at this sparkling, sentimental, almost kitsch image to voice the emotion that wells up in us.*

*Rita Donagh had chanced upon the image – a newspaper front-page photo – on the train that evening, nine months ago. Two statesmen presenting the Joint Declaration, a document the authorities have put into public circulation, though few have got round to reading it cover to cover. What is there to read when the Christmas tree says it all? Rita Donagh treated the*

*FROM ABOVE:* John Major and Albert Reynolds at the Joint Declaration, 15th December 1993; Shadow of the Six Counties, 1980, oil and collage on canvas, 25 x 35cm

The image of a quilt, found in the empty dwelling in Ireland in which her mother was born, used in *Counterpane* (1987-88) sums up the concern with 'representing Ireland', the business of covering an event and covering it up. It evokes something of that mix of gravity and grandeur with a grieving almost unexpectedly personal, intimate tone associated with David's *Death of Joseph Barra*. *Counterpane* is also quite literally a painting made 'against pain'.

Art styles which have held sway in the late-modernist world are cited and placed in inverted commas in Rita Donagh's artwork: media communications' idiom, the grain of the voice of popular culture and its jargon, conceptualist language, sheer painterly expressionism are amongst the styles she excerpts and recasts. In her concern with the 'grammars of representation', 'Ireland' silently presses through – for, like a bloodstain in a fairy tale, to use Adorno's words, it cannot be rubbed off.
March 1989

*found image – touching it up, enlarged and photocopied – an image easily made at a photocopy shop and at hand, in principle, for wide distribution.*

*24.00 hrs, 31 August 1994 – A cease-fire is declared: 'The War is Over'. The Declaration and its hopes have to be acted on. Rita Donagh's works stand not only as landmarks and witnesses to the 'Troubles' but as reminders of the need to examine its enormities through personal questioning and searching. Her paintings evoke the 'Troubles' through pitiful scraps of detail – an epaulette , a coverlet, a bit of newsprint, a paint dribble, a blood stain: her most recent piece landmarks the possibility of exit from the 'Troubles' by making us attend both to the rhetoric of a ministerial occasion and to the gloss put on it by frail human feeling, sentiment and hope captured by a jingle-bells, fairy-tale Christmas tree.*

*September 1994*

Bystander, *1977, oil and collage on canvas, 152 x 152cm*

*FROM ABOVE: Archive floor plan; Archive Interface*

# FALSE ENDINGS

## ANECDOTED HISTORIES, DETERRITORIALISED SUBJECTS AND CENTRAL EUROPEAN IMAGINARIES

*Reflections on George Legrady's 'An Anecdoted Archive from the Cold War'*
*Irit Rogoff*

It was a dull conference in Germany in the middle of the summer. A fierce heatwave further dulled senses already laid low by tedious conference papers, and so when a suggestion was made that some of us go out to the nearby valley to look at a radically innovative factory building being designed by James Sterling, it seemed like momentary salvation. The building was indeed remarkably interesting but we had fallen into the hands of the site manager who was in love with every doorknob of a factory that stretched for miles through the valley. There was no water on the site and the temperature was in the hundreds. After several hours of traipsing about I had reached the end of my tether. I turned to the person next to me who turned out to be a Polish cultural historian who had, in a moment of weakness in 1989, briefly and inadvertently become the mayor of Krakow, and said that I intended to faint and thereby put an end to the group's collective misery. He responded with a pitying look and said that I had much to learn about politics. He then turned to our guide, struck a mayoral pose with arms spread, and head slanted and said with great bravura, 'How can we ever thank you for this magnificent tour which has been the highlight of our visit to Germany, we shall now take its precious memory home with us'.

At that very moment the tour ended and I understood that claims concerning 'the death of Communism' had heralded a false ending. In fact, it became clear that while state structures may have toppled, the lived cultural practices of ironic allusion, oblique references and deferred meanings were not only with us, but that we, sophisticated Western cultural theorists, had a great deal to learn from them about the actualities of ambivalence and split subject positionalities. What is left behind in the wake of state Communism exemplifies dense textuality, the constant production of a multiplicity of concurrent signifying effects. There is no nostalgia for lost heroic radicalisms in the desire to understand its complexities as a model for the double or triple consciousness which is required of the ever-growing army of the culturally displaced at the end of the 20th century. While I would not accept such positions as Stejpan Mestrovic's, which argues that the confluence of Postcommunism and Postmodernism, the loss of two grounding metanarratives, have worked together towards an unravelling of the West,[1] I would certainly argue against the notion that Eastern Europe has been 'lost' or 're-placed' by simulacra of pure Western capitalism.

How to withstand the triumphant rhetoric of historical beginnings and political endings, a rhetoric that takes for granted and without problematising, notions of linear progression, periodisation and teleological history, are questions being asked across every facet of culture. In the ephemeral remains of Communist culture, in what has continued because it is psychic rather than material,

we have an opportunity to construct a model that sets up theoretical interconnections between some of the major traumas of the second half of the century. By this I mean a model which works across all three worlds to understand how the collapse of colonialism, of Communism and Cold War certitudes, of indigenous economies and markets, of long sustained regional and ethnic balances, can be set up in some form of relationality rather than hierarchised according to who holds claim to the greatest hardships and grievances. One of these common issues has to do with the need to avoid the effacing nature of Capitalism's global triumph or the erasures of migration's required assimilations. Another question concerns the need to de-hierarchise the radical shifts of the post-colonial, migratory, post-Cold War world, of how to hold on to the moment of double consciousness and produce from it a model that extends beyond the position of marginality within a hegemonic culture.[2]

In George Legrady's 'Anecdoted Archive from the Cold War', a computer archive of assorted images grouped within highly personalised taxonomies and framed within the ordering principles of the former Hungarian state's propaganda rhetoric, there is a thread of double consciousness that might be followed. This is an interactive work of art on computer disk which can be engaged with in the context of the art gallery or through one's own home computer in the form of a CD ROM.[3]

An endless process of transparent layerings and the use of computer interactivity in order to chart some negotiations between the conscious and unconscious mind of historical narrative are the informing structural principles of this work. The first level of transparent layerings is anchored in concrete, named and acknowledged histories. The initial site of the work is the floor plan of the former Museum of Communist Propaganda which was installed by the ruling Hungarian Communist party on the site of the former Budapest Castle and which now serves as the Ludwig Museum. Entering the archive, following along the sound of footsteps heard against cold, institutional stone floors we encounter a floor plan and are required to choose the trajectory of our visit in this autobiographical archive of an identity constructed through the Cold War.

The narratives that inform the archive are numerous: the history of Hungary before, during and after the Second World War; the Communist takeover and the current moment. These are intersected with the story of one bourgeois family whose history is overlaid but not erased by Communism. The narrative includes the family's life in Hungary, migrations to Austria and Canada, partial journeys of return and Legrady's own wanderings in the region on a journey of accumulating references for reading the text which had been written over Hungarian national identity.

The museum as starting point is the site of many accumulations. A site of memory, Legrady also claims it as a possible arena for a dialogue with authority about the process of historicisation. Officially sanctioned legitimacy battles it out with personal memory throughout the different rooms of the archive's floor plan. The duel is particularly interesting because it extends beyond a simple binarism between official Communist history and resistant bourgeois memory. The entire duel is set up through a series of 'seconds' as it were, an intertextuality that reads every association through numerous others, an understanding that one does not have a personal memory but always a cultural memory. For all of the archive's extremely personal artefacts – baby pictures, home movies, images of the artist's parents' young love, sagas of family houses, personal testimonials of the experience of escape, migration and the difficulties of adapting to a new culture, family voices recounting stories and much, much more – the narrative always remains cultural. One is reminded of Barthes commenting on his own autobiographical meanderings in *Barthes on Barthes*:

> Here I am henceforth in a state of disarming familiarity: I see the fissure in the subject (the very thing about which he can say nothing). It follows that the childhood photograph is both highly indiscreet (it is my body from underneath which is presented) and quite discreet (the photograph is not of 'me'). So you will find here mingled with the 'family romance' only the figurations of the body's pre-history – of that body making its way towards the labour and pleasure of writing. For such is the theoretical meaning of this limitation: to show that the time of the narrative (of the imagery) ends with the subject's youth: the only biography is of an unproductive life.[4]

The process by which the self is produced culturally is one of the strategies I would like to track in my walk through the archive. In the first room entitled *Images* we find a collection of 'various public and personal images representative of the aesthetics, values, paradoxes and iconography of both sides of the Cold War'. From the moment we enter the archive it is made clear that all of the identities involved in this long and global conflict are constituted out of one another's imaginaries. A file on 'border crossing' shows where the Legrady family crossed the border into Austria on their escape from Hungary in 1956. It serves the purpose of establishing a line of division between the two worlds, a border of personal making. In the same room/menu we have a fashion spread from *Vogue* magazine which uses a variety of Hungaries as the background for its fashion shoot. There is the decadent old Budapest of the turn of the century, all opera houses, cafes, casinos, crystal chandeliers and flirtatious young women and Gypsy Princes. There is the Communist chic of early radical socialist images, of workers on the train and in industry; muscular, heroic and utopian and there are the wild horsemen of the Steppes, folkloric in costume and pre-Western in their historical allusions. A Western imaginary of Hungarian history constituted out of novels, operettas and the desire to not burden itself with too complicated a history of Hungarian internal resistance. A pictorial essay on the other face of Europe, it romanticises and consumes politics as style.

In the next room we are treated to a display of shop windows from across Eastern Europe; in each a contemporary display of commodities from lingerie to electronics is accompanied by images of Karl Marx (the occasion for this photo journey of shop displays was the 100th anniversary of his death), of the insignia of the workers' party and the state juxtaposed with the labels of Western credit cards. Each side of this conflict can only perceive of itself in terms of the other, an identity worked out through negative differentiation which proves only that they are completely inseparable. In another room we find a series of 'posings', young men in Vietnam and the young women they left behind in trailer parks across the United States. Another aspect of the Cold War, this time articulated through a purely American language that does not demonstrate a recognition of a world outside itself even as it goes out to fight a war within a global economy of the Cold War. The defiance of this knowledge expresses itself in the haunting innocence of these images, an early 1960s innocence of a suburban sensibility that had not encountered another world for some two decades. The language of this photo display is purely cinematic and it brings to mind the film Jean Luc Goddard made on the Vietnam conflict seen from the perspective of Paris and entitled *Far from Viet Nam*. Nothing could be further from Vietnam than the innocence manifested in these self stagings – 'posings' – refracted through that myth of decadent, knowing, old Central Europe which is staged in the adjacent fashion spread.

This space is followed by two rooms entitled *Stories*. The first contains materials from the period of 1949 (the Communist takeover) to 1956 (the Hungarian revolution) and the mass migration of anti-Communist Hungarians out of the country. Legrady's parents stage their love scene in 1952 on a famous Budapest bridge with a distinctive touristic view behind them. They claim the view, their location within it, their love becomes inscribed with Hungarianness, inseparable from its background and we begin to fear for its stability in our knowledge that it will soon be displaced onto other landscapes. Does this kind of staging insist on a bourgeois narrative for this view of Budapest? Does it defy a Communist takeover of a beloved culture or does it write a private love as a form of national culture? Parallel, we run Robert Doisneau's famous Parisian image of a couple kissing in front of the Hotel de Ville, an image that also writes a national, rather than a private, romance. A European intertextuality of couples kissing passionately across the capitals of Europe, an alliance that works to loosen the grip of Communist encroachment on Central Europe and to return these places to an earlier geography of shared pleasures.

Forty years on, Legrady has found the exact spot of this scene and has photographed it, empty of lovers and of claims, just a blank, touristic view of the city from the bridge. Looking back and forth between the two images one begins to read the loss of the city but not of its former citizens, a city without the cultural lovers coded 'Hungarian' and 'European' rather than a couple who have been deprived of a romantic setting. They have moved on into escape, migration and the perils of adapting to another culture. In this room the ultimate European narrative is set up in dialogue with the mythical narrative of the family's escape from Hungary to Austria in 1956. Legrady had asked all the members of his family to write and illustrate their memories of their flight into Austria. In

this image his brother Miklos remembers train journeys, guards of immense size, interrogation rooms, the border, the different landscape and so on. A child's memories filtered through an adult's knowledge. This is truly a version of Barthes 'family romance', a memory of great trauma which is cajoled by the adult world into an optimistic discourse of new beginnings, of possibilities and of adventures. The cartoon style adventures of these new worlds is counter balanced within this section of the archive by others of continuity, of the family house and its many generations of occupants and most intriguingly of the bullet holes on the facade of the Budapest house that Legrady was born in. The house had been marked by numerous bullets during the fighting in the Second World War and probably acquired more bullet holes during the fighting in 1956. Legrady had videotaped all the bullet holes, turning them into a narrative of punctured facade. They too continue a pre-Communist Hungarian history, European and bourgeois. A couple of years later he returned to find the bullet holes filled in and the house, neglected throughout the years of Communism, repainted and resurfaced.

Of all the many hundreds of images which are crammed into the archive, like a mind bursting with associations and references, it is the *Bullet Holes* and the room entitled *Money* which I find most intriguing and productive for the interactivity which the computer opens up to the public. The section on *Money* is simply a set of images of coins and bills and the stories and histories associated with them. It opens with a set of coins entitled 'Loose Change' which Legrady found at his grandmother's house in Hungary after her death. Through them he sketches the history of foreign interventions into Hungarian history from Austria, through Fascist Germany to Russia. Their status as relics, as the debris of the long gone, vanquished and replaced empires and regimes, their stripping of agency, a currency with neither use value nor exchange value, make them a particularly useful and debased set of historical referents. They are framed with other stories of money, from the Second World War, from the Communist regimes of Hungary, Russia, Czechoslovakia and East Germany, from the moment in which Soviet Federal rubles ceased to be a currency of exchange in the breakaway Ukraine, and so on. A history of

money as a non-capital entity, money which does not circulate, whose value is not in its live buying power but in its dead symbolic power, money which serves as a testament to all the failed political, national and military adventures which printed it as their most pervasive and widely circulating representation.

The sections on bullet holes and coins and money puncture the surface of the archive, they suture onto their spare images all of the associations we encounter every where else within it and they affect the transition of what Barthes called the *Studium* to the *Punctum*. The Studium, says Barthes:

. . . is the application to a thing, taste for something, a kind of general enthusiastic commitment, of course, but without special acuity. It is by Studium that I am interested in so many photographs, whether I receive them as political testimony or enjoy them as good historical scenes: for it is culturally that I participate in the figures, the faces, the gestures, the settings, the actions . . . The second element will break (or puncture) the Studium. This time it is not I who will seek it out (as I invest in the field of Studium with my sovereign consciousness) it is this element which rises from the scene, shoots out of it like an arrow and pierces me. A Latin word exists to designate this wound, this prick, this mark made by a pointed instrument: the word suits me all the better in that it also refers to the notion of punctuation, and because the photographs I am speaking of are in effect punctuated . . . these marks, these wounds are in effect so many points . . . this second element which will disturb the studium I shall therefore call the punctum.[5]

It is at this moment of punctum in which the archive shifts ground from a narrative, a series of historical accounts, to a critical model for the lived conditions of disrupted histories and displaced identities. A narrative recounts a series of events in a temporal sequence and narratives are only available to us through processes of narrations by situated authors. In the moment of punctum that authorial position and that narrative sequence are disrupted, one element, a bullet hole or a coin exit their original narrative structure, their story, and begin writing a new one for which no narrative structure exists at the present.

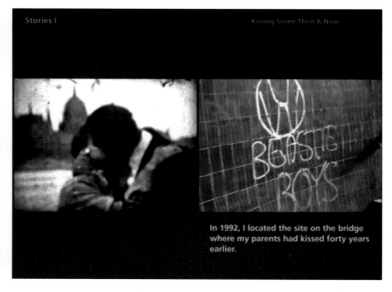

*L to R:* Escape Story Miklos; Kiss and Now

*FROM ABOVE: Bullets(1); Bullets(2); Bullets(3)*

Through the archival layering of the computer we begin to arrive at an imaging of a Communism that overlay bourgeois culture but did not erase it. Bourgeois culture *co*-existed within and beside it through the not-yet-told narratives of bullet holes and loose change, through a debris that begins to come together through a process of intertextuality, a process which reads it not through itself but through other texts. In Legrady's archive, Communist culture is a facade overlaying bourgeois culture. As long as Communist culture was nascent it required the proof, the bullet hole, the coin in someone's dresser drawer, that it had pierced the heart of bourgeois culture. In its demise these were plastered over – the integrity of the bourgeois body, first was punctured and then resurfaced. Neither is at an end, for their mutual narrative structure sustain each other.

The cultural displacement of the family to Canada, to the New World and the return of Legrady on numerous scavenging journeys to Europe begin producing the final stage of what I would like to term 'co-inhabited histories'[6] This term designates the confluence of two conditions:

1 Historical narratives inhabited by subjects who are only partially entitled, who cannot claim complete, or coherent state sanctioned belonging.

2 Subjects who are themselves inhabited by several historical narratives concurrently. Narratives whose relation to these subjects may be tangential, phantasmatic or imaginatively claimed. To think through a Central European Communist history, through bourgeois narratives viewed from North America is to set up several structures of *co*-inhabited histories. One of the most promising aspects of this concept of *co*-inhabitation for the post-colonial world of hybrid and displaced subjectivities is that it cannot be reduced to one logic, one order and therefore one point of origin or one claim to conclusion. It becomes a specific variant on Foucault's notion of genealogy. The disruptive claims he made for genealogy such as:

> . . . if interpretation is the violent or surreptitious appropriation of a system of rules, which in itself has no essential meaning, in order to impose a direction, to bend it to a new will, to force its participation in a new game, and to subject it to secondary rules . . . then the development of humanity is a series of interpretations.[7]

The archive, layered simultaneously through the technologies of the computer's simultaneity and through the simultaneity of historical *co*-inhabitation, shifts ground from traditional historical narrative to the form of what Deleuze and Guattari term a Rhizome.[8] Unlike the arborescent structure that is a traditional linear account centred around organised power, in the rhizomatic form of the archive there is no centre. A smooth space of deterritorialisation and distribution emerges, a nomadic historical structure rather than a narrative of historical nomads. A nomadic historical structure could not entertain the concept of endings, false or otherwise, for it would constantly be searching for the untold, circular and continuing histories within the hidden crevices of its unfolding spaces.

**Notes**

1 Stejpan G Mestrovic, *The Balkanization of the West – The Confluence of Postmodernism and Postcommunism*, New York and London, 1994.

2 Paul Gilroy's recent *The Black Atlantic – Modernity and Double Consciousness* (Boston, 1994) proves a remarkably interesting example of how to conceptualise double consciousness through the inversion of conventional routes of migration. By tracking the movements of African Americans from North America to Europe and the shifts that they affected within European culture and European culture affected within them, the entire model of 'progressive' cultural movement and its relation to migration is revised.

3 The piece has been exhibited extensively in museums throughout Europe and the United States. It is also available as a publication on CD Rom, George Legrady, *An Anecdoted Archive from The Cold War*, Base Arts, POB 78154, San Francisco, California, 94107.

4 *Roland Barthes by Roland Barthes*, New York, 1977, opening pages.

5 Roland Barthes, *Camera Lucida*, New York, 1985, pp26-27.

6 For a detailed discussion of this concept see Irit Rogoff, 'Co-Inhabited Histories – Historical Infitrations with Vera Frenkel' forthcoming in *Camera Austria*.

7 Michel Foucault, 'Nietzsche, Genealogy History', in *Language Counter Memory Practice*, Ithaca, 1977, p145.

8 Gilles Deleuze and Felix Guattari, *On The Line*, New York, 1992.

*L to R:* Home Video (3); Coin 1950

Dorian Fake, *1993, enamel on laminex*

# CONSTANZE ZIKOS

*Judith Pascal*

When is colour cruel? How would we know? The colour psychologists of advertising tell their clients, say, that blue-and-white means 'fresh', but how to package 're-venge'? A certain violence has entered the vocabulary of the perfume market, but usually under the catch-all, tiresome concept (rubric) of 'sophistication'. There are perhaps too many shades of meaning in the negative emotions to be easily accommodated by any simple symbolism. But the expressive representation of violence having long been exhausted, and traditional colour symbolism irredeemably devalued, is assault still possible in the visual arts?

A Melbourne writer once said Constanze Zikos's work 'should be jailed'. She was writing about the pieces with which Zikos made his entry into the Australian art scene: the dazzling, harsh, spray painted laminate panels, which constituted an extended meditation on the meaning of the symbols and patterns of the Ancient Greeks in contemporary Australia . . . When I saw them I was excited by the way in which, for all their classicism, they seemed to carry with them the unmistakeable strains of Death Metal, or sometimes vintage disco at its most heartbreaking. Of course, it then became clear that the classicism Zikos was proposing was neither stylism nor revival, but an elaboration of Nietzsche's vision of a Greek culture with tragedy at its centre, and the theories of George Hersey for whom the meaning of the forms of classical architecture can be under-stood only if they are seen, as it were, sprayed with sacrificial blood.

To refuse to forget history, and to allow present and past to commingle in daily life, is a part of the process by which a culture under threat defends itself. Cultures which in the name of progress obliterate their own traditions will always be perplexed and embar-rassed by the tenacity with which other cultures maintain theirs. And those traditions are frequently maintained in such a way as to defy easy assimilation to the picturesque; laconically, halfheartedly even, and with no interest in the niceties. It is the privilege of those for whom a symbol or image really means something, to be able to tamper with it without disrespect. This is the context that the classical imagery of Zikos must be seen. It consists, in his case, of a stubborn refusal to make distinctions between the high and low cultural manifestations of images such as the temple front, the Greek vase, the geometric border. So be it on the back wall of a Greek café in Melbourne, or in Ancient Corinth itself, a classical motif is a classical motif.

The role of colour in this, is fundamental. It is the means by which Zikos carries on his commentary on the images he has selected from the canon. It is by virtue of Zikos' choices of colour that a Classical pattern must be read as sign from an ideal Homeland but also one which can appear in provincial clubland. The colours, in a sense, 'disappoint'. They refuse to assimilate with the philistine good taste which dogs the Classic. Nor, interestingly do they simply 'modern-ise'. Whilst fully aware of the 'second' identity of his paintings as geometric abstractions, Zikos avoided the pitfalls of that particular mode which in its anxiety to appear serious, frequently adopts colour schemes of rather pretentious and strained severity.

Nor can the colours be easily dismissed as vulgar Popism. One never has the sense that the artist has had any place for deliberate and arch inversions of good taste which at best, amuse, and at worst, do not. At their worst (which is also their best), Zikos' colours and surfaces evoke a kind of deep, tragic emptiness. And as it happens, the most tragically empty provincial discotheque I have ever been to was close to the Ancient Greek city of Paestum in Italy. More recently, Zikos' work has begun to make use of fabrics, embroidery and upholstery. The authoritative imagery of the Classi-cal world has been replaced by the authoritarian imagery of the Australian public realm, presented in the form of domestic decor. The Australian flag, for example and proposals for its redesign, have inevitably become a battleground for different and competing interests and Zikos has responded with a radical repetition with variations of the 'traditional' design. These works struck me as playing a faintly sadistic game with our expectations of 'appropriate' colour. Where, in the case of the Australian flag, we expect to see blue, in the Zikos version although we sometimes in fact find blue, it is not the solid deep blue we might have wanted. We are given . . . turquoise. Where we expect scarlet, we are given ma-genta. And the material of the flag is velvet. It is difficult to fully describe the pleasurable sinking feeling that these little disappoint-ments can induce in the viewer. The form of the works, blatantly form the realm of 'design and decoration', wholly ambiguous in its relations with the domestic realm, causes a certain confusion when presented in the gallery context.

Zikos has never faltered in his commitment to the craft of his art. It is significant that his work is never in any sense 'decadent'. His studio is in an old building in Chapel street, Melbourne, in a former fashion salon and workshop, from which some of the bolts of fabric were not taken away.

De Chirico once wrote, with psychic insight, of the atmosphere which might surround 'the German consulate in Melbourne'. But do you know, or do you want to know what suburban Melbourne is like, at the end of a hot summer?

*OVERLEAF:* God Save the Queen, *Obverse and Reverse side, 1995, photo Trevor Mein*

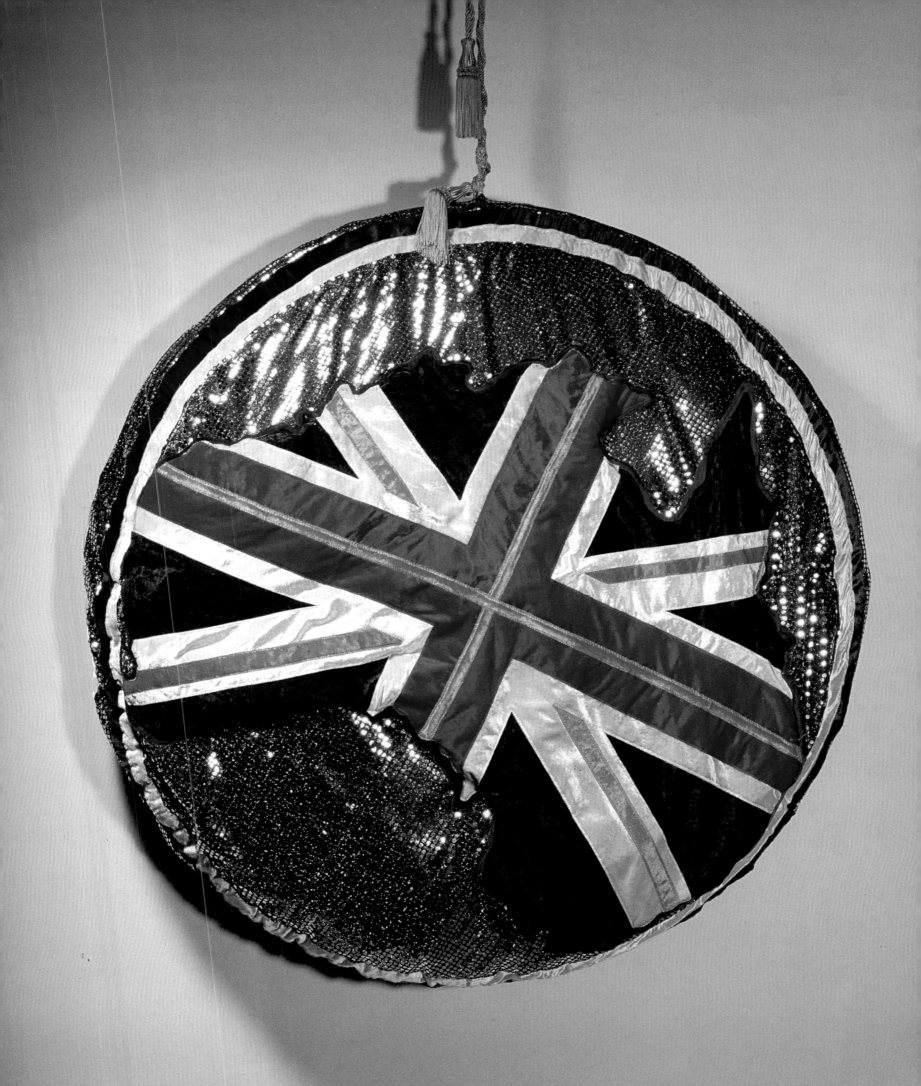

Dorian Fake II, *1993, enamel on laminex, photo Kenneth Pleban*

Your Lifetime Icon x 6, *1992, enamel on laminex, photo Kenneth Pleban*

# CONTRIBUTORS' BIOGRAPHIES

**Nikos Papastergiadis** is a lecturer in Sociology at the University of Manchester and is the author of *Modernity as Exile: The Stranger in John Berger's Writing*, 1983; **John Berger**, writer and critic, lives in France, recent titles include *Keeping a Rendevous*, 1993 and *To the Wedding*, 1995; **Ella Shohat** is Associate Professor of Cultural and Women's Studies at CUNY Graduate Center and of Cinema Studies, CUNY, Staten Island. **Robert Stam** is Professor of Cinema Studies at New York University, they are the authors of *Unthinking Eurocentrism: Multiculturalism and the Media*, 1994; **Juan Davila** is an artist living in Melbourne, he is editor of *Art and Criticism Monograph Series* (Melbourne) and publisher of *Revista de Crtica Cultural* (Santiago), his most recent exhibition was 'Juanito Laguna' at the Chisenhale Gallery, London and Ikon Gallery, Birmingham; ***scenario URBANO*** is a collaboration of artists and designers engaged in the production of multi-media projects for museums, radio and urban sites, along with more speculative projects, it includes Dennis Del Favero, Tony MacGregor, Derek Nicholson and Eamon D'Arcy; **Andrew Renton** is a London based art critic and writer; **Kathy Temin** is a Melbourne based artist; **Néstor García Canclini** is a Professor at the Autonomous University Metropolitana-Iztapalapa and author of numerous books published in Mexico, *Hybrid Cultures: Instructions for Entering and Exiting from Modernity* is being translated by the Univeristy of Minnesota Press; **Penelope Harvey** is a senior lecturer in Social Anthropology at the University of Manchester and is working on *Hybrids of Modernity: Anthropology, the Nation State and the Universal Exhibition*; **Victor Anant** is a writer who lives in Pakistan and Spain; **Jean Fisher** is a critic and editor of *Third Text* and *Global Visions*, 1995; Brussels based **Jimmie Durham** is an artist, and the author of *A Certain Lack of Coherence* and exhibits internationally; **Paul Carter**, historian and writer, lives in Melbourne, recent titles include *Living In A New Country*, 1992, *The Sound In-Between*, 1992 and *Baroque Memories*, 1994; **Guy Brett** is the former art critic of *The Times* and author of *Exploding Galaxies: The Art of David Medalla*; **Sarat Maharaj** is a senior lecturer in Art History in the Department of Historical and Cultural Studies at Goldsmiths' College, University of London, he is currently working on Joyce, Duchamp and Hamilton and is a member of the advisory council of *Third Text*; **Irit Rogoff** is Professor of Visual Culture at the University of California, Davis; **George Legrady** is Professor of Conceptual and Electronic Art at the California State University, San Francisco; **Judith Pascal** is a writer who works in Melbourne; **Constanze Zikos** is a Melbourne based artist and teaches art at the University of Melbourne; **Jochen Gerz** and **Esther Shalev-Gerz** are Paris based artists, *The Harburg Monument against Fascism* was documented by Hatje in 1994; **Christos Marcopoulos**, artist and architect was born in Holland, graduated from the Cooper's Union Institute, New York and now teaches at the Architectural Association, London; **Monkeydoodle** is a collective of art students at Goldsmiths' College, University of London: Tom Betts, Rosie Brignell, Andrew Drummond, Francis Clarke, Iain Forsyth, Mel Gibson, Chloe Grimshaw, Jill Haslam, Eliza Hudson, Kioko Mizuno, James Newton, Stuart Penny, Jane Pollard, Thalia Reid, Anna Saunt, Paul Thurlow and Oliver Varney.